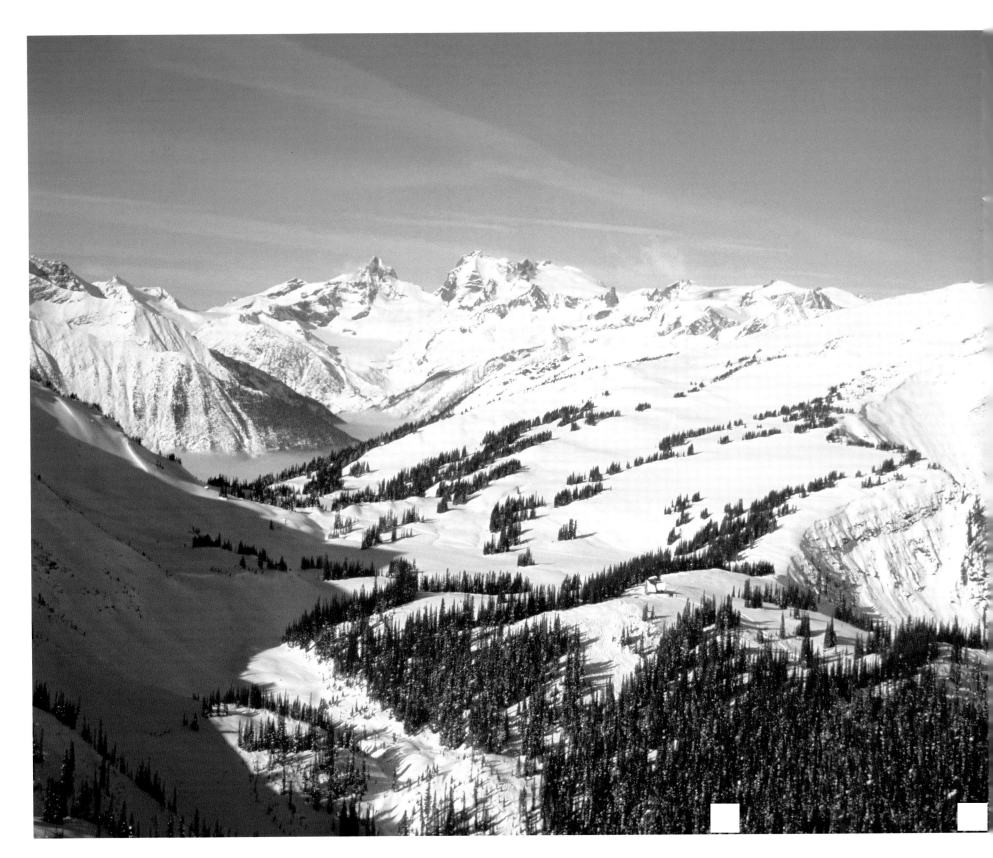

EXOTIC RETREATS
ECO RESORT DESIGN FROM BAREFOOT SOPHISTICATION TO LUXURY PAD

JULIA FAIERS

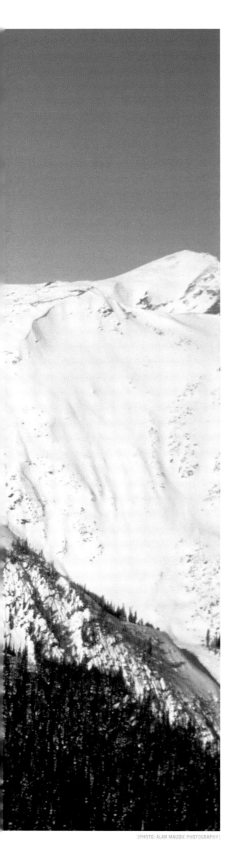

EXOTIC RETREATS

ECO RESORT DESIGN FROM BAREFOOT SOPHISTICATION TO LUXURY PAD

JULIA FAIERS

A ROTOVISION BOOK

PUBLISHED AND DISTRIBUTED BY
ROTOVISION SA
ROUTE SUISSE 9
CH-1295 MIES
SWITZERLAND

ROTOVISION SA
EDITORIAL OFFICE
SHERIDAN HOUSE
112/116A WESTERN ROAD
HOVE BN3 1DD, UK

TEL: +44 (0)1273 72 72 68
FAX: +44 (0)1273 72 72 69
EMAIL: SALES@ROTOVISION.COM
WEB: WWW.ROTOVISION.COM

10 9 8 7 6 5 4 3 2 1

ISBN: 2-88046-809-4

ART DIRECTOR LUKE HERRIOTT
BOOK DESIGN BY WILSON HARVEY,
LONDON +44 (0)20 7798 2098

REPROGRAPHICS IN SINGAPORE
BY PROVISION PTE.

Footnote: Tsunami

The devastating tsunami that struck many parts of Asia on December 26, 2004 destroyed not only countless lives, but also huge areas of pristine beauty. While we are powerless to reverse the devastating loss of life, one positive aspect to have come from this terrible tragedy is the way in which the world has united to help the affected areas, raising vast sums of money to ensure that local populations get back on their feet as soon as possible.

At the forefront of aid efforts are people in the tourism industry. Those who managed to escape the destruction of the tsunami are pulling out all the stops to help affected hotels and their surrounding communities rebuild their lives and businesses. Thankfully, the Asian resorts included in this book did not suffer any damage or loss of life, but each, in its own way, is contributing to the relief efforts.

Lisu Lodge in Thailand is operated by East West Siam. The company called an emergency meeting on the evening of December 26, which resulted in its sending a convoy of buses to the area of Khao Lak, the worst-hit area of Thailand, to assess the damage and provide aid and communications. They helped transport the injured to hospitals, searched for missing people, and assisted in setting up crisis centers for survivors to send word to their embassies. The company's head office in Bangkok also worked with local community agencies across the country to provide immediate aid in the form of tents, clothing, food, and water.

Banyan Tree Group, which includes in its operation Banyan Tree Phuket and Banyan Tree Bintan, set up The Asian Tsunami Recovery Fund, pledging financial and human resources to help affected communities, with the aim of ensuring a mid- to long-term benefit for people in badly hit areas. The company's chairman, Ho Kwon Ping, stresses "Relief funds are pouring in and international agencies are doing great work in providing for the most immediate needs. However, when the aid agencies finish their work and move on, there will be a whole range of new challenges for these communities."

While money and aid will undoubtedly help to restore some semblance of normality to the areas worst affected by the tsunami, it cannot repair the damage done to the tourism industry itself in countries such as Indonesia, Thailand, Sri Lanka, and the Maldives. Lars Sorensen, owner of Tree Tops Jungle Lodge in Sri Lanka, reported that while his inland location meant they avoided the physical effects of the wave, his business has temporarily ground to a halt due to the sudden cancellation of all bookings after December 26. He tells of the majority of the island's population working in the tourism industry losing their jobs overnight, and shows real concern for the long-term future of tourism on the island. "The big hotels run by large companies can repair damage quickly, and can expect to be up and running again in three or four months. The smaller, family-run guesthouses, however, will find it much harder to rebuild their businesses, as they don't have the financial backup of these larger resorts."

In the wake of the disaster, when the donations start to dwindle, it seems that the best way to help these communities is to visit their resorts and lodges. Without tourists, these areas of outstanding natural beauty might never recover.

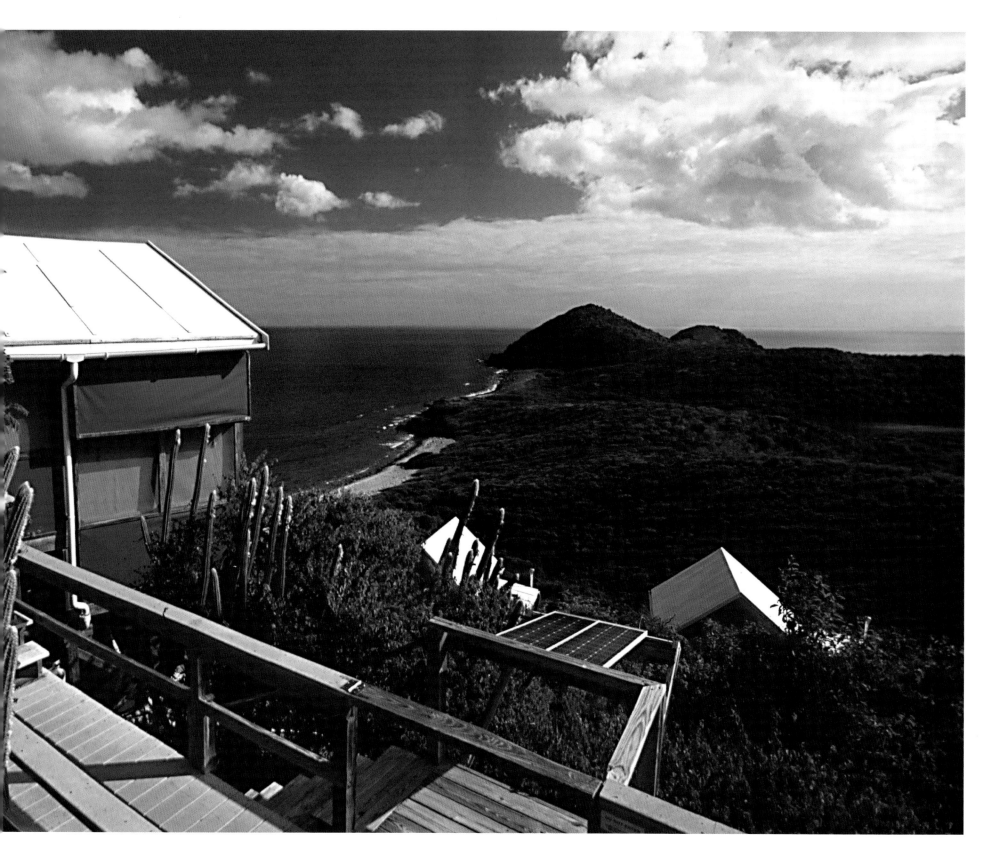

82

86

90

92

96

100

104

108

114

117

120

121

123

128

132

135

138

142

146

148

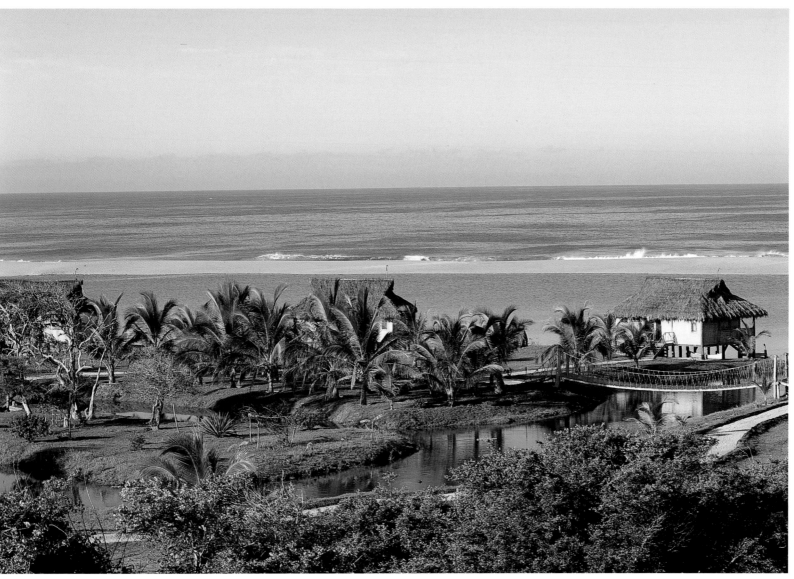

CONTENTS

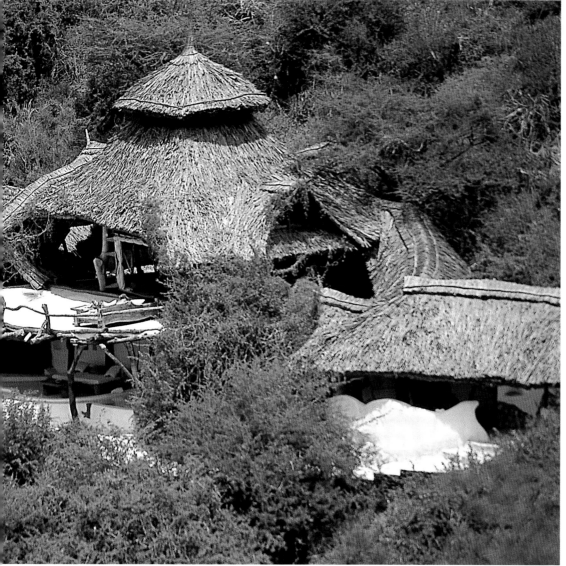
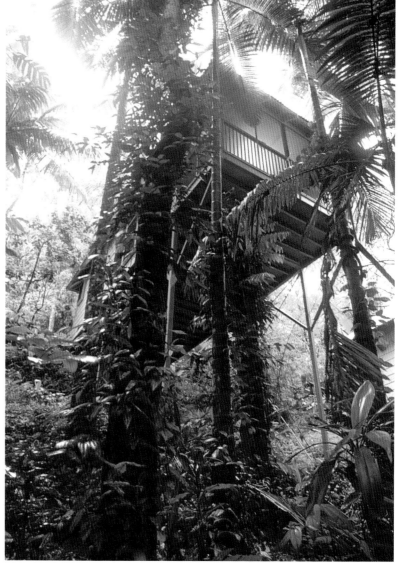

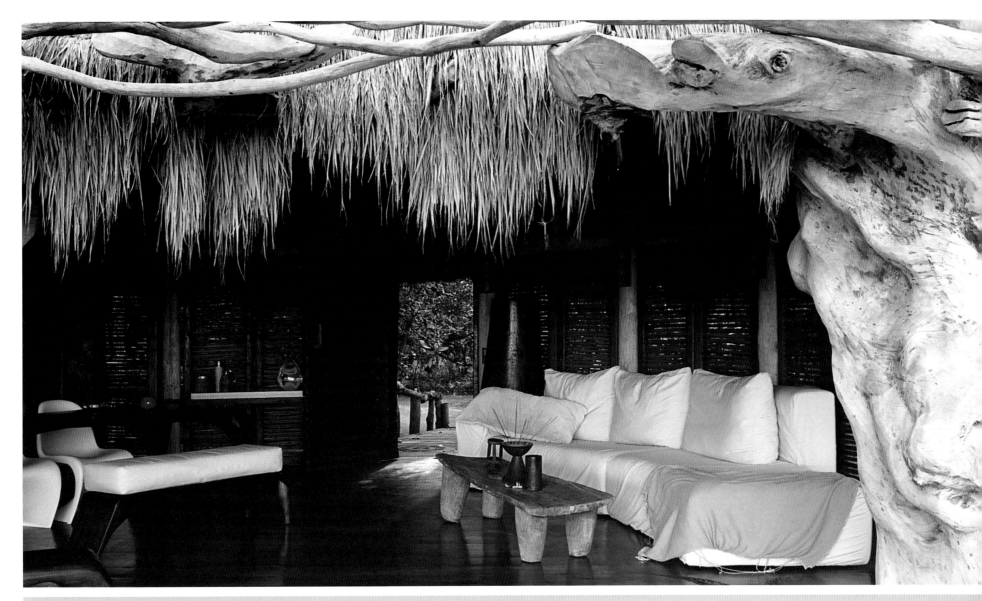

INTRODUCTION

"Exotic retreats" conjures up different things to different people. For landlocked Europeans, there could be nothing that fits this description better than a beach hut on a tiny island in the Pacific, accessible only by fishing boat. For inhabitants of sunny California, a rustic cottage in the Italian countryside is the epitome of far-flung exoticism. This book brings together 40 unforgettable retreats in some of the world's most precious, diverse, and unusual destinations. Each differs from the others in architectural style, location, and level of luxury afforded. What links them all is their operators' determination to tread lightly on the earth by following the basic tenets of sustainable tourism.

Call it what you will—sustainable tourism, ecotourism, responsible travel—it all boils down to the same thing: an underlying ethic whereby the resort, lodge, retreat, or hotel (and therefore the tourist) gives back more to the local community than it takes away. Once upon a time, ecotravel was all about tenacious backpackers in search of destinations unspoilt by the destructive hand of global consumerism. In the last decade, this niche market for the intrepid has received a nudge into the mainstream of tourism. The 1992 Rio De Janeiro Earth Summit, attended by 182 Heads of State, and the resulting Agenda 21, finally acknowledged the effect that mass tourism would have on the planet if its expansion continued unchecked. It spelt out to a greedy travel industry the necessity for acting responsibly and taking measures to lessen its impact on holiday destinations and their indigenous cultures. Since then, ecotourism has been declared the fastest-growing sector of the tourism industry, with the United Nations declaring 2002 the "International Year of Ecotourism."

The statistics are somewhat alarming. In 2004, there were around 700 million international travelers per year, and it is expected that this will have doubled by 2020. On a slightly more reassuring level, a survey carried out by responsibletravel.com in 2004 revealed that 80 percent of people asked said they were more likely to book a holiday with a company that had a responsible travel policy. The market for exotic resorts and retreats has never been greater, and this is reflected in the burgeoning number of eco destinations all over the world. Sadly, some of them are jumping on the green bandwagon, energetically proclaiming their eco status, due to a few solar panels, while having desecrated a fragile ecosystem in order to build their shining new hotel. In ecotourism, size is a serious factor. If a hotel claims to be green but provides accommodation for hundreds of tourists, this is going to have a negative impact on the environment and local community. Not so the 40 retreats in this book. All adhere to the fundamental tenets of ecotourism, catering for the few rather than the masses, to ensure that they don't interfere with the everyday lives of the local community. The Boat Landing Guest House and Restaurant in Laos, for example, limits its tour groups to just six people, with the result that its trips to nearby hill tribes are an educational excursion rather than an invasion.

There are innumerable definitions as to what makes a destination "sustainable." The following is a guide to the basics that all of the retreats in this book use as the foundation of their philosophy. The retreat must:

⊕ depend on the natural environment;
⊕ be ecologically sustainable;
⊕ contribute to the conservation of the environment;
⊕ incorporate cultural considerations;
⊕ provide a net economic return to the local community.

While tourism conference attendees spend hours discussing the latest definition of what actually constitutes sustainable travel, and how to introduce and implement a general certificate of sustainability, the owners of the following resorts aren't losing sleep over semantics. They are quietly running their low-key businesses, helping the community, and providing a rewarding holiday experience for their visitors.

So who are the people who eschew the dollars of mass-market tourism for such beneficial small-scale projects? In some cases they are travelers who never went home, who chose to share their love of a new place and culture with like-minded visitors. Rob and Marta Hirons traveled the world before settling in a remote area of Belize to build The Lodge at Big Falls. Others have built retreats primarily to house people interested in a specific activity, such as diving, fishing, or bird-watching. Raúl Arias de Para renovated a disused United States military tower in the Panamanian rain forest to create the Canopy Tower, an observatory for the myriad species of exotic birds that inhabit the forest canopy.

The majority of people who decide to embark upon these projects tend not to be part of big-business chains backed by big money, with the result that the design and construction of their lodges and hotels tend to be hands-on affairs. The owners of the resorts featured here often found themselves becoming jacks-of-all-trades, donning the mantle of architect, builder, project manager, and interior designer. Where professional architects and interior designers have been involved, they were invariably chosen for their sensitive, green approach. In several cases, existing buildings have been renovated to limit the impact on the environment; Locanda della Valle Nuova in Italy used to be a farmhouse, and the Kasbah du Toubkal in Morocco was once the palace of a local ruler.

I selected these 40 retreats, lodges, and hotels not only because of their commitment to the principles of ecotourism, but also because they show how important architecture and design are to the bigger picture of sustainable tourism. From the barefoot luxury of simple stone huts on an island in Lake Malawi to the elegant, organically shaped wooden structures in a sophisticated Seychelles' resort, they all use architecture to blend seamlessly into the landscape.

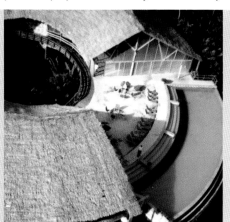
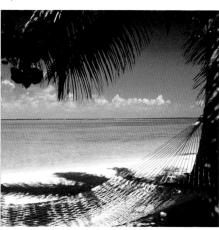

IT ALL BOILS DOWN TO THE SAME THING: AN UNDERLYING ETHIC WHEREBY THE RESORT, LODGE, RETREAT, OR HOTEL GIVES BACK MORE TO THE LOCAL COMMUNITY THAN IT TAKES AWAY

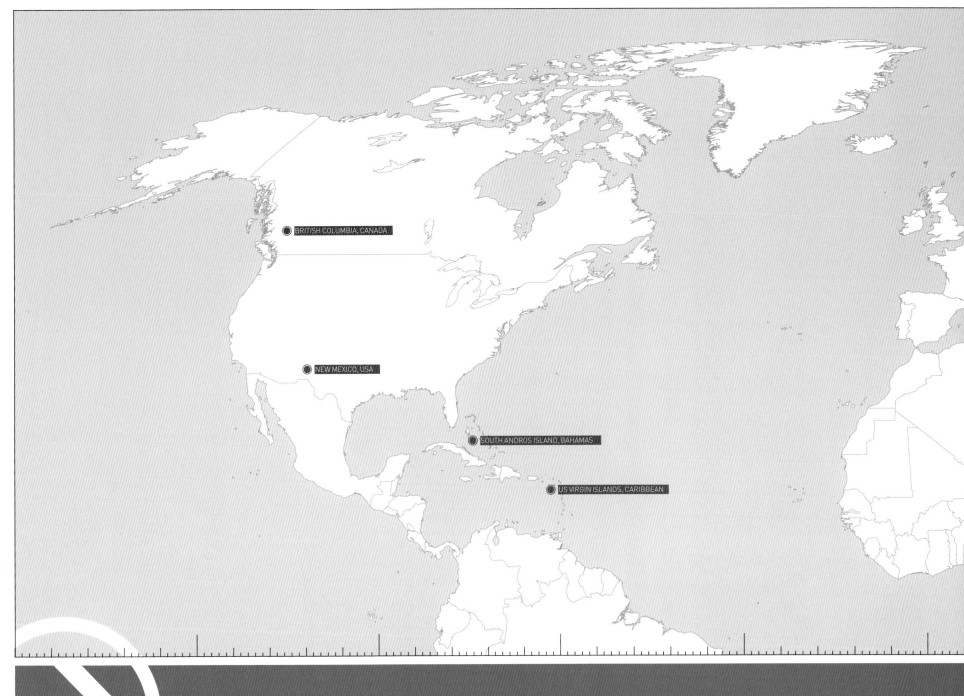

BRITISH COLUMBIA, CANADA

NEW MEXICO, USA

SOUTH ANDROS ISLAND, BAHAMAS

US VIRGIN ISLANDS, CARIBBEAN

BAHAMAS
SOUTH ANDROS ISLAND

CANADA
BRITISH COLUMBIA

CARIBBEAN
US VIRGIN ISLANDS

UNITED STATES
NEW MEXICO

NORTH AMERICA

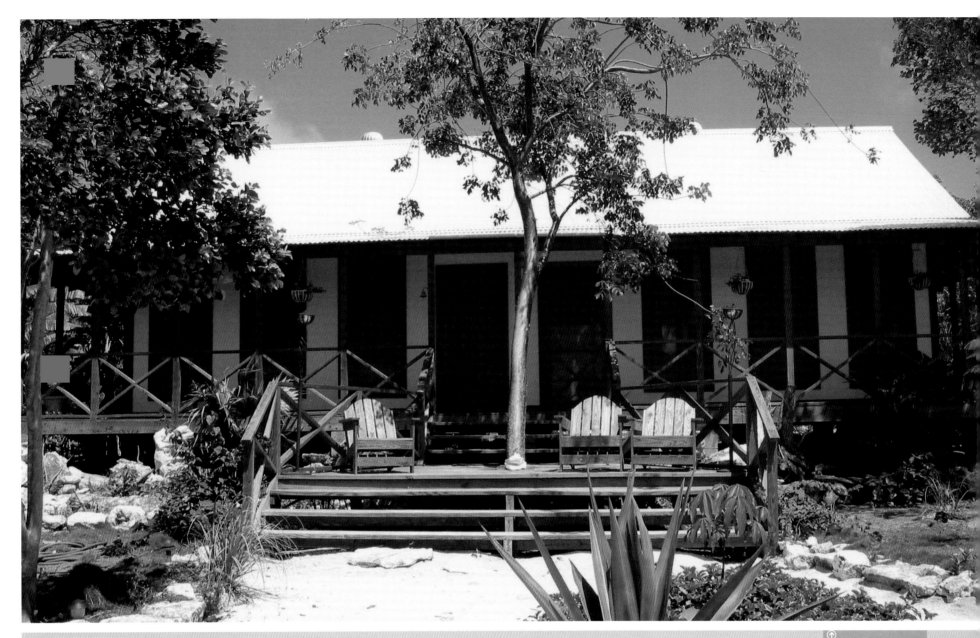

TIAMO RESORTS
SOUTH ANDROS ISLAND, BAHAMAS

The white roof of the central lodge is just one of the passive cooling techniques employed at Tiamo Resorts; it reflects sunlight to keep down the temperature inside the lodge. [Photo: Cookie Kinkead]

Each building is raised above the ground to minimize site impact and internal temperatures.
[Photo: Cookie Kinkead]

Cream-colored canvas drapes help to keep the bedroom cool, while the room is fully screened to encourage cross breezes and to keep bugs out.
[Photo: Cookie Kinkead]

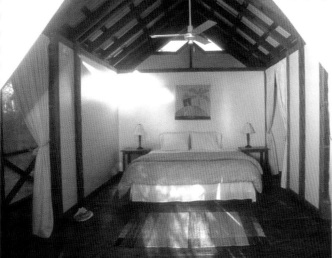
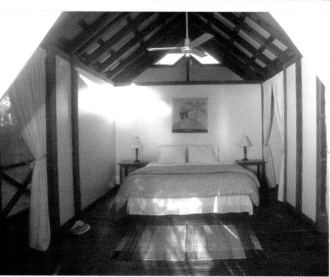

The sublime beach view from one of the bungalows.
[Photo: Cookie Kinkead]

Despite being the largest of the islands that make up the Bahamas, South Andros Island's massive natural barrier reef (the third largest in the world), coupled with its thick undergrowth, has prevented the typical developer attempting to make money from tourism here.

The owners of Tiamo Resorts, Mike and Petagay Hartman, are far from your typical developer. Their softly, softly approach to building in this fragile ecosystem is so successful that when approaching by boat, you can barely see the resort's buildings until you actually land on the beach. The 11 bungalows are wood-frame structures built from nontoxic, treated pine, harvested from sustainable forests. All employ passive cooling techniques—wraparound porches keep direct sun from the main living areas, reflective white roofs bounce light and heat back into the atmosphere, and the high, pitched ceilings and open-plan design encourage maximum airflow. Each building is elevated on simple columns, and is positioned to have the

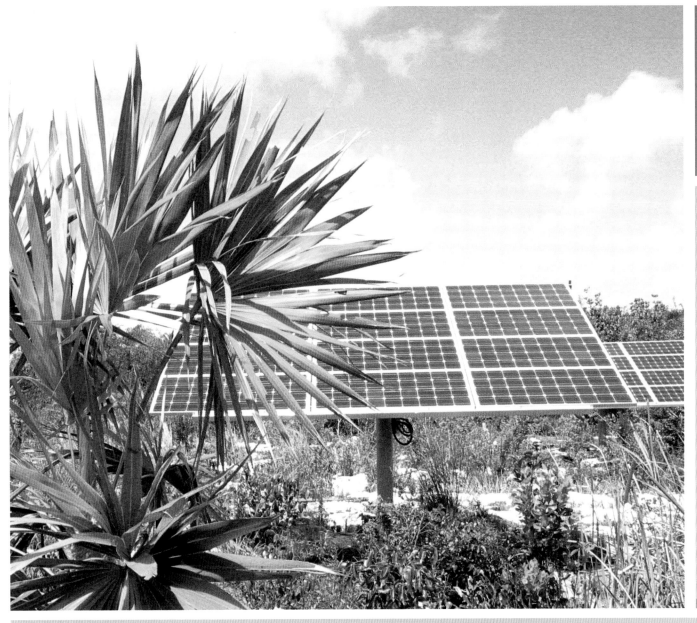

CONTACT: TIAMO RESORTS, GENERAL DELIVERY, DRIGGS HILL, SOUTH ANDROS ISLAND, BAHAMAS, T: 00 242 357 2489, INFO@TIAMORESORTS.COM WWW.TIAMORESORTS.COM

Tiamo's solar electricity system produces over 130,000 watts every day. [Photo: Cookie Kinkead]

least impact on the environment, situated between existing trees and vegetation to prevent unnecessary disruption to nature. All boast a stunning view of the ocean.

So determined were Mike and Petagay to get the design and construction of the bungalows right first time, rather than learning from mistakes that might adversely affect the environment, they built a prototype in Indiana first. All the scrap materials from this were saved and used to make furniture at the resort. Any materials that had to be brought to the site were delivered by hand using small, shallow draft boats that wouldn't damage the ecosystem. This isn't token "green" tourism. Mike and Petagay mean business.

For the privilege of staying in this barefoot paradise, with its luxurious staff-to-guest ratio of one-to-one, they ask guests from the USA to take home and recycle bundles of plastic items, as there is no recycling facility anywhere on the Bahamas. Nor will you find a glossy, expensive brochure for this exclusive resort—they promote themselves on the Net, paper free.

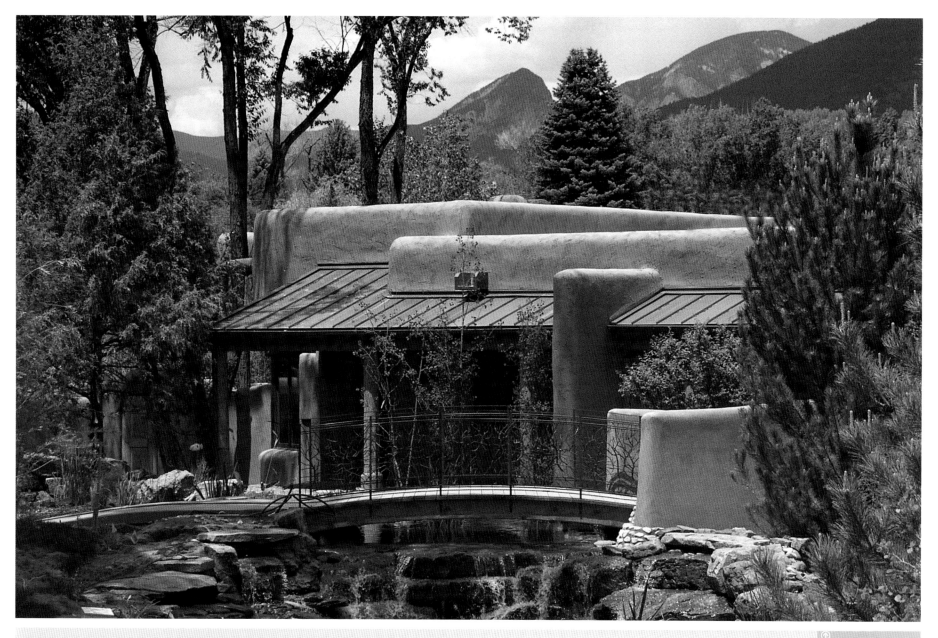

EL MONTE SAGRADO
LIVING RESORT AND
REJUVENATION CENTER
NEW MEXICO, USA

The resort is built in the New Mexican vernacular style, using local materials. It is surrounded by gardens full of waterfalls and tropical flora and fauna.

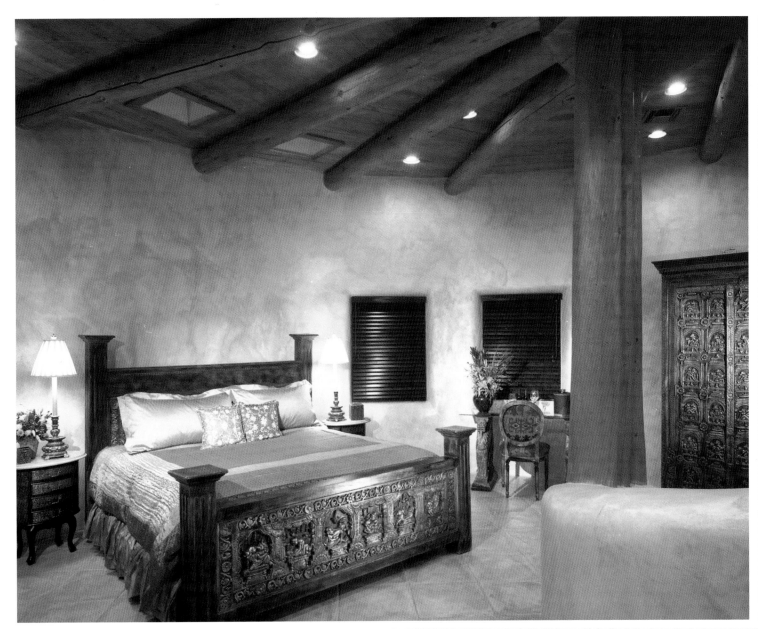

The rooms are either decorated in a Native American style or globally themed, as for this Kama Sutra bedroom which features an antique bed from India.

Tom Worrell, the owner of sustainable resort El Monte Sagrado in New Mexico, didn't take the "usual" route toward ecofriendly tourism. He started out as a high-flying businessman, running his family's Virginian newspaper consortium at the age of just 29. But, after an epiphanic trip to Africa in 1978, his whole perspective changed. He comments, "I felt an incredible awe for nature. It was then that I knew there was something else I had to do."

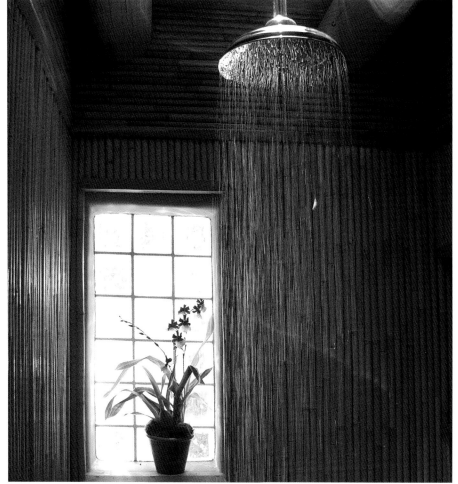

The library at El Monte Sagrado enjoys views over the surrounding gardens and mountains.

The resort's responsible attitude to water means that guests can enjoy a luxury shower with no need for guilt.

CONTACT: EL MONTE SAGRADO LIVING RESORT AND REJUVENATION CENTER, 317 KIT CARSON ROAD, TAOS, NEW MEXICO 87571, USA, T: +1 505 758 3502, INFO@ELMONTESAGRADO.COM WWW.ELMONTESAGRADO.COM

That "something else" was to try to repair some of the damage done to the planet, through education and the green construction and operation of El Monte Sagrado. Tom adds, "my aim has been to demonstrate that it is possible to develop and not damage the earth, to enjoy the highest style of living, and still be environmentally responsible."

El Monte Sagrado (which means "sacred mountain") lies at the foot of the Sangre de Cristo Mountains. Here, 36 suites and casitas are positioned around the "Sacred Circle," an area of green meadow. Central to the resort's sustainable ideology and practice is the respectful use of water. Tom's view is that "we should not think we control or own water, or any other natural resource. Instead, we must learn to borrow them responsibly." The hotel's water comes from a Living Machine, an ecologically engineered system for collecting, treating, and recycling the resort's water, resulting in a recycling rate of nearly 100 percent. Tom Worrell insists he has no illusions about his life's mission. "Nobody can save the world. But I can concentrate on what's right in front of me." At El Monte Sagrado, he has made a valiant attempt to create a sustainable resort that is both educational and luxurious.

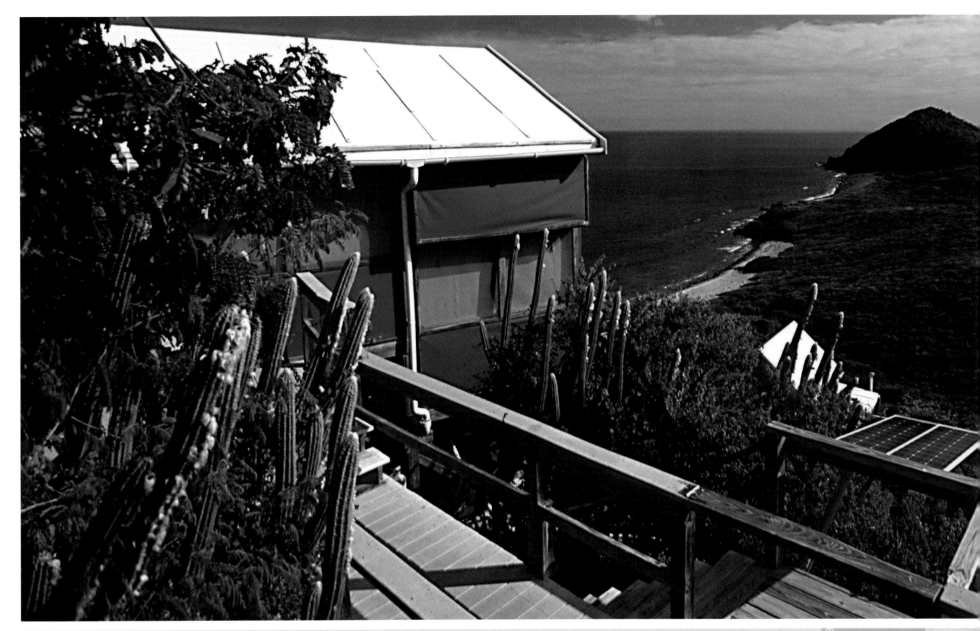

CONCORDIA ECO-TENTS
US VIRGIN ISLANDS, CARIBBEAN

The units are connected via a series of boardwalks, with all deckboards, railings, and pickets made from composite wood and plastic.

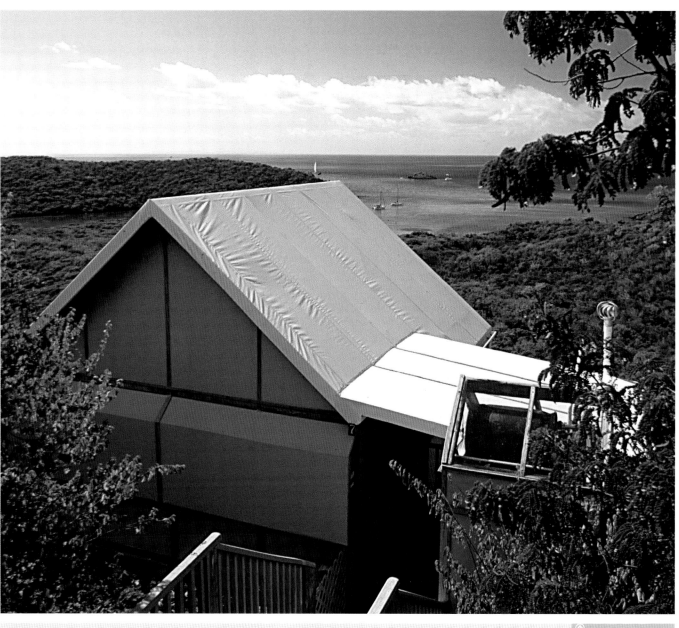

American civil engineer Stanley Selengut has enjoyed a long and illustrious career specializing in environmentally sensitive resort development. The project he holds dearest is Concordia Estate, on the island of St. John in the US Virgin Islands. Purchased in the 1960s, he continues to reassess and improve it every year.

His latest achievement on the 50-acre (20-hectare) estate is the design and construction of Concordia Eco-Tents. To date, this development is the most evolved illustration of his respect for the environment and his desire to provide a meaningful tourism experience for visitors.

The camp consists of 11 tents, each covered with a space-age polyvinyl roofing material. These roofs have survived intact for the 10-year life span of some of the tents, and have withstood several Category one and two hurricanes without any problem. Stanley's philosophy centers around self-sufficiency and environmental awareness. The tents all catch their own rainwater; create electricity for lights, fans, refrigeration, and pumps; and use the sun to heat water for showers. What makes Stanley's particular brand of self-sufficiency different is that it is all monitored so that guests are aware how much of the earth's natural resources they are using. Without this, he says, people relax into old habits and use as much electricity and hot water as they do at home. Here, a light comes on when

The roofs of the cottages are made from a space-age material that reflects heat but transmits light.

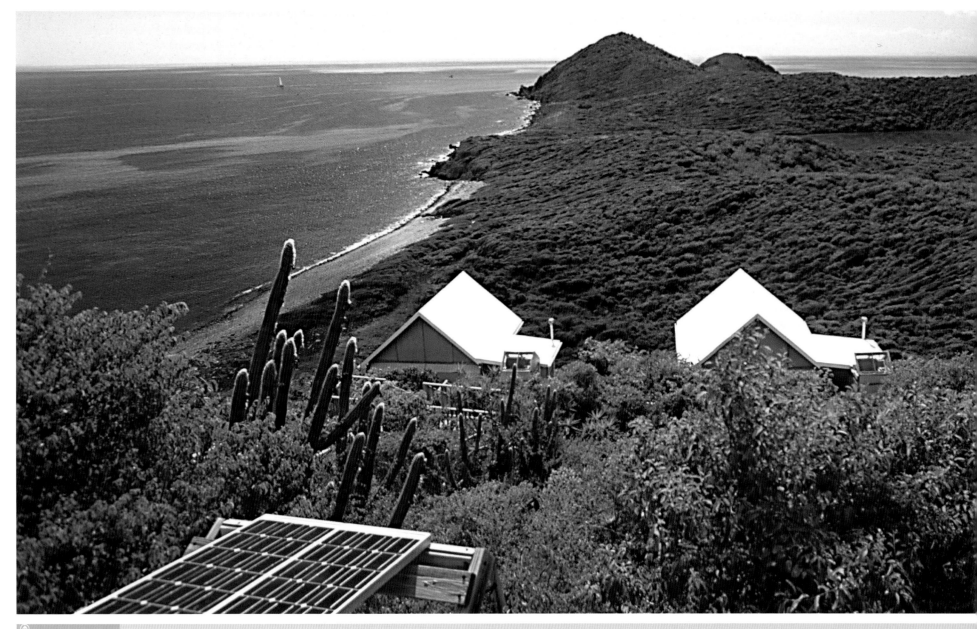

The Eco-Tent cottages all overlook the Virgin Islands National Park.

a battery is low, so guests know that they are using more energy than necessary—an important lesson in the appreciation of natural resources.

Stanley says, "We take a holistic approach to what's important to visitors on vacation by providing a craft shop, arts, and music on the estate. There are no televisions in the tents: we want people to remember how to communicate with each other. We don't mollycoddle our guests. We believe they are looking for life-enhancement through a different type of vacation."

For Stanley, an important part of running an eco resort is the rigorous practice of "green" building. He incorporated the construction methods as part of the design plan, using off-site staging of the tents to minimize disruption of the site during construction. Each unit rests on a 16 × 16ft (5 × 5m) platform, on handdug posts and footings, and is linked to other units by a series of similarly constructed boardwalks. Stanley has now begun the next stage of the Concordia Eco-Tents resort with the addition of seven new tents, several of

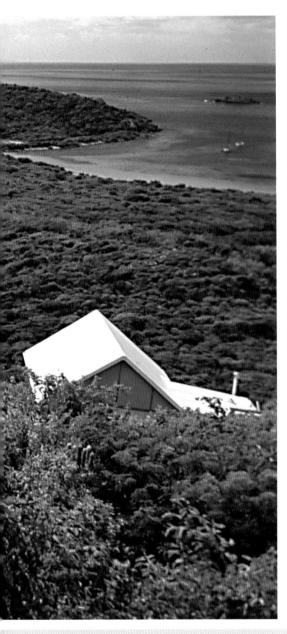

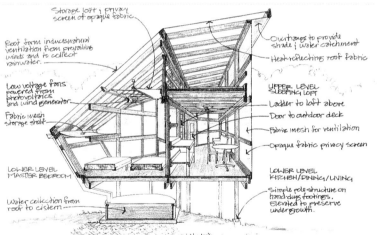

Storage loft; privacy
screen of opaque fabric.

Roof form induces natural
ventilation from prevailing
winds and to collect
rainwater.

Overhangs to provide
shade & water catchment

Heat reflecting roof fabric

Low voltage fans
powered from
photovoltaics
and wind generator.

UPPER LEVEL
SLEEPING LOFT

Ladder to loft above

Door to outdoor deck

Fabric mesh
storage shelf

Fabric mesh for ventilation

Opaque fabric privacy screen

LOWER LEVEL
MASTER BEDROOM

LOWER LEVEL
KITCHEN/DINING/LIVING

Simple pole structure on
hand dug footings.
Elevated to preserve
undergrowth.

Water collection from
roof to cistern

J. Hardesty

The tents' design blends
inside with outside to create
an intimacy between guests
and the environment.

CONTACT: CONCORDIA ECO-TENTS, P.O. BOX 310, CRUZ BAY,
ST. JOHN, VI 00830, T: +1 340 715 0501, MAHOBAY@MAHO.ORG,
WWW.MAHO.ORG

which have been designed to create a meaningful
environment for severely disabled guests, not just
in terms of the tent design, but also in providing
easy access to the beach.

Stanley is extremely proud of the intimacy
between guests and nature that his tents offer.
He adds, "The design allows for full ventilation
and spectacular views from all areas of the tent.
And the icing on the cake is the fact that guests
are separated from the outside by just a thin cloth
skin, which is a really rewarding experience."

The plan for the sustainable
tents incorporated the
construction methods. These
included off-site staging of
the tents to minimize
disruption of the site.

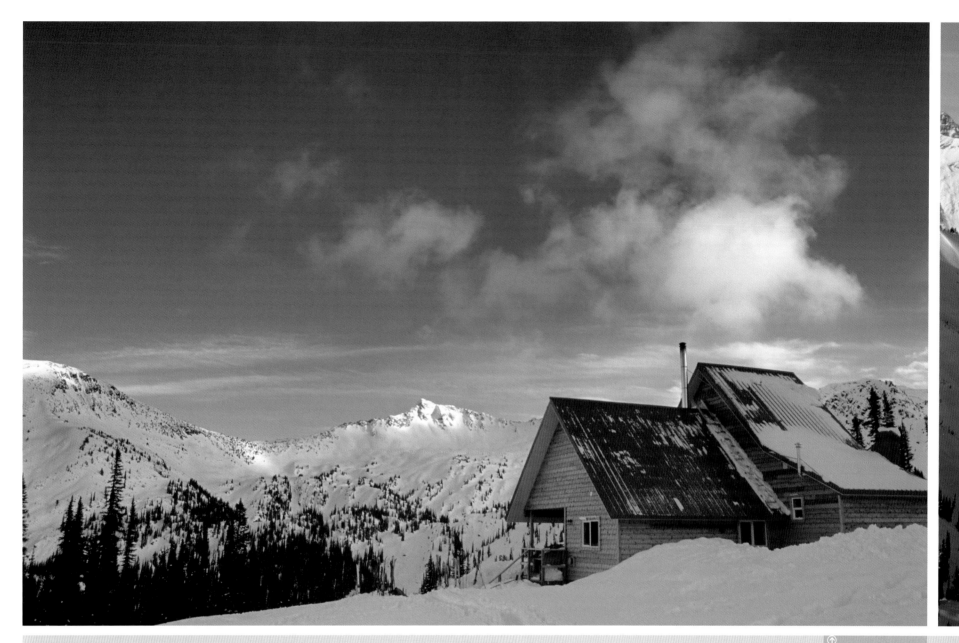

Sentry Mountain Lodge at sunset. The steeply pitched roofs of the lodge are designed to contend with heavy dumps of snow. [Photo: Alan Maudie Photography]

SENTRY MOUNTAIN LODGE
BRITISH COLUMBIA, CANADA

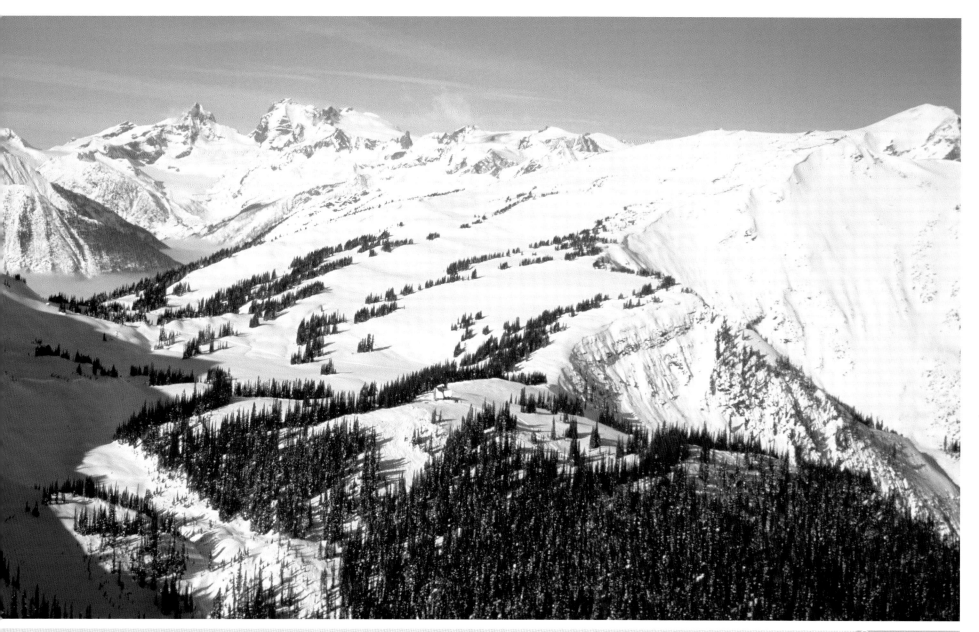

Perched at 6,920ft (2,100m) on a peak set deep in the Selkirk Range of British Columbia, Sentry Mountain Lodge represents the culmination of the passion and dedication of its owner/operators Mike Macklem, his life-partner Aleksandra Sniatycka, and their ski buddy Tim Styles.

Having shared the thrill of skiing together in all conditions and terrains, the adventure-loving friends decided to take their love of nature and winter sports one step further by creating their own backcountry lodge in the mountains of British Columbia. They bought a land lease of over 40 square miles (100km^2) from the government, in a particularly remote area that they thought perfect for both winter and summer pursuits, and set about designing a lodge that was different from other mountain lodges. Instead of providing basic, Alpine-style lodgings for larger groups, they decided to keep things intimate by including just four guest rooms. Mike confirms, "we wanted to create as convivial an atmosphere as possible. This lodge is designed to feel like home from home." With such a remote location, all the construction materials had to be brought in by helicopter. The threesome were determined to keep the number of trips necessary to a minimum, so they designed the lodge with as efficient a footprint as possible, and open-plan layouts reduced the amount of lumber required. No architects were needed— their vision was clear from the start—and they

The lodge's lofty location in the Selkirk Range is ideal for adventurous skiers and snowboarders who relish the challenge of deep powder conditions. [Photo: Alan Maudie Photography]

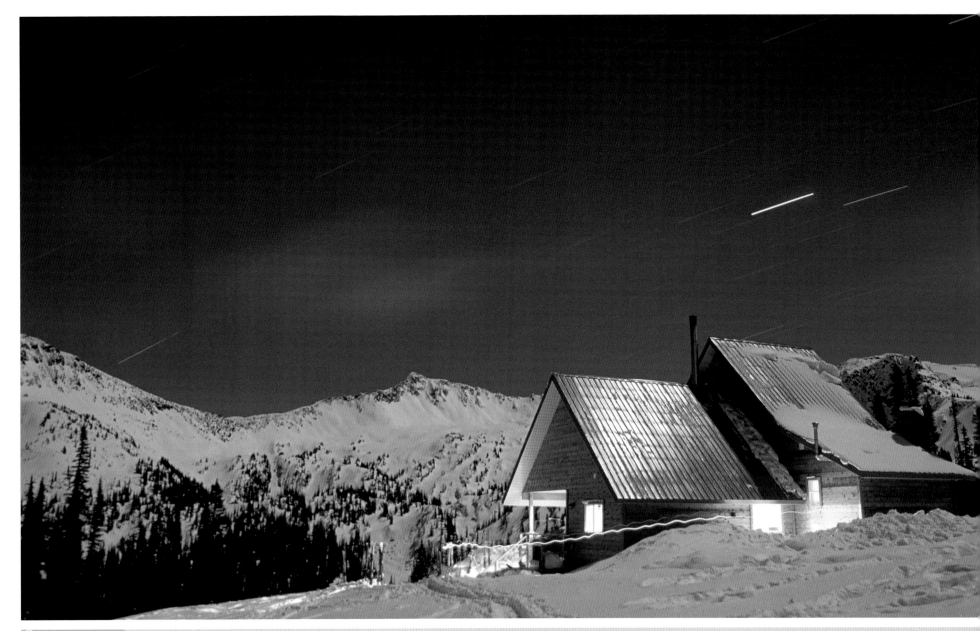

Waste and energy are a particular concern; the lodge has a composting toilet, and a microhydro plant, for the electricity, is planned. [Photo: Alan Maudie Photography]

used the skills of a talented carpenter to help them build the lodge. Such was their zeal to keep the surrounding landscape as pristine as possible that Mike, Aleks, and Tim could be found on their hands and knees in the snow, retrieving every last nail and piece of wood left behind by the builders. As holders of the lease, they consider themselves stewards of that land—a responsibility they take very seriously. Because the lodge is off the grid,

and accessible only by helicopter, issues concerning waste and energy take on an increased importance. Mike, Aleks, and Tim are all rigorous in their attempts to keep the lodge self-sufficient. They rejected the idea of using a septic tank for fear of leaks and contamination, and opted instead for a composting toilet which, since having it installed, they are hoping to modify to make even more efficient. They plan to install a

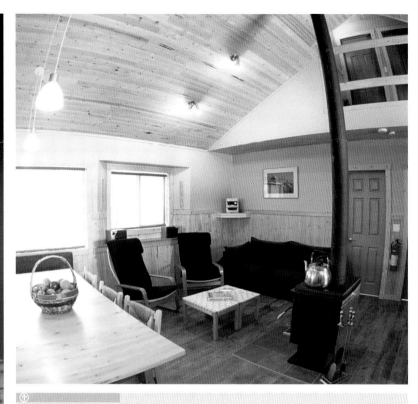

The photographer's fish-eye lens takes in the timber construction and open layout of the lodge, designed in a European bed-and-breakfast style. Heating is provided by a wood-fired stove. [Photo: Alan Maudie Photography]

In summer, the lodge's certified guides take guests out on long walks to admire the surrounding flora and fauna. [Photo: Alan Maudie Photography]

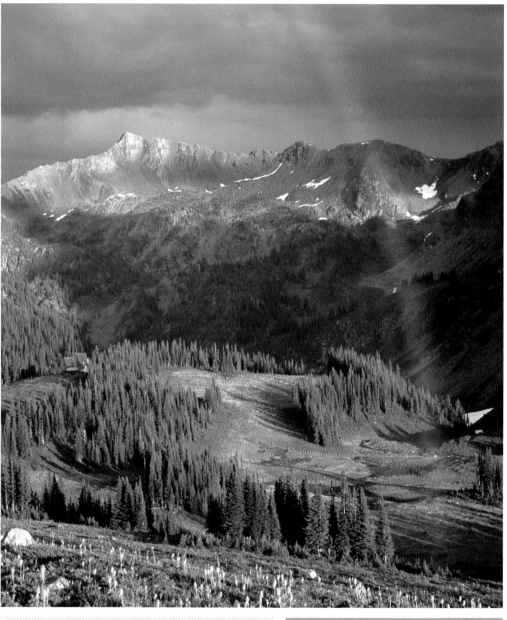

microhydro plant to create the lodge's electricity, and have a very strict policy about waste; if it can't be recycled on-site, it has to be flown out by helicopter. Mike concludes, "Our guests really learn from their experiences here. Arriving by helicopter shows them how remote we are, and makes them realize the fragility of the environment. If they drop garbage up here, no one is there to pick it up later."

CONTACT: SENTRY MOUNTAIN LODGE,
P.O. BOX 97, GOLDEN, BRITISH COLUMBIA,
CANADA V0A 1H0, T: +1 (250) 344 7227
INFO@SENTRYMOUNTAINLODGE.COM
WWW.SENTRYMOUNTAINLODGE.COM

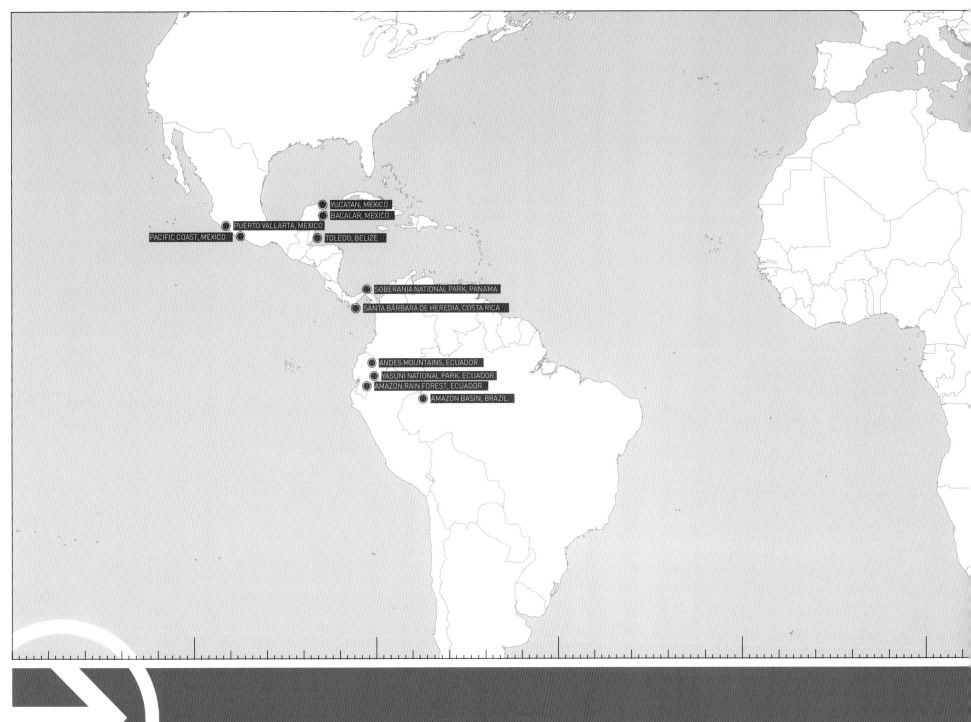

YUCATAN, MEXICO
BACALAR, MEXICO
PUERTO VALLARTA, MEXICO
PACIFIC COAST, MEXICO
TOLEDO, BELIZE

SOBERANIA NATIONAL PARK, PANAMA
SANTA BÁRBARA DE HEREDIA, COSTA RICA

ANDES MOUNTAINS, ECUADOR
YASUNI NATIONAL PARK, ECUADOR
AMAZON RAIN FOREST, ECUADOR
AMAZON BASIN, BRAZIL

BELIZE
TOLEDO

BRAZIL
AMAZON BASIN

COSTA RICA
SANTA BÁRBARA DE HEREDIA

ECUADOR
AMAZON RAIN FOREST
ANDES MOUNTAINS
YASUNI NATIONAL PARK

MEXICO
BACALAR
PACIFIC COAST
PUERTO VALLARTA
YUCATAN

PANAMA
SOBERANIA NATIONAL PARK

LATIN AMERICA

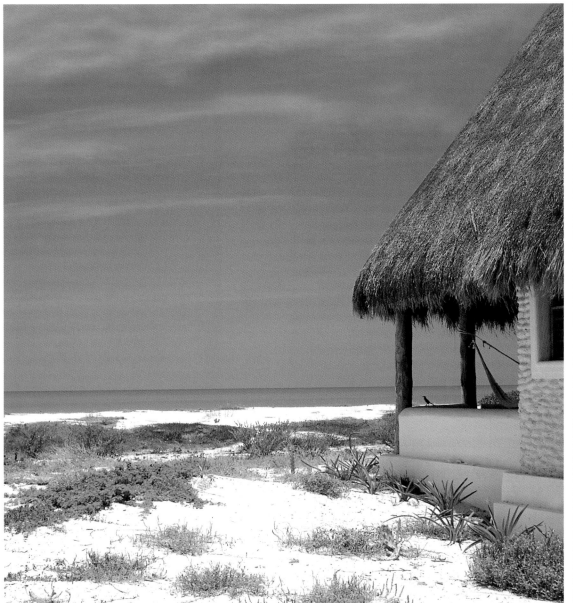

In order to preserve the unique vegetation along the coastline, all the buildings were built back from the sea.

Large windows and ceiling fans remove the need for air-conditioning units.

The hotel's 15 cabanas successfully blend into the surrounding nature.

HOTEL ECO PARAISO XIXIM
YUCATAN, MEXICO

Verena Gerber's decision to create an ecohotel in the heavily protected Celestún Biosphere Reserve required perseverance, patience, and determination. In the face of government bureaucracy, Verena obtained planning permission for an impressively sustainable tourism venture that is both pleasing to the eye and gentle on the land. Verena comments, "The biggest challenge of building the ecolodge arose from its remoteness, and the fact that it was situated in a biological reserve. Because it is a

The freshwater swimming pool is heated by solar panels, and enjoys great views of the sand dunes.

The hotel reception, where guests are welcomed and advised how to limit their impact on the environment during their stay.

CONTACT: HOTEL ECO PARAISO XIXIM, MUNICIPIO DE CELESTÚN, YUCATÁN, MÉXICO, T: +52 (01)988 916 2100, INFO@ECOPARAISO.COM WWW.ECOPARAISO.COM

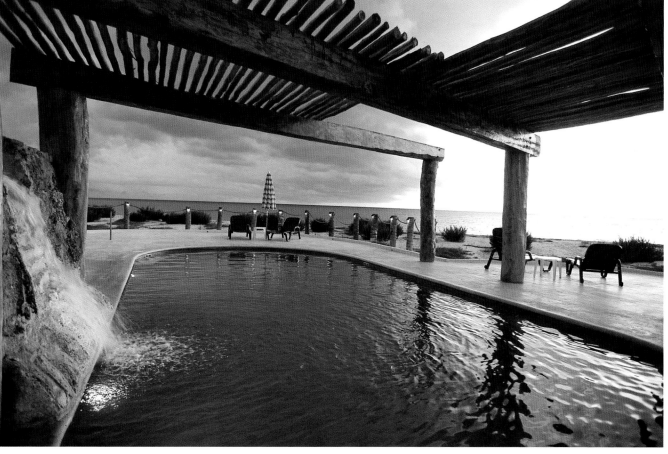

The layout of the hotel and its cabanas.

protected area, we weren't able to use any local materials; they all had to be brought in from neighboring towns." The resort barely leaves a footprint. Of the 62 acres (25 hectares) of land that belong to the hotel, only 3,600yd^2 (3,000m^2) have been built on. This is roughly 1.2 percent of the available land. The hotel was built on the second dune from the sea, as the first is home to unique vegetation. Verena adds, "It was very important to us to keep the beach and the first dune intact, as this is where turtles come to hatch.

We also respected the topography of the land; we didn't level out the land during construction, but left the sand dunes as they were."

The construction materials used allow the bungalows to merge with nature. Thatch is used for the roofs, while local stone and handmade tiles reflect the indigenous architectural style. The exterior finish of the cabanas is of sand, white cement, and chopped straw from the thatched roofs, and needs no painting. Operations are run on a strictly ecological basis,

with the hotel shunning the traditional practice of unnecessary daily laundering of towels and sheets. Soaps and shower gel are available in dispensers to avoid the waste caused by plastic packaging, and foods, such as jam and butter, are bought and served in bulk, not individually packaged servings.

Guests flock to the lodge to watch the vast number of exotic birds in the local area—over 530 species at the last count.

All palm for the cabana roofs was cut within two or three days of the full moon: according to local lore, roofs will not be durable and will rot very quickly if the palm is cut at any other time.

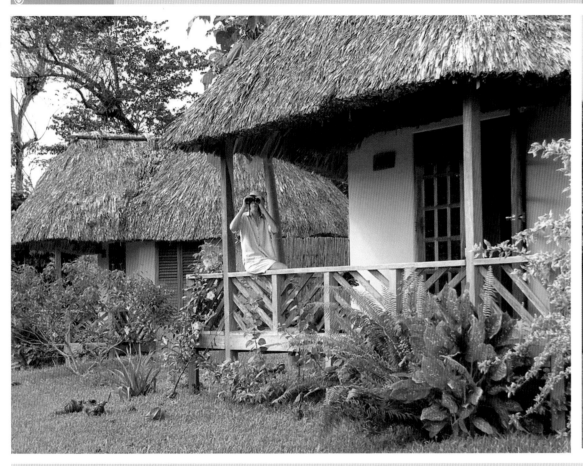

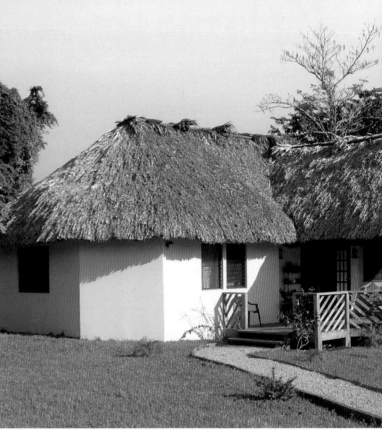

THE LODGE AT BIG FALLS
TOLEDO, BELIZE

It took 20 years for Rob and Marta Hirons to realize the dream of running their own ecolodge in this little-known area of Belize. You can't get much more remote than Big Falls in Toledo—it is only in the last few years that the 80-mile (130km) dirt track linking the village of Big Falls to the north of the country has been paved. The Lodge sits quietly in an area of rain forest populated by the indigenous Kekchi and Mopan Mayan peoples. The design of the lodge owes much to the ideas of

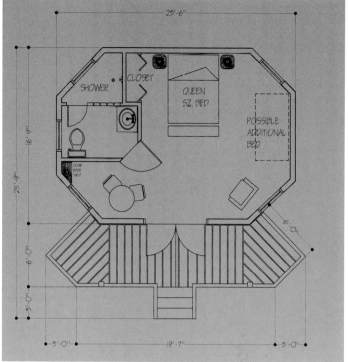

The central lodge echoes the design of the cabanas, but on a larger scale, and with a vast, high, thatched roof reminiscent of a vaulted church. This serves as a communal area, with a bar, restaurant (pictured), resource center, and bathrooms.

Ground plan of a guest cabana, designed to be cooled by the trade winds.

CONTACT: THE LODGE AT BIG FALLS, P.O. BOX 103, PUNTA GORDA, TOLEDO DISTRICT, BELIZE, INFO@THELODGEATBIGFALLS.COM WWW.THELODGEATBIGFALLS.COM

Rob and Marta, who insisted on incorporating the local tradition of using exposed thatch roofs, open windows, and no air-conditioning. Ariel Mitchell, a Belize City-based architect, took on board this nonnegotiable brief, and designed a collection of spacious cabanas surrounding a central lodge, subtly merging the internal and the external environments. Ariel says, "Because of the high temperatures of summer and the extreme wet during the rainy season, it was important that the

facilities could be ventilated naturally and the roofing system would be strong enough to withstand the 160in (406cm) of annual rainfall typical in the Toledo district."

The cabanas that house the guests are octagonal, with a tall, screened and louvered window made from sustainable tropical cedar in each corner. This allows the rooms to catch the trade winds that blow during the afternoons and evenings of the dry season (from March to May),

keeping the cabanas cool without the need for air-conditioning. Ariel used bay leaf palm to thatch the roofs; this is another means of keeping temperatures down and at the same time, it creates an attractive textured finish on the inside of the cabanas. French doors, made locally from sustainable mahogany, lead out into the veranda area, which is also thatched and feels very much an extension of the inside. The roof creates shelter over the veranda,

allowing guests to relax outside and watch birds even during one of Toledo's heavy tropical downpours. Rob insists there's nothing more invigorating than lying in a hammock with a gin and tonic, watching the rain.

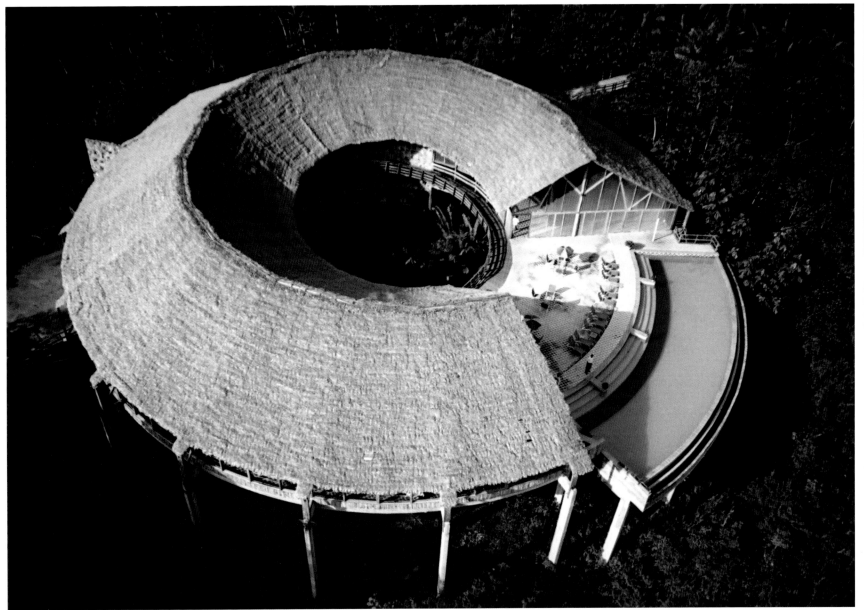

PAKAAS PALAFITAS LODGE
AMAZON BASIN, BRAZIL

The striking circular central lodge features an open-air swimming pool within its circumference. It is based on a traditional raised palafita design, and is built from sustainable materials.

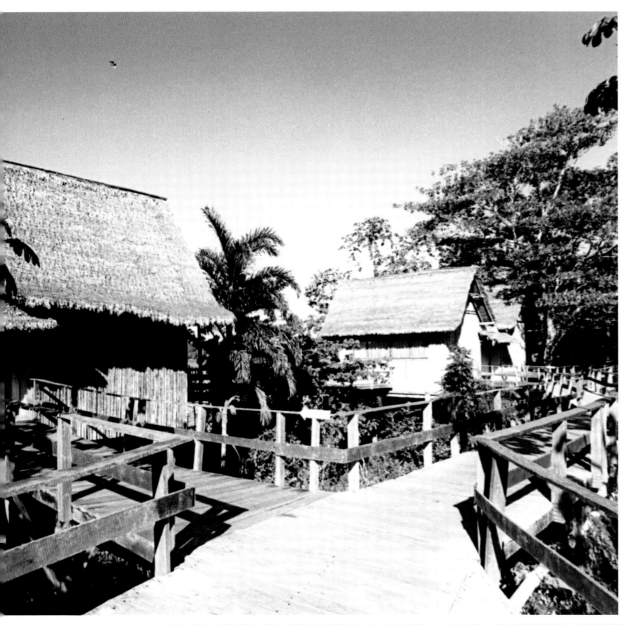

CONTACT: PAKAAS PALAFITAS LODGE, P.O. BOX 141, GUAJARÁ-MIRIM, RONDONIA, 78.957-000 BRAZIL, T: + 55 (69) 541 3058, RESERVAS@PAKAAS.COM.BR WWW.PAKAAS.COM.BR

The resort's 50 cabanas are linked by over 1 mile (2km) of suspended walkways, which limit their impact on the local vegetation.

The swimming pool at the central lodge affords stunning views over the Amazonian tributaries. The resort has a totally recyclable water system, so as not to interfere with river's ecosystem.

Situated at the confluence of two Amazonian tributaries, Pakaas Palafitas Lodge is a rare resort. With one luxurious central lodge and 50 cabanas, it manages to provide accommodation for a significant number of tourists without impacting negatively on its fragile surroundings.

The resort's owners put in a great deal of background research before designing and building the ambitious project. Through visiting accommodation in famous cultural tourist centers in Latin America, including Machu Picchu, they aimed to discover from ecotourists what makes for a culturally and ecologically rewarding vacation.

Brazilian architect W. Julio Reis was brought in to translate their ideas into a living resort. The center of this is the main lodge, based on a "palafita" design, which Reis describes as "a construction suspended from the ground, normally used by Amazonians to keep the high water levels from entering the house, as well as insects and animals." This building serves as the nucleus of the resort. The 50 cabanas are linked by suspended walkways that allow guests to explore the jungle without damaging the precious ecosystem.

The resort is involved in an active program including conservation of local flora and fauna, reforestation of native trees such as mahogany and cedar, and the establishment of plots of land in which local communities can grow organic vegetables to supply the resort and neighboring markets. The resort's philosophy is to educate both guests and the local communities about protecting the biodiversity of this section of the Amazon jungle. Putting their money where "their mouth" is, the owners have introduced a totally recyclable water system at the resort, so as not to interfere with the ecology of the river.

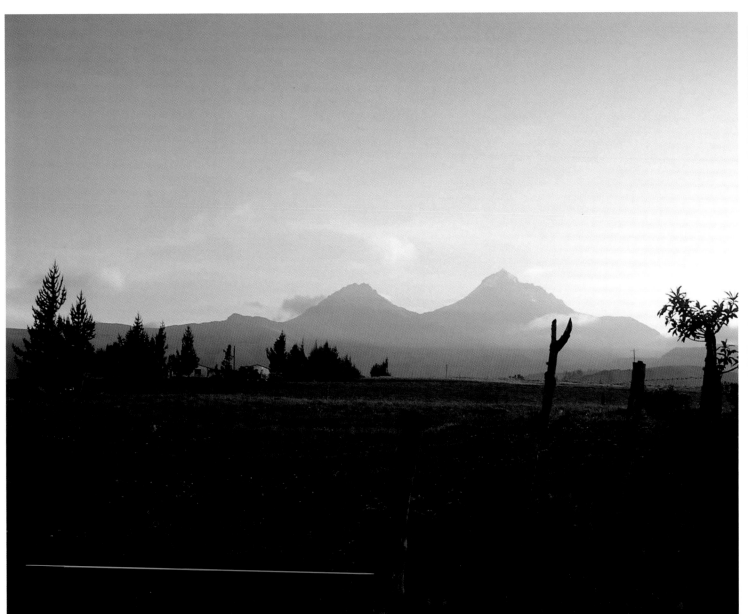

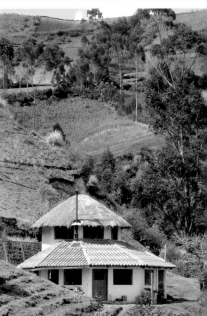

THE BLACK SHEEP INN

ANDES MOUNTAINS, ECUADOR

On a clear day, Iliniza Sur is visible from the Black Sheep Inn.

The owners' octagonal adobe house. Thick, solid adobe walls provide natural insulation; glass skylights mean that electric light is unnecessary during the day; a woodstove provides heat at night; the straw and Spanish tile roofs drain into a cistern for the gardens; and the terraced retaining wall provides protection for seedlings.

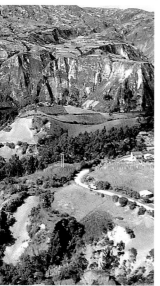

View from the Ridge Hike. The Ridge Hike is a one-hour loop that starts from the Black Sheep Inn.

Laguna Quilotoa is an emerald volcanic crater lake. One of the best day hikes in Ecuador is from here to the Black Sheep Inn. The first hour offers fantastic views of the laguna while hiking around the crater rim; the second hour descends to the small, indigenous village of Guayama; and the last two hours cross the Rio Sinui Canyon.

Construction of the three-story, A-frame bunkhouse, which now provides 10 beds and offers amazing views of the mountains. Homemade adobe bricks are stacked to the right of the building.

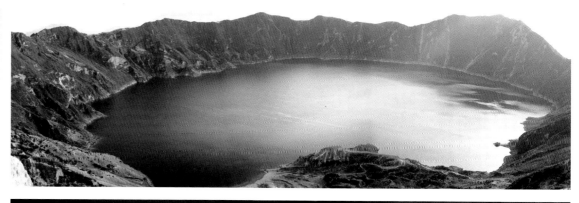

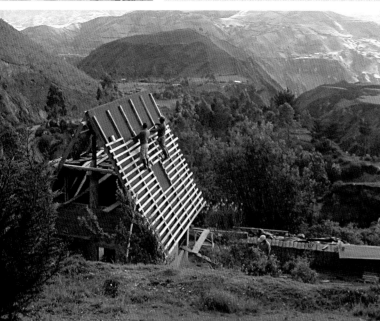

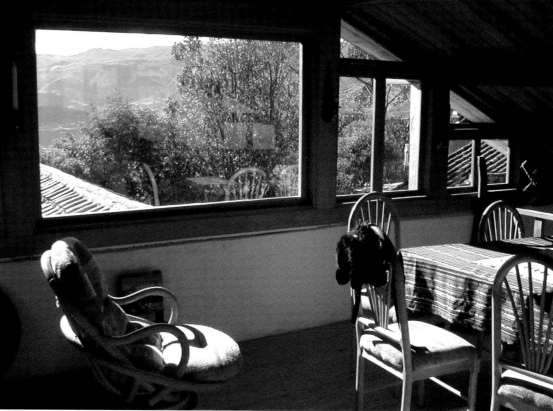

High in the Andes, a small guesthouse perched on a hillside has become renowned not only for its sensational views over Rio Toachi Canyon, the "Grand Canyon" of Ecuador, but also for its curiously esthetic interpretation of the composting toilet. American owners Michelle Kirby and Andrés Hammerman regard their toilets, which they designed themselves, as one of the biggest successes in this eco outpost. Housed in a whitewashed building, and incorporating indoor gardens and windows with spectacular views of the canyon, the toilets create fertilizer that's used for nourishing newly planted trees. But the toilets are just one aspect of Andrés and Michelle's self-built testament to responsible tourism. No architects were involved.

Andrés comments, "I have a Master's degree in architecture from ISTE (International School of Trial and Error)! Everything here was built as a grassroots project. We often made changes halfway through, because we could see where improvements were needed. We made all of the adobe bricks on-site, from clay and dirt dug here on the property."

The chalet-style main lodge's exposed timber construction. It benefits from great natural light and stunning views.

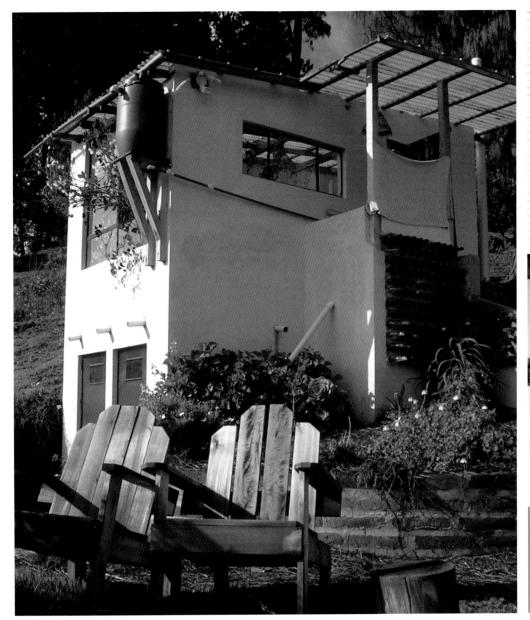

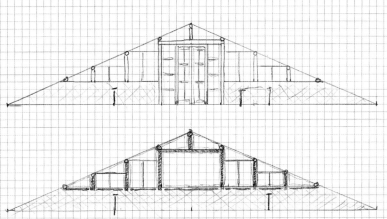

CONTACT: THE BLACK SHEEP INN, P.O. BOX 05-01-240, CHUGCHILÁN, COTOPAXI, ECUADOR
INFO@BLACKSHEEPINN.COM, WWW.BLACKSHEEPINN.COM

In the true spirit of ecotourism, the local community forms an indispensable part of the equation. Andrés continues, "Three local men helped us with the building. We learned many of their skilled techniques, and they have learned from our innovative designs. We also have a full-time staff of six local people who run the lodge for us." The Black Sheep Inn's involvement with the community extends beyond the front door of the lodge—they have donated essentials, such as computers, text books, and a phone line for the school and police station, to neighboring villages.

The building that houses the composting toilets. Rainwater is collected in the blue tank and used for handwashing, and for watering the indoor garden. The urinal area is marked by recycled glass bottles set in the wall.

Private rooms at the inn have small woodstove fireplaces. All rooms have recycling baskets, candles, original local artwork, and compact fluorescent lighting.

Sketch of the lodge, which is based on a combination of local techniques and innovative design.

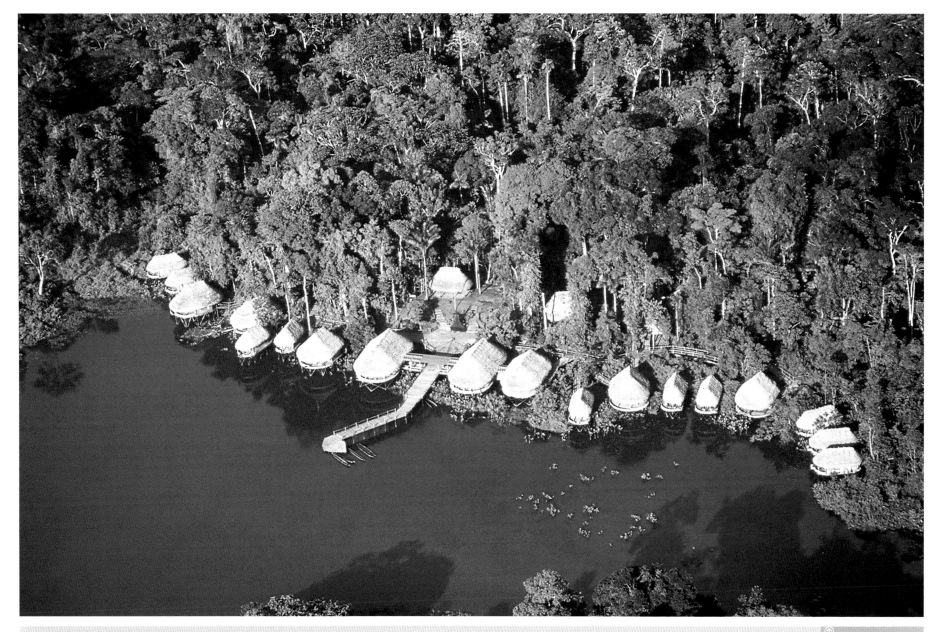

KAPAWI ECOLODGE & RESERVE
AMAZON RAIN FOREST, ECUADOR

The cabanas and walkways are raised on stilts so as not to disturb the vegetation.

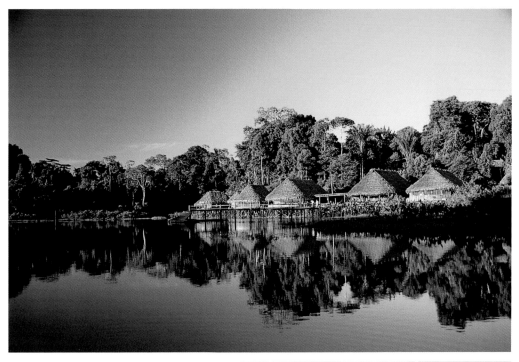

CONTACT: KAPAWI ECOLODGE & RESERVE
CANODROS 2735, P.O. BOX 59-9000, MIAMI,
FLORIDA 33159-9000,USA, T: +1 5934 2285 711
T (FROM THE USA AND CANADA): 1-800-613-6026
CANODROS@CANODROS.COM, WWW.KAPAWI.COM

**Kapawi Ecolodge &
Reserve nestles
unobtrusively in its
isolated position on the
banks of Kapawi Lagoon.**

**Local timber is used for
the floors, while bark
serves as an ecofriendly,
tactile take on wallpaper.
Insect canopies over the
beds give guests peace of
mind, though they are not
strictly necessary, as the
cabanas are all fully
screened.**

**The height of the timber-
and-thatch roof gives the
communal living room a
spacious, open feel,
bringing the outside in.**

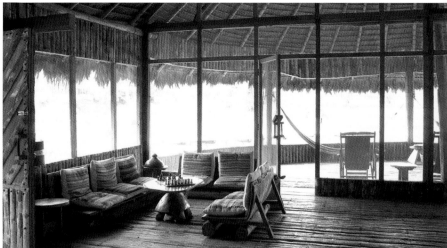

Located in the heart of untouched Amazon rain forest in Ecuador, close to the Peruvian border, the Kapawi Ecolodge & Reserve lies at the end of a 40-minute canoe ride from a nearby village, taking visitors along the Pastaza—an Amazonian tributary—to the Kapawi Lagoon. The resort comprises a cluster of 20 cabanas clinging to the banks of the lagoon, on stilts. These are linked by wooden walkways so as not to disturb the precious vegetation. But what makes this eco retreat different from so many others is that it is part-owned by the indigenous population, the Achuars. The Achuars were the last Ecuadorian tribe to stay free from outside influence, remaining isolated up until the 1970s. The philosophy of co-owners Canodros is singular in its vision—to work with the Achuar community to provide a successful alternative to the destruction commonly created by enterprises in the Amazon rain forest. With a population of roughly 5,000 inhabiting an area of around 2,000 square miles (5,000 km^2), the Achuar will take over ownership of the Kapawi Ecolodge from Canodros in 2011, by which time they will have received over $600,000 USD for the use of their land for ecotourism. The retreat exists for, and is inspired by, Achuar culture. The cabanas follow Achuar architectural practices,

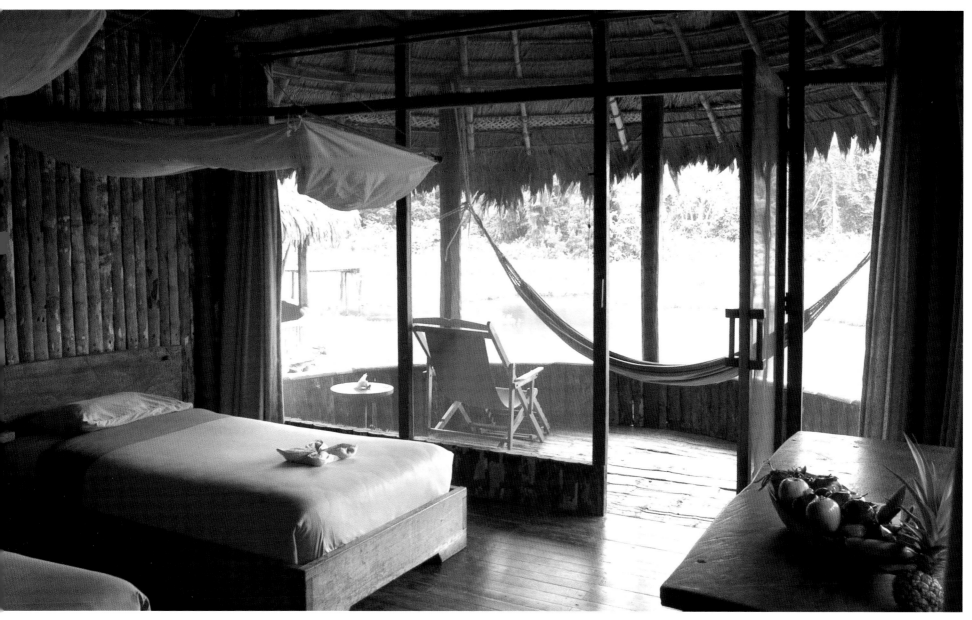

using wooden dowels in place of nails. The peaked roofs are made from woven palm leaves, and each cabana features a fireplace, according to tradition. The fire is lit every evening to ward off insects and to keep the roof thatch waterproof. There are no televisions, radios, or phones. Guests entertain themselves by venturing off into the dense green canopy with a local guide, or by taking a dip in the lagoon; steps from each terrace lead into the water.

Aside from the incredible surroundings, the experience is enriching for the tourist as they can see that the local population is genuinely benefiting from their presence. In some tourist destinations the locals receive no more than steady employment. Here, in a few years' time, they will be running the show themselves.

Each cabana has a private terrace with hammock, overlooking the lagoon. All electricity is provided by a photovoltaic system, and water in each private bathroom is solar heated.

VILLAS ECOTUCAN
BACALAR, MEXICO

The windowframes are painted bright blue to add some Mayan color to the bleached-out stone-and-thatch huts.

Guests relax in the shade of a thatched hut set in the lush green land surrounding the Villas Ecotucan. Over 100 acres (40 hectares) of the resort's land was preserved for walking and wildlife watching.

The tall, thatched restaurant area is festooned with colorful banners. The layout of the resort is based on a typical Mayan village.

CONTACT: VILLAS ECOTUCAN, BACALAR, MEXICO, T: +52 (01)983 8342516, ECOTUCAN@YAHOO.COM WWW.VILLASECOTUCAN.COM

Set on a hill overlooking the Laguna de Bacalar, 220 miles (350km) south of Cancún, Villas Ecotucan is a model of sustainable, low-impact tourism. Husband-and-wife team Sophie (a Canadian) and Arturo (a Mexican), fell in love with the tiny town of Bacalar while traveling around the area, and pledged to return and build a hotel there. Seven years—and two children—later they fulfilled that promise, buying the land, and building the retreat's five stone-and-thatch huts with the help of their parents. No architects were involved: Arturo, an engineer, designed the lodgings himself, basing the resort layout on a traditional Mayan village. Gravel paths connect the cabins through the background of their lush tropical gardens.

From the word go, the pair proceeded with a rigorously protective attitude to the environment. Just over an acre (less than half a hectare) of land was cleared in order to build the cabins, and over 100 acres (40 hectares) of land were preserved for guests to enjoy jungle walks and observe local wildlife. The cabins were all built using materials gathered from the local environs. Sophie says, "We made walls from broken rocks that we dug up, and made the roof thatch from leaves collected from guano trees in the jungle." The resort is fully powered by solar energy, and a septic-tank system filters black and gray water, which is then used to water the lodge's fruit trees.

Sophie continues, "It has been a hard two-and-a-half years of building and learning, but we feel we have created a beautiful, relaxing hotel that respects the environment and culture that surrounds it." The staff are all locals, including an 89-year old Mayan man.

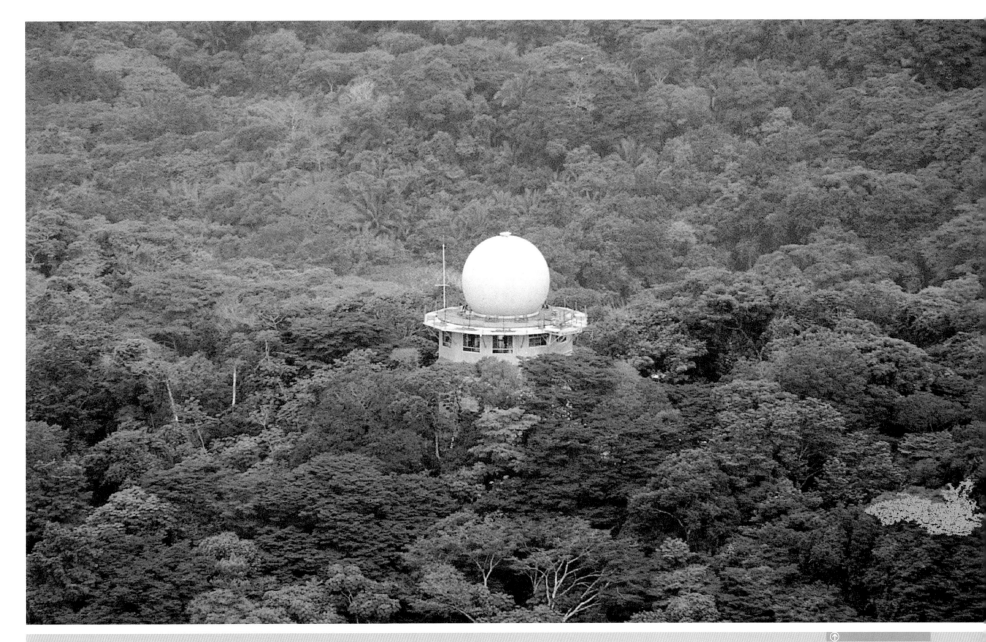

CANOPY TOWER
SOBERANIA NATIONAL PARK, PANAMA

The tower is topped by a 30ft (c. 9m) high geotangent dome. This sits on a galvanized steel base, and is supported by steel beams radiating from the center of the building.

Large windows allow guests to observe the rain forest from the comfort of the communal room.

Peeking above the surface of the Panamanian rain forest, the Canopy Tower appears as though it were put on earth purely for ornithologists. This couldn't be further from the truth. Built by the United States Air Force in 1965, to house a powerful radar, the tower was abandoned by the military in 1995. At this time banker-turned-conservationist Raúl Arias de Para began the lengthy bureaucratic process of gaining permission to turn the decaying tower into an eco-observatory for birdwatchers and enthusiasts of the local flora and fauna. Raúl recalls, "It helped that I had good

friends in several government ministries. I asked them all for help. Finally, I prayed a lot and my wife, who is very religious, took a priest to the tower and he blessed it. A couple of weeks later, the final permit came through."

With planning permission under his belt, and the help of several architects and friends, he began the renovation. The biggest transformation came from installing windows. Apparently, the US Air Force didn't want its employees distracted by the rain forest when they should have been watching for incoming missiles, so they built it

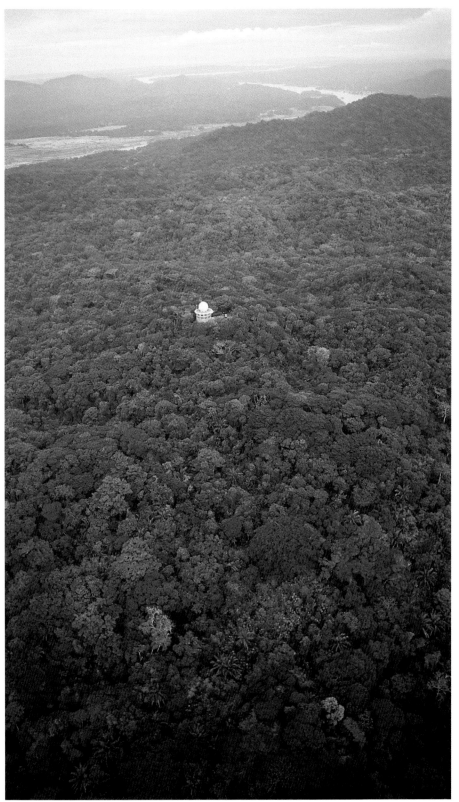

Canopy Tower overlooks the Soberania National Park and offers views of the Panama Canal in the distance.

The beds and furniture are made of teak cut from Arias de Para's own plantation.

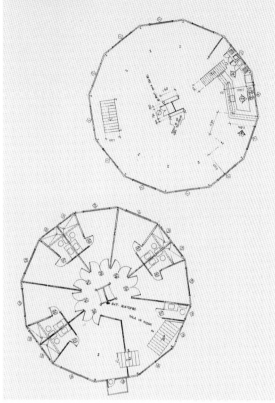

The blueprint for the ground plan of the tower shows how windows were planned for the originally windowless structure.

CONTACT: CANOPY TOWER, SOBERANIA NATIONAL PARK, PANAMA, T: 011 (507) 264 5720 STAY@CANOPYTOWER.COM, WWW.CANOPYTOWER.COM

The rusting gray tower was painted blue and yellow to mimic the colors of the Panama toucan.

with no windows. The galvanized steel tower was structurally very sound, and relatively little work was needed to convert the existing four floors into guest accommodation, with a communal and dining area at the top of the tower, and an observation deck on the roof.

The tower is run with sustainability in mind, making as little imprint on the environment as possible. Water is provided by an on-site well, the toilets are all low-flush, and the water for showers is heated by manually controlled electric heaters. There is biodegradable soap in the bathrooms, and gray water is used for the toilets and to irrigate the garden. But what makes the Canopy Tower an exotic retreat with a difference is its owner's unswerving dedication to protecting the rain forest, and sharing his passion for the local bird- and wildlife with his guests. Without that, the tower would probably still be rusting into oblivion.

The palm-thatched roofs of the cabanas were made using traditional materials and construction methods.

The bright color scheme of the cabanas is continued throughout the interior decoration of the center.

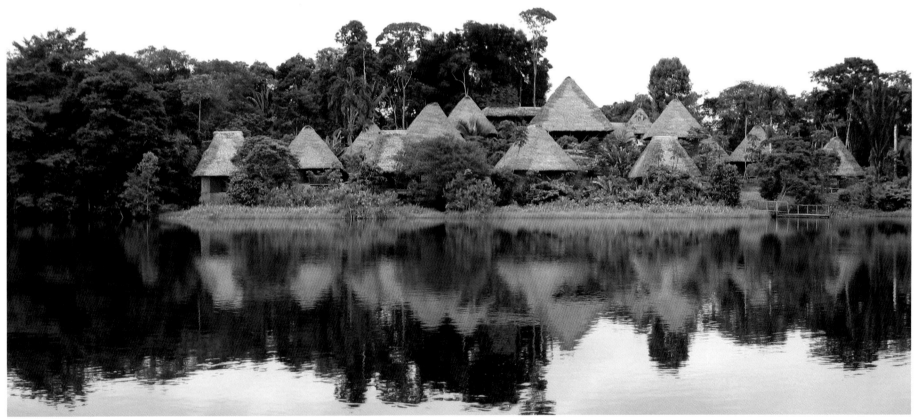

NAPO WILDLIFE CENTER
YASUNI NATIONAL PARK, ECUADOR

The bright orange guest cabanas of Napo Wildlife Center stand out against the universally green environment of this area in the Amazon Basin, yet don't jar with the appearance of the natural environment.

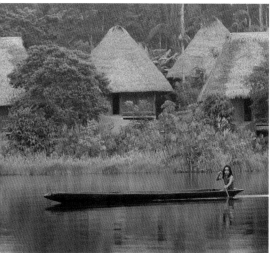

Only the best timber was used in the construction of the cabanas to ensure that they last as long as possible without the need for expensive repairs or replacements.

CONTACT: NAPO WILDLIFE CENTER,
P.O. BOX 17-21-965, QUITO, ECUADOR,
T: +593 (0)99011 505
SALES@ECOTOURSECUADOR.COM
WWW.NAPOWILDLIFECENTER.COM

The story of Napo Wildlife Center's creation goes against the grain of many sustainable tourism ventures. Where the majority of eco retreats are the result of people moving into an area and joining forces with the indigenous population to give rise to a tourism destination that benefits both guests and locals, it worked the other way round in this area of the Yasuni Park in Ecuador. A handful of families in the Quichua Community of Anangu decided to share the rich biodiversity of

their homeland by building a lodge for nature-loving guests. When financial constraints and lack of materials put a stop to the dream, conservation organization Fundacion EcoEcuador entered the equation, offering financial and technical support. The Napo Wildlife Center today represents the fruitful collaboration between these two parties.

Situated on Anangu Lake, 3 miles (5km) up a tributary of the Napo, the center is part of the Biosphere Reserve of the National Park, which

stretches over 2½ million acres (1 million hectares) of precious Amazonian rain forest. The Ministry of Environment has granted the Quichua community of Anangu and EcoEcuador the right to manage and protect 82 square miles (200km^2) of the Biosphere Reserve, and they take the job very seriously. As with all remote sites, the essential problems that arise from tourism ventures include generating electricity, disposing of wastewater safely, dealing with

The local people designed the huts so that the king-sized bed would face east, allowing guests to enjoy the rising sun.

trash, and avoiding disruption to the local wildlife. Tackling the issue of electricity, the center has solar panels that charge a bank of batteries. When additional electricity is required at peak times, they supplement this with two generators. The camp's General Manager, Norby, stresses that this combination of solar power and generators is unique in Ecuador. Two man-made wetlands treat the wastewater, converting it back into water that's safe for the environment and safe to drink.

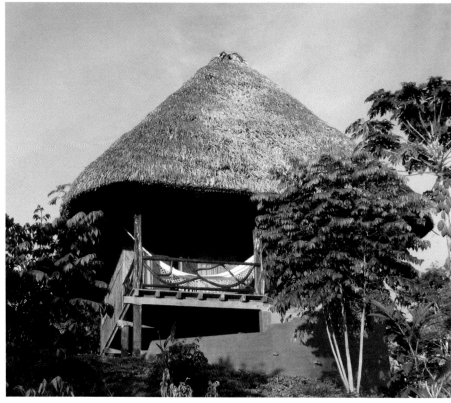

←
The whole community was involved in the design and construction of the retreat; women and children all helped out with painting and creating the gardens.

↑
For the cabanas, the camp's designers chose bright primary colors inspired by local wildlife. The pigments are made from natural minerals sourced from the Andes.

The guest cabanas—large, private dwellings integrated into the surroundings—were designed by the Anangu people and use traditional construction methods and materials (mud-brick walls and palm-thatched roofs), and the best-quality wood to ensure their longevity.

Norby adds, "When the river rises, it takes with it some of the land, and ancient trees. We have collected these fallen trees, such as mahogany, as these logs will last forever, reducing the need to carry out repairs on the cabanas at a later date, which would be costly both to the business and to the environment."

The local people worked side by side on the design of the center with Ecuadorian architect's practice Barro Viejo (which means "old mud"), whose modus operandi has always been hands-on and field-based, an attitude that helped the creative interaction between Barro Viejo and the local community.

Napo Wildlife Center's main attraction, apart from its stunning location, is the access it provides to unimaginable numbers of exotic birds and wildlife species. It has recently built a canopy tower nearby for even closer access to local birdlife, and guests are also able to visit two blinds built by the center at the most accessible parrot licks in Ecuador.

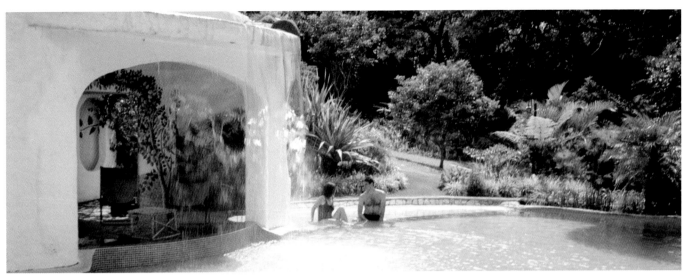

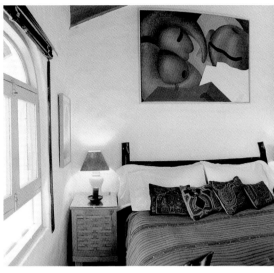

Finca Rosa Blanca is set discreetly among lush greenery on a hill above the Central Valley. Surrounded by the local Higueron trees, it offers views over coffee plantations, forests, and volcanoes.

Throughout the hotel, only fallen wood, from the forests of Costa Rica, and wood cut during highway construction was used.

FINCA ROSA BLANCA COUNTRY INN
SANTA BÁRBARA DE HEREDIA, COSTA RICA

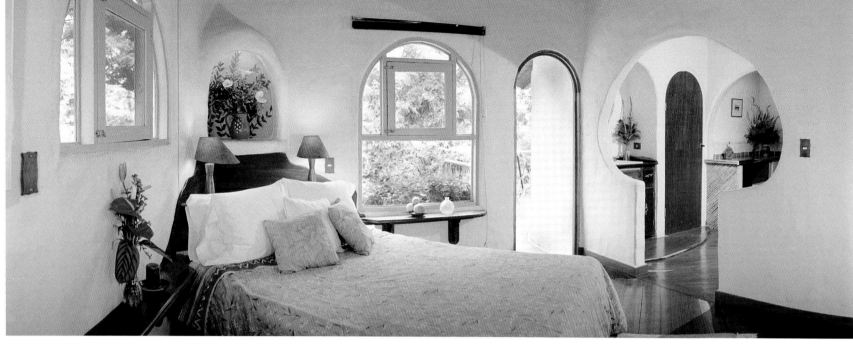

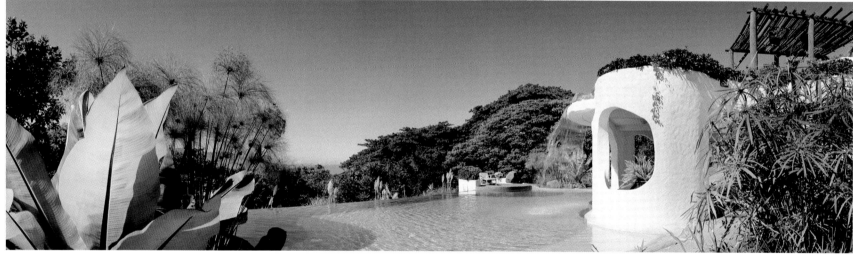

Finca Rosa Blanca, an extraordinary ecohotel overlooking the Central Valley in Costa Rica, started out as an unusually creative family home. Sylvia Jampol, the original owner and creative force behind the hotel's undulating curved spaces and elevations, had long held her dream of designing and building a home that would blend with nature, without severe, straight lines, and that would show off her eclectic collection of art and artifacts. It wasn't until she took a vacation in Costa Rica that she realized this was the perfect location for her vision of a house with no corners. Originally, the house was built as just that, with enough space for all the friends and family she wanted to invite to stay.

However, the rapturous response she received from her nonpaying guests inspired her to turn the house into a hotel—it now comprises seven rooms and two villas. Sylvia's daughter-in-law Teri, who is now joint owner/operator of the hotel with her husband Glenn, comments, "The architecture is a mélange of Gaudi-esque, Santa Fe, and Costa Rican style, all transformed by the creativity of my mother-in-law, our architect, and by the many artisans and friends and family who had input." Sylvia's architect Francisco Rojas adds, "It was a great privilege to be a part of this project, selecting the site and integrating the building with the trees, the green areas, and especially the coffee plantations. The unusual architectural language

In keeping with Finca Rosa's eco principles, no chemicals are used in the pool.

The El Guarumo junior suite, which takes its name from an indigenous tree, displays Finca Rosa's many large windows and soaring ceilings; these make the most of the natural light, and maximize airflow.

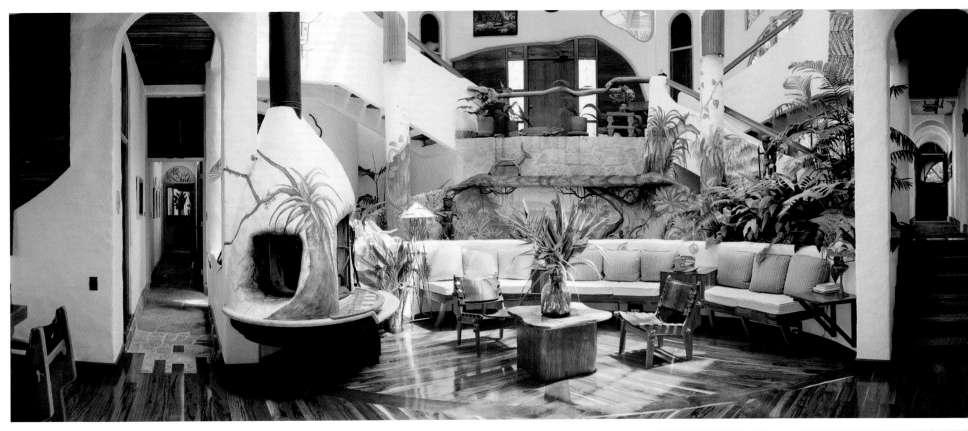

↑
The hotel's massive atrium, which serves as a lounge, dining area, and library, is 40ft (12m) high, filled with tropical plants, and decorated with murals painted by local artists. Its high ceilings encourage a constant air flow.

→
Throughout the hotel, large windows and multi-skylights provide unlimited natural daylight.

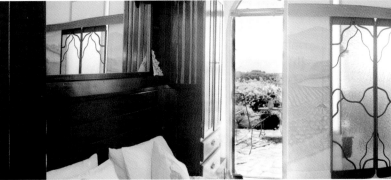

inside takes its inspiration from the irregular forms of the human body, and my aim was to create a space that would present many surprises."

Since the tourism project got under way, Teri and Glenn have kept one important goal at the forefront of everything they do—to leave the minimum possible trace of their existence through a process of recycling and regeneration, social consciousness, and education. Teri continues, "We tried to create a structure that had many environmental aspects; multiskylights for ambient light during the day, and soaring ceilings for airflow. We also only used fallen wood from the forests of Costa Rica and wood cut during highway construction." In addition, they recycle all food waste, and manure from the horses into fertilizer for the organic vegetable garden and plants surrounding the hotel. All nonorganic waste, such as glass and plastic, is recycled. Teri and Glenn select brands according to the provider company's commitment to recycling their own products. They donate a proportion of their profits to a wide variety of local causes, including supporting a local National Park, helping to rebuild the local primary school, and helping to purchase more books for the school library. For the hotel, solar panels are used to heat water, no chemicals are used in the pool, and all

CONTACT: FINCA ROSA BLANCA
COUNTRY INN, APARTADO POSTAL
41-3009, SANTA BÁRBARA DE
HEREDIA, COSTA RICA,
T: +506 269 9392,
INFO@FINCAROSABLANCA.COM,
WWW.FINCAROSABLANCA.COM

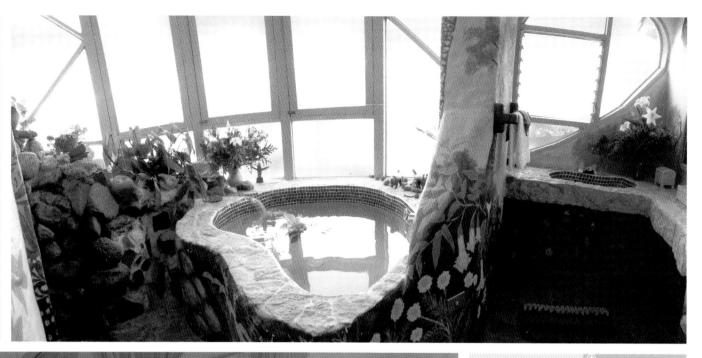

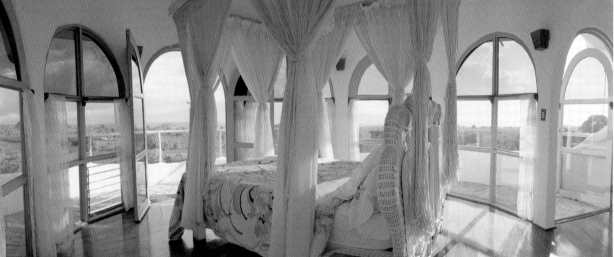

Stairs from the master suite lead down to this luxurious bathroom, where rain forest murals surround a bathtub fed by water that tumbles down a stone waterfall.

The master suite features sleeping quarters situated in a tower 40ft (12m) above the ground, and enjoys a 360° view of the surrounding countryside.

soaps and detergents are biodegradable. Teri and Glenn have every right to be proud of their quirky, arty hotel. Not only is it a genuine one-off, they've also been awarded four green flags from the Costa Rican Tourist Board for their compliance with the government's Certification for Sustainable Tourism.

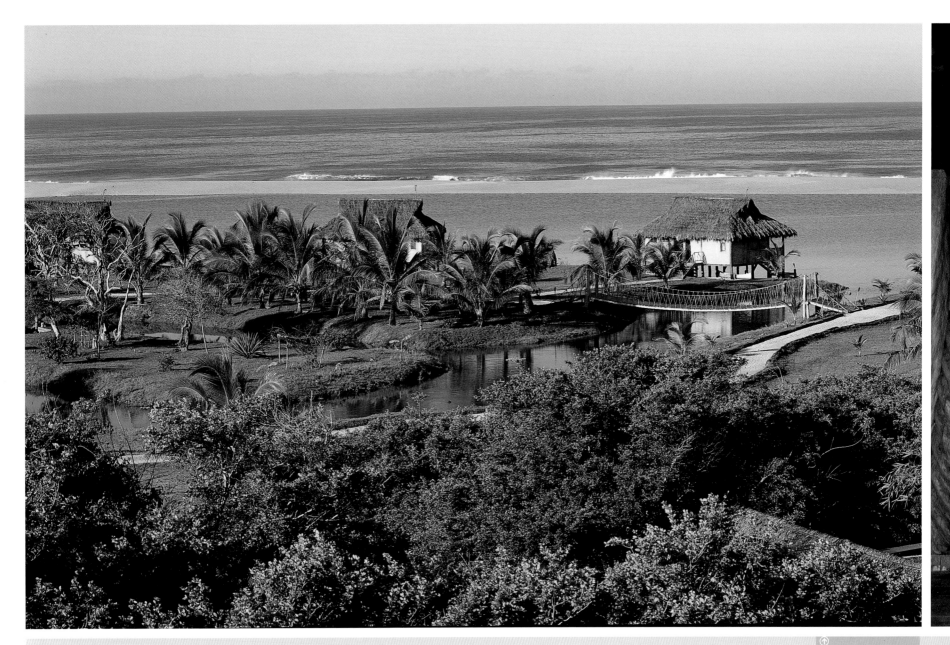

HOTELITO DESCONOCIDO
PACIFIC COAST, MEXICO

Set back from the beach to avoid disturbing the natural habitat, the resort's palafitos stretch out along the Pacific coast.

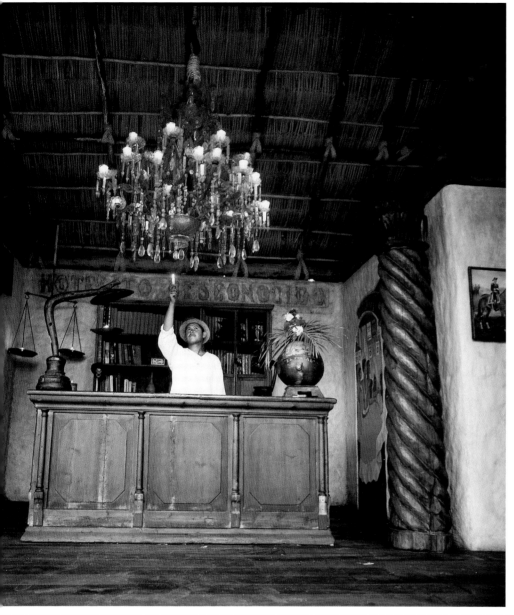

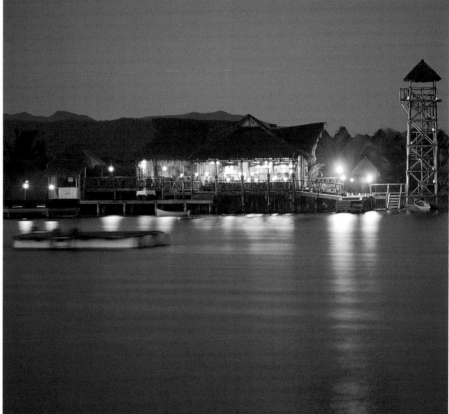

Hotelito's reception area features typically Mexican-style decor and a rustic take on luxury, with high ceilings and a stunning chandelier.

At night, the resort is lit by over 1,000 candles. All melted wax is recycled.

CONTACT: HOTELITO DESCONOCIDO, PLAYON DE MISMALOYA, SN CRUZ DE LORETO TOMATLAND, JALISCO, MEXICO 48460, T: +52 (322) 281 4010 HOTELITO@HOTELITO.COM, WWW.HOTELITO.COM

First opened in the fall of 1997, Hotelito Desconocido (meaning "little unknown hotel") was one of the first ecohotels to bring together the often mutually exclusive concepts of luxury and environmental awareness. Its owner, former Italian fashion designer Marcello Murzilli, gave up a multimillion-dollar company to pursue his dream of building a hotel that would do as much for the welfare of the environment as it did for its guests. The resort lies on an unspoilt stretch of Mexico's Pacific coast, 60 miles (100km) south of Puerto Vallarta. The Mexican National Institute of Ecology had concerns about how the hotel would impact on the nearby lagoon, as it is home to some 150 species of bird. They needn't have worried. Marcello employs staff biologists whose job is to ensure that the local ecosystems and their inhabitants are closely monitored and protected. The lagoon continues to thrive, thanks to this attitude. The staff biologists are also on hand to ensure that nothing disrupts the natural behaviors of another of its important neighbors—the sea turtle. The turtles lay their eggs on Hotelito's beach each year, and it's possible to watch from a safe distance as the babies hatch and scramble toward the ocean.

Marcello worked alongside local villagers to build the resort's villas and palafitos (bungalows). They have been placed on elevated platforms on log stilts to avoid damaging the estuary habitat below. The palafitos are designed to reflect Mexican culture, and feature pared-down, rustic-chic interiors. Guests are encouraged to counter the luxury of their stay with a concerted effort to put aside modern technology and embrace a more relaxed, ecologically aware frame of mind. For this reason you'll find no televisions, phones, or computers anywhere, and at night, a multitude of candles guide guests from their lodgings to the central lodge.

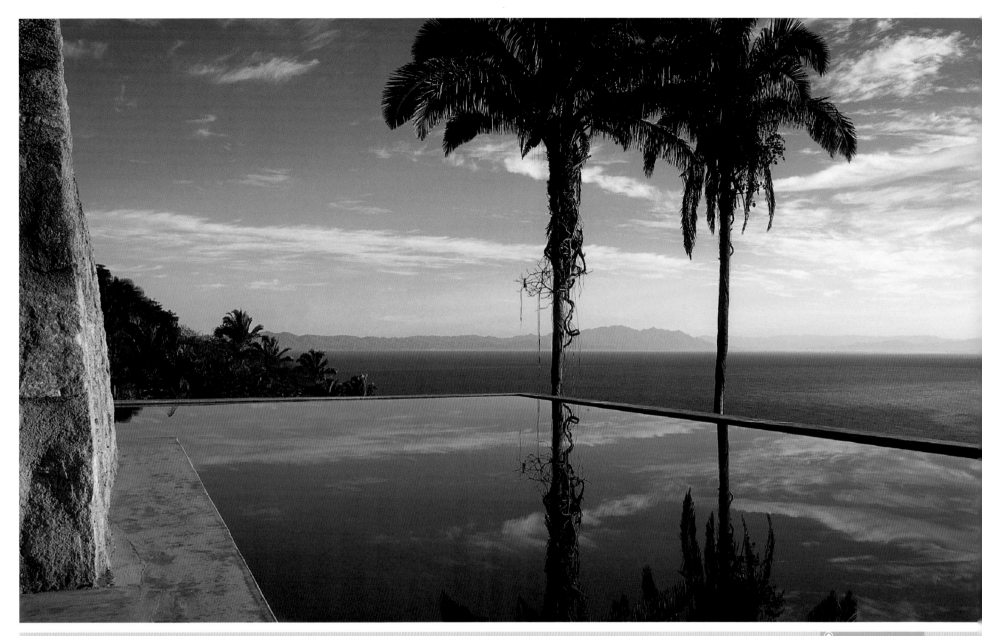

VERANA
PUERTO VALLARTA, MEXICO

Verana's stunning infinity swimming pool is fed from a natural spring further up the hill, and enjoys open views of the Pacific Ocean.

The hotel library is modernist and painted in a warm ocher typical of the local architecture.

Verana is a member of a new breed of ecohotels. Situated on a hillside overlooking the Pacific Ocean and the mountains of the Sierra Madre Oriental, the hotel is a fusion of back-to-basics rusticity and design-savvy contemporary, and wears its ecofriendly badge as proudly as its fashionable boutique style.

The intoxicating blend of traditional simplicity and pared-down modernity, evident throughout the scattered buildings that make up the resort of

Verana, represents, in a nutshell, the design ethos of its creators, construction company owner Heinz Legler and his set-designer partner Veronique Lievre. Their mutual love of early twentieth-century design invariably lay untapped in their day-to-day working lives; the purchase of the land on which Verana now stands was their first attempt to ignore the tastes and opinions of others and follow their own design instincts. Veronique comments, "we camped on the land to try and

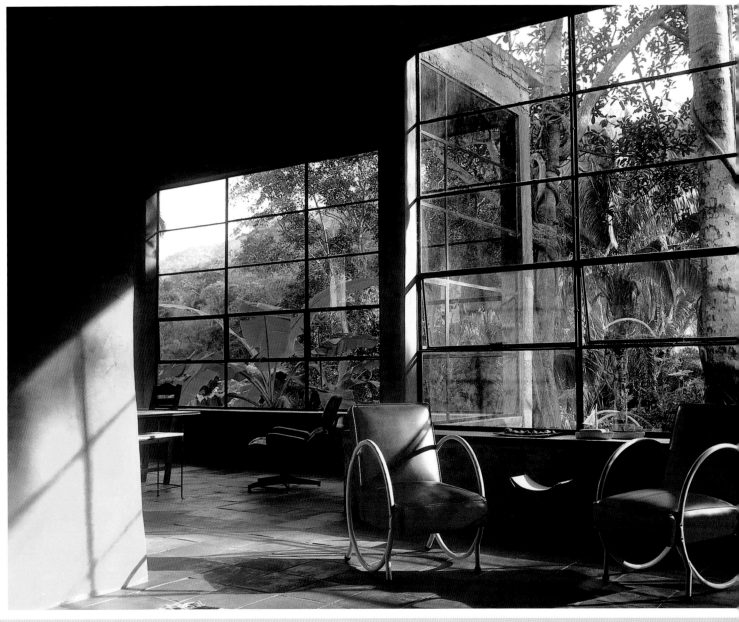

Casa Grande, which Heinz and Veronique built for themselves a little uphill from the rest of the hotel, is now rented out entirely to guests. It reflects their love of early twentieth-century furniture and design. Veronique managed to acquire the 1940s red chairs from a shoe shop in Puerto Vallarta.
[Photo: Jae Feinberg]

find the best site for the house, and at that point we didn't have much of a concrete plan. It was all a bit of an experiment, and when we started building, it was with the intention of creating a hideaway just for us and our friends. It was only later that we decided to convert it into a hotel."

The resort itself grows organically, like the jungle that surrounds it. The first year they were open there were only two huts built for guests, but then they added a restaurant, then more huts, and it continues to develop on a manageable scale that

doesn't damage the environment. Despite being just 20 minutes from the local town of Puerto Vallarta, the resort enjoys a remote position that means it has to engage with issues of waste, energy, and recycling. Until recently, the entire operation was run from solar energy. This is now supplemented with mains electricity, which is particularly necessary for the hotel's busy working kitchen. They use as little plastic as possible and grow much of their own organic food, including pineapples, papayas, and lemons.

The basic construction materials couldn't be more ecofriendly or local. While out exploring their land, Veronique and Heinz discovered an area rich in vibrant orange earth, which they then used to make colorful bricks for the hotel. Construction was carried out entirely by local people, and materials were brought to the site by mule. Heavy items like cement were transported by boat—a 45-minute ride from Puerto Vallarta. The resort's scattered footprint sits incredibly quietly in the landscape.

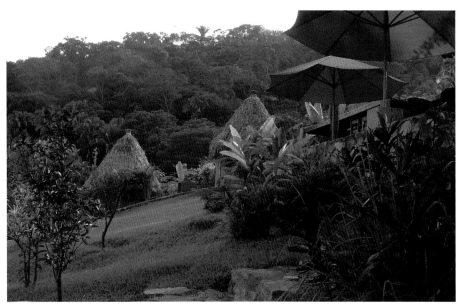

The sloping garden of Verana shows a private guest hut, the resort gift shop, and the deck of the bar and restaurant. With bricks made from local earth, and camouflaged by the natural vegetation, the resort sits quietly in the landscape.

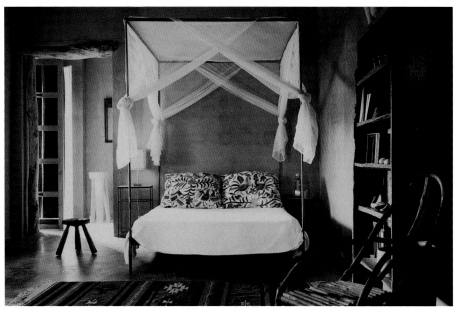

The style of the bedroom in the Stonehouse accommodation is a mixture of old colonial and traditional Mexican. The doorframe is made from dead wood found on the land, and the chair in the foreground was made by a local man.

CONTACT: VERANA, BLVD FCO. MEDINA ASCENCIO #2180, LOCAL 7 & 8, PMB 078-185, PUERTO VALLARTA, JAL 48319, MEXICO, T: +1 800 530 7176, ANA@VERANA.COM, WWW.VERANA.COM

Veronique concludes, "when guests approach by boat, they are really surprised at how camouflaged the hotel is. It blends so well into the environment and looks like its been there forever."

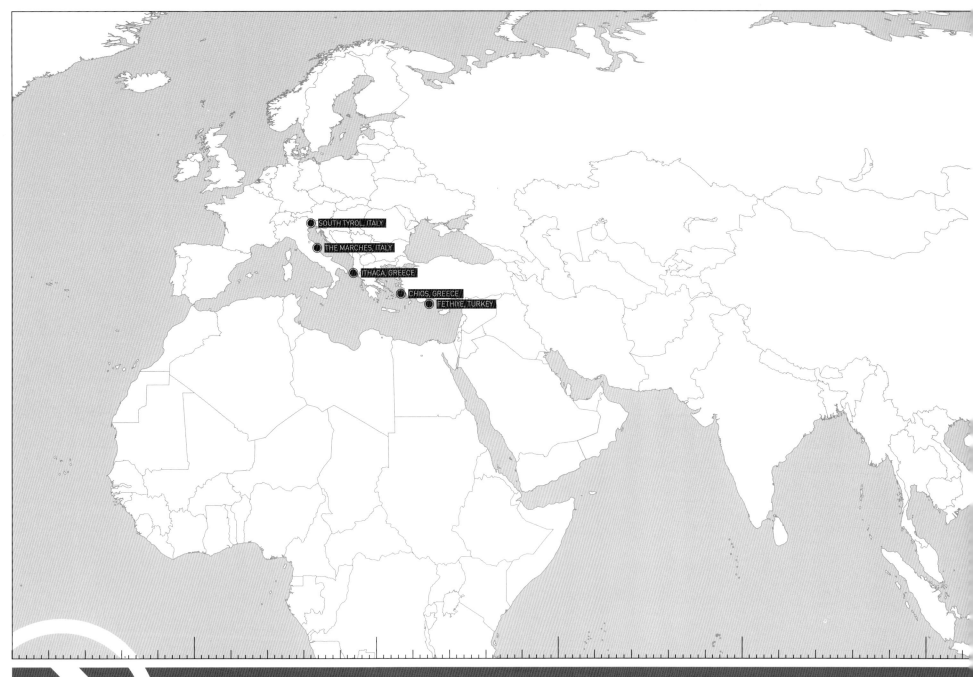

SOUTH TYROL, ITALY

THE MARCHES, ITALY

ITHACA, GREECE

CHIOS, GREECE

FETHIYE, TURKEY

GREECE
CHIOS
ITHACA

ITALY
SOUTH TYROL
THE MARCHES

TURKEY
FETHIYE

EUROPE

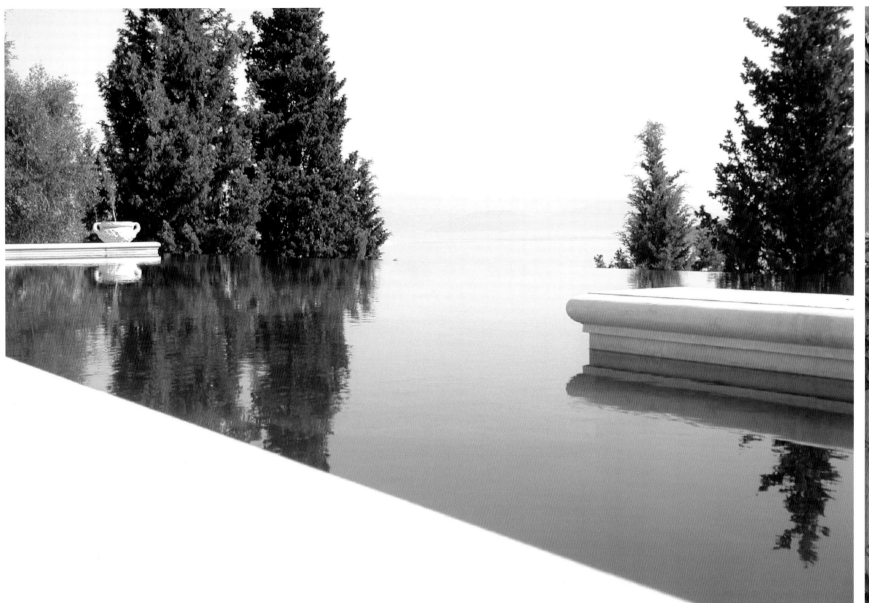

LEVENDI'S ESTATE
ITHACA, GREECE

The large pool features huge, carved-stone steps on three sides, while on the fourth, water cascades over an infinity edge, blending the horizon of the pool with the view of the bay beyond.

CONTACT: LEVENDI'S ESTATE, APHALES BAY, PLATRITHEAS 28301, ITHACA, GREECE, T: +30 6944 169 770, LEVENDIS@OTENET.GR, WWW.LEVENDISESTATE.COM

Guest accommodation, which is simple and comfortable, draws on traditional Greek interiors for inspiration. Organic cosmetics and toiletries are provided in all of the bathrooms.

Each of the guest houses on Levendi's Estate are situated on the terraced hills, deliberately covered with vines to provide shade and privacy. Keeping guest accommodation to a maximumm of 18 limits their impact on the island.

Ithaca is the birthplace of Homer's legendary hero Odysseus who constantly dreamed of returning home while away on his adventures. Over 2,000 years later Ithaca still holds an indescribable pull for those who visit Levendi's Estate on the northern shores of the island—and return time after time.

Marilyn Raftopulos, owner of Levendi's Estate—7 acres (almost 3 hectares) of private grounds overlooking the beautiful Aphales Bay—cites the island's naivety about mass tourism as one of its great strengths. Levendi's is typical of the low-impact tourism that allows the island to keep its unspoilt charm. Including four houses, each with its own private vine-shaded veranda, the estate offers accommodation to a maximum of 18 guests so that the tranquillity of the area is not disturbed.

The philosophy of the estate is simple. Marilyn's reason for starting the venture, on the site of her family's olive groves, grew from searching for the ideal tourist destination for her

The guest houses nestle between boughs of the estate's mature olive groves, which have been in the family for five generations, and from which is produced organic oil.

own family. She found it difficult to source a holiday in Greece that provided all the necessary home comforts, but that also respected the natural geographic beauty of the country and honored its bountiful flora and fauna. For Marilyn, what these destinations really lacked was intimacy with the country, its people, and its culture. Levendi's is her personal solution; in it her and her husband's skills in building, design, running a restaurant, and cultivating organic foods all marry to provide a low-key, luxurious, and culturally

fulfilling holiday. Marilyn adds, "Our first guiding principle was to invite people to share our lives and begin to learn about a new environment at the same time; to offer the experience of really 'living' in Greece, rather than mindlessly taking a holiday in a different country."

The estate is a self-sufficient farm, producing organic oil from the terraced olive groves, organic vegetables, Mediterranean herbs, and citrus fruits. A separate farm for the family's pet sheep and hens provides fresh milk, yogurt, and eggs, and

The herb- and flower-lined pathways, meandering through the olive groves and merging toward the swimming pool, link the guest houses. These herbs are used in the resort's delicious meals.

Each guest house features a private veranda, enabling visitors to dine in privacy, overlooking Ithaca's spectacular Aphales Bay.

water comes from a natural underground spring. The estate's produce is available to guests, who can help themselves to the fruit and vegetables growing on the farm and choose from a menu of dishes prepared using the homegrown ingredients.

Levendi's is a place to indulge in the peace of the surroundings. There are no televisions and there is no air-conditioning in the guest cottages—an ecofriendly stance that helps to eliminate all unnecessary noise in this idyllic Ithacan setting.

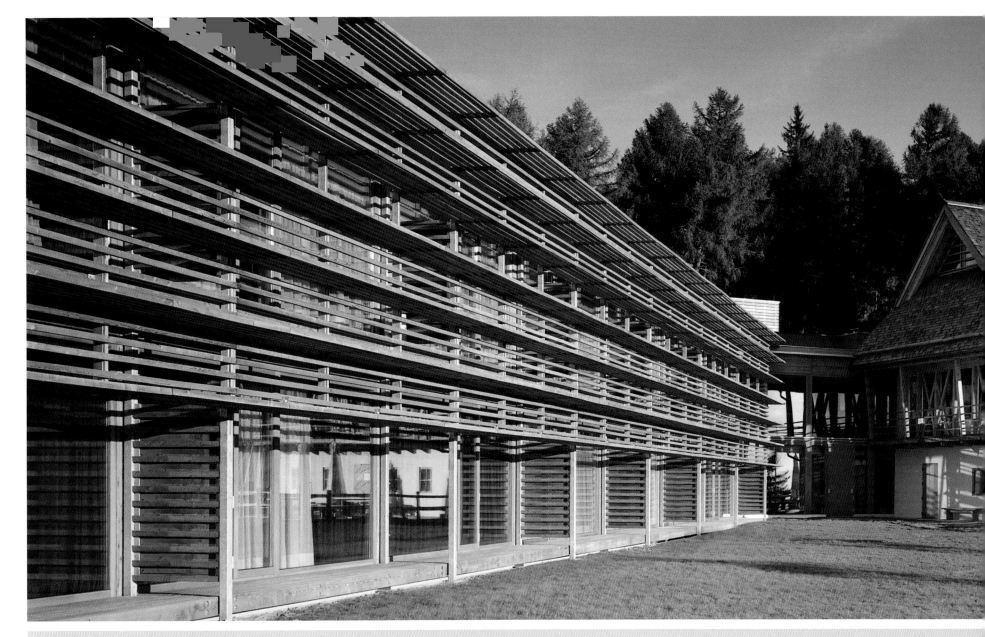

VIGILIUS MOUNTAIN RESORT
SOUTH TYROL, ITALY

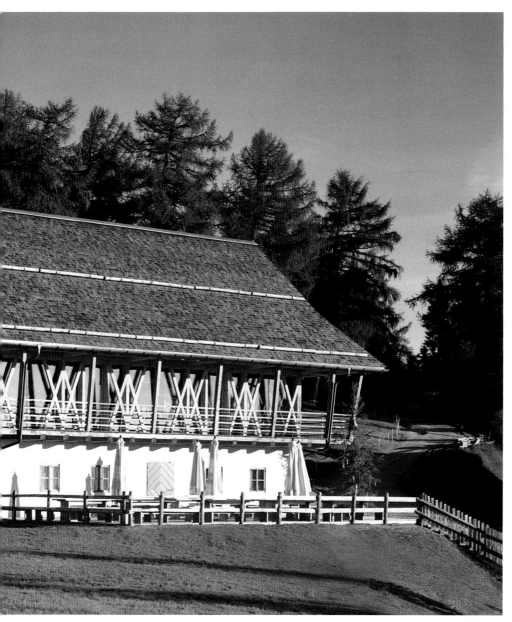

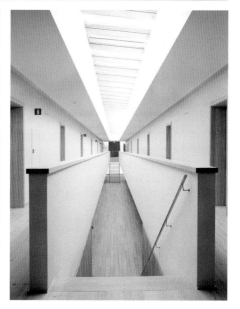

The approach to Vigilius Mountain Resort couldn't be more cathartic, with access possible only by foot or by cable car (funicular). An ascent to around 5,000ft (1,500m) above sea level allows you—both physically and metaphorically— to leave your worries behind and enjoy the lush meadows and blue skies of this untouched part of the South Tyrol.

Vigilius is the brainchild of Ulrich Ladurner who, as a boy, spent idyllic, Heidi-style summers on Mount San Vigilio with his grandfather. For him, the hotel is a childhood dream come true. He commissioned international architect Matteo Thun to conceive a building whose architecture would blend and fuse with this cherished, pristine mountain landscape.

The brief was to create a large extension to an existing, traditional-style hotel, Vigiljoch, which would visually interact with nature, regenerate the area, and allow guests to take time out in perfectly peaceful surroundings. The new hotel is a sleek, streamlined vision of wood and glass built over three floors, including a basement. It offers 35 guest rooms and six suites. To help integrate such a modern building into the environment, Matteo included a "green roof," covered in grass, plants, and flowerbeds, which guests can relax in if a walk to the surrounding mountain pastures seems too much like hard work. The roof garden also helps to regulate temperature, and prevents the hotel from overheating.

Matteo has used an organic architectural language, choosing renewable resources—wood

The boundaries between inside and outside are creatively blurred in the minimal stone corridors of the guest quarters. Light streams in through the glass roof, banishing traditional notions of dreary hotel corridors.

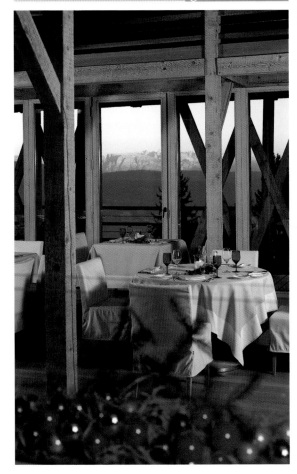

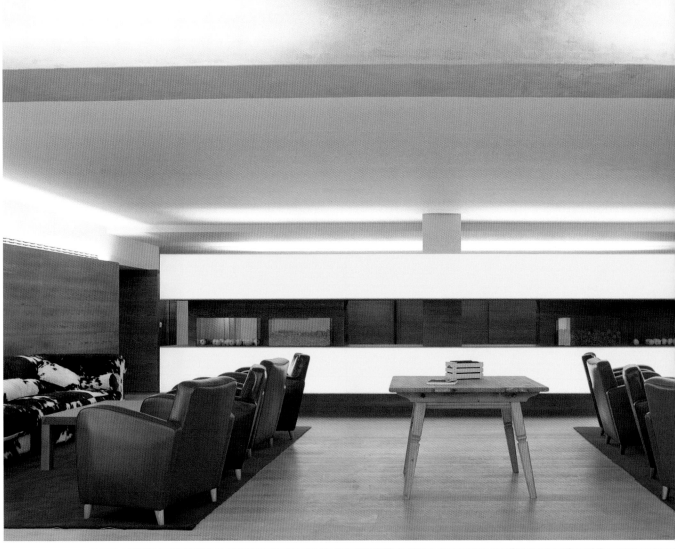

and glass—to create the bold exterior. The facade's adjustable wooden louvers regulate the amount of sun entering the building, thereby controlling the temperature inside. All the rooms have internally heated stone elements; these serve as dividers to delineate the bathroom from the bedroom, and help to heat the rooms in winter. The new building was deliberately designed on a north–south axis so that from the rooms' large windows, guests can enjoy the experience of either dawn or sunset over panoramic mountain views.

The architect's enthusiasm for the hotel is infectious. "It is like a secret lair camouflaged by the landscape, a bit like a child's tree house, but an adult, supersophisticated version of a child's hideaway," he grins. The wood/glass creation blends into the surrounding landscape astonishingly well. Matteo continues, "from the outside, you hardly notice the hotel, but from inside, you can see so much from the windows that it feels like you're still outside!"

The contemporary design of the hotel reception contains some quirky references to its surroundings, namely the cowhide couches.

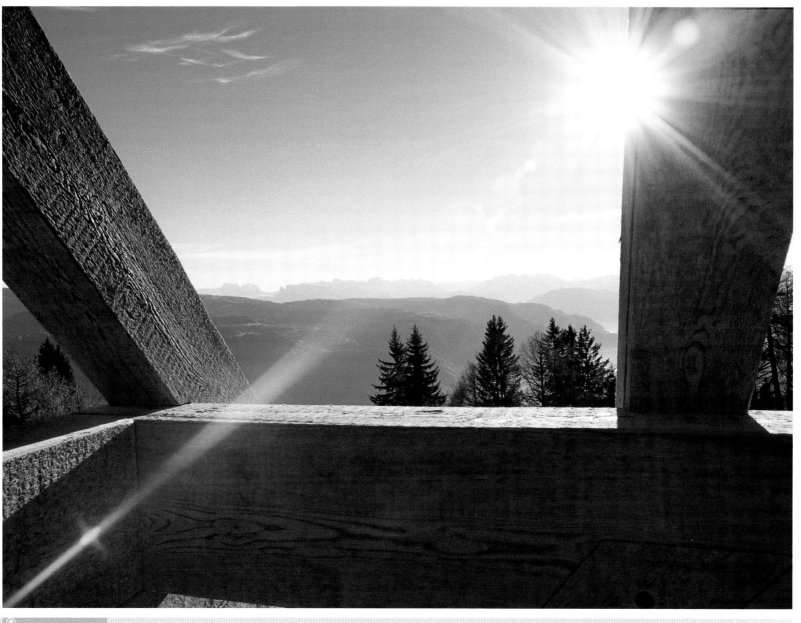

The new building was designed on a north–south axis so that guests can enjoy the dawn or sunset over panoramic mountain views through their room's large windows.

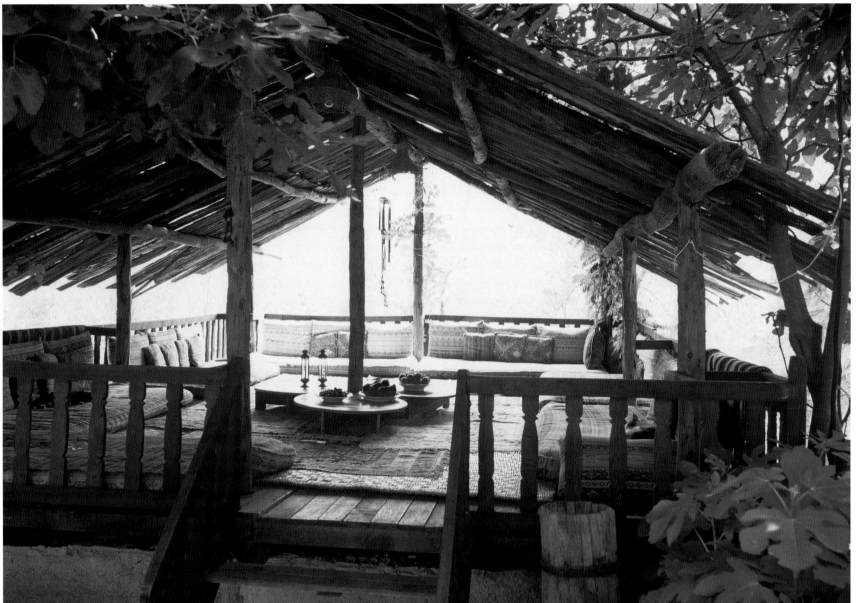

HUZUR VADISI
FETHIYE, TURKEY

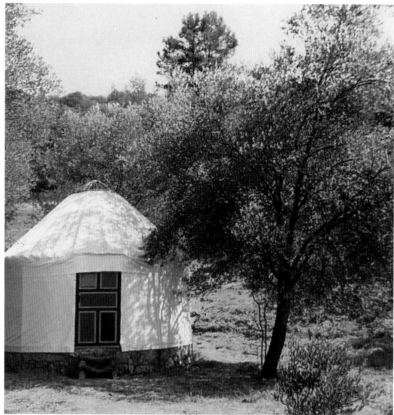

The yurt, Turkish for "home," sleeps up to three people. It sits on a stone base, which helps to moderate temperatures.

The warm climate means that most meals can be eaten alfresco, in front of the farmstead, which is decorated according to local styles.

Away from the more touristy centers of southwestern Turkey lies the remote resort of Huzur Vadisi. A 5-mile (8km) trip into the mountains from the small seaside village of Gôcek, the retreat is hidden in a tranquil, pine-forested valley.

Turkish and English couple Tanfer and Jane Taka run the resort following the guidelines of sustainable tourism, but Huzur Vadisi's raison d'être is really as a getaway spot for yoga and walking enthusiasts. The camp offers a wide selection of courses covering various schools of

yoga, and when you see the peaceful setting, it's easy to understand why people flock here to practice their asanas.

Tanfer and Jane are committed to running a low-impact tourist destination, and used local materials in the restoration of the farmstead and in the building of the kosk and yurts. During construction, all labor was sourced from neighboring towns and villages. The retreat was designed to blend in with its surroundings—the swimming pool, for example, is made with

The yurts have a simple, timber-frame construction. Their sturdy beds are sheathed in cotton mosquito nets to ensure a comfortable night's sleep.

CONTACT: HUZUR VADISI, GÖKCEOVACIK, GÔCEK 48310, FETHIYE, TURKEY
HUZURVADISI@COMPUSERVE.COM
WWW.HUZURVADISI.COM

natural stone rather than being lined with the more customary blue tiles. The camp consists of an old farmstead, a traditional wooden Turkish kosk (a summerhouse), and eight yurts (domed tents with wooden trellis frames). After a hard day of wildflower spotting in the mountains, or strenuous yoga practice, these tented rooms provide a relaxing retreat. On hot summer nights, the apex of the roof is left open to the sky, so you can see the stars from where you sleep.

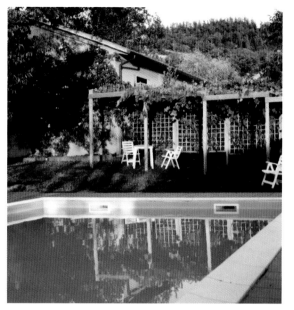

LOCANDA DELLA VALLE NUOVA
THE MARCHES, ITALY

From the organic jams and cheeses made on the farm to the simple "backyard" pool, the Locanda provides an authentic family retreat.

Locanda della Valle Nuova lies in a 185-acre (75-hectare), organically run farm.

⊕ ↗
The view from the Locanda in fall. The ancient oak trees were granted protection during the renaissance by the dukes of Montefeltro, and remain protected to this day.

Tucked away among the rolling green hills of the Italian province of Pesaro e Urbino lies Locanda della Valle Nuova, a small-scale, family-run, ecotourism project with a big heart.

The Savini family's desire to provide an authentic experience of the Italian countryside for guests followed a low-tech route from the start, as local "agritourism" laws state that for tourism, old buildings must be renovated rather than building new ones from scratch. Their desire to create an ecohotel could therefore not be executed from the

CONTACT: LOCANDA DELLA VALLE NUOVA,
LA CAPPELLA, 14 - 61033 SAGRATA DI FERMIGNANO,
PESARO/URBINO, ITALY, T: +39 (0)722 330303
INFO@VALLENUOVA.IT, WWW.VALLENUOVA.IT

foundations up, but they have included energy-saving systems where possible, such as the environmentally friendly cork insulation and the heating system, which uses renewable energy.

The family's experiences and lives touch every aspect of the design, decor, and operations of the project. Giulia Savini's father had enjoyed many years' experience in hotel design. This equipped him with the skills necessary to turn a crumbling old house into this beautiful, comfortable locanda, which offers six en-suite double bedrooms. Not

only did he plan and carry out the refurbishment, he also designed the wooden furniture, which was then made locally from solid beech. Giulia and her mother contributed personal effects to the guest rooms—everything from objects discovered on their travels to finds at the local market.

One of Locanda della Valle Nuova's greatest attractions is its self-sufficiency in providing fine, organic food for its guests. Giulia says, "Our farm produces more than 70 percent of the food we serve in the restaurant, and we buy as much as

we can of the rest from nearby organic farms. We mill our own wheat and with this, we make our own bread, pasta, brioches, and cakes. We also grow our own vegetables, gather eggs from our chickens, and rear our own livestock—cows, pigs, and chickens—for organic meat. We also make our own conserves, a firm favorite with the guests being my mom's musk-rose jam!"

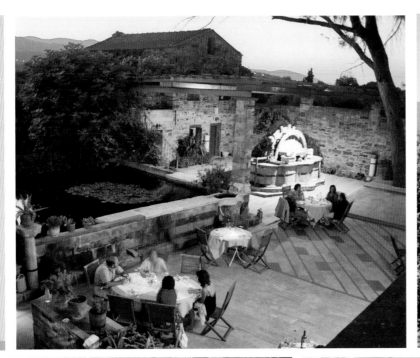

Perleas Mansion includes seven apartments that house around 14 guests. The building is constructed from the local red and ocher stone.
[Photo: Isidoros Loizos]

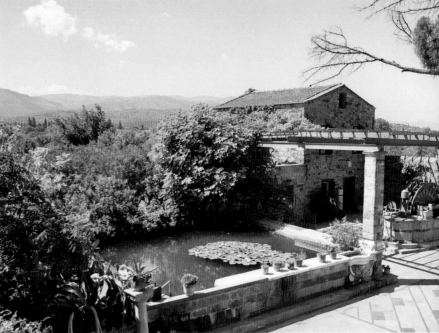

PERLEAS MANSION
CHIOS, GREECE

The ornamental pool provides a natural means of keeping the resort's temperature down.

The Aegean island of Chios, with a population of just 50,000, is a beautiful place that time seems to have forgotten. The area of Kampos, once the thriving site of wealthy landowners' estates, has seen its former occupants abandon the region for the mainland, leaving the fertile lands unused. It was into this forlorn situation that the current owners, Vagelis and Claire Xyda, arrived when they bought Perleas Mansion in 1998. The area of Kampos has a vibrant tradition of building estates to a specific blueprint; this consists of the

The main house overlooks a central courtyard which, following the layout of traditional estates in this area, contains a well with a wooden bucket for drawing drinking water, covered by a pergola. [Photo: Isidoros Loizos]

The pale color of the local stone used in the buildings gives the whole estate a light softness.

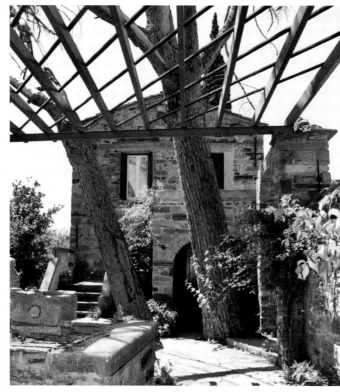

In rebuilding the mansion, the Xyda's used as many local materials and furnishings as possible.

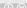

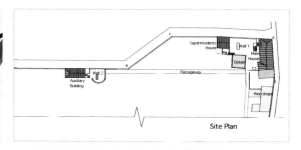

Site Plan

Plan of Perleas Mansion's main house. Maria used as much as she could from the rubble of the original house to rebuild the two new storys, and any missing elements were sourced locally. [Plan: Maria Xyda]

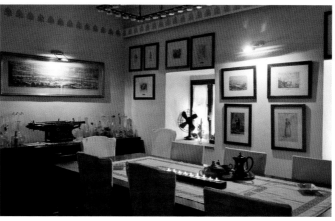

CONTACT: PERLEAS MANSION, VITIADOU ST, CAMBOS 82100, CHIOS, GREECE, T: +30 22710 32217, INFO@PERLEAS.GR WWW.PERLEAS.GR

main owners' house and a "superintendent's" house separated by a central yard, with subsidiary buildings for storage and animals set apart from these main houses. The central yard features a main well with a cistern and water reserve, always covered by a pergola.

Architect Maria Xyda was charged with the renovation of the neglected mansion. The original three-story main building, built around 1750, was reduced to a single-story wreck in 1881 by an earthquake that devastated much of the island.

Maria used as much as she could from the rubble of the house to rebuild the two new storys, and any missing elements were sourced locally.

The owners' decision to turn the renovated mansion into a hotel allows them to invest more time and money into reviving the whole estate. They have planted many trees, including orange, tangerine, and lemon, plus olive groves from which they produce oil. They have gained organic accreditation for all the produce they grow, and make seasonal fruit jams which are enjoyed by

guests and sold at organic food shops on the island. The relaxed, back-to-basics lifestyle seems to have won many fans. Maria's business partner Demetri Kakouros comments, "The way of life is so attractive that many people who've stayed here even express the desire to buy a house like this in Kampos and repeat the same model!"

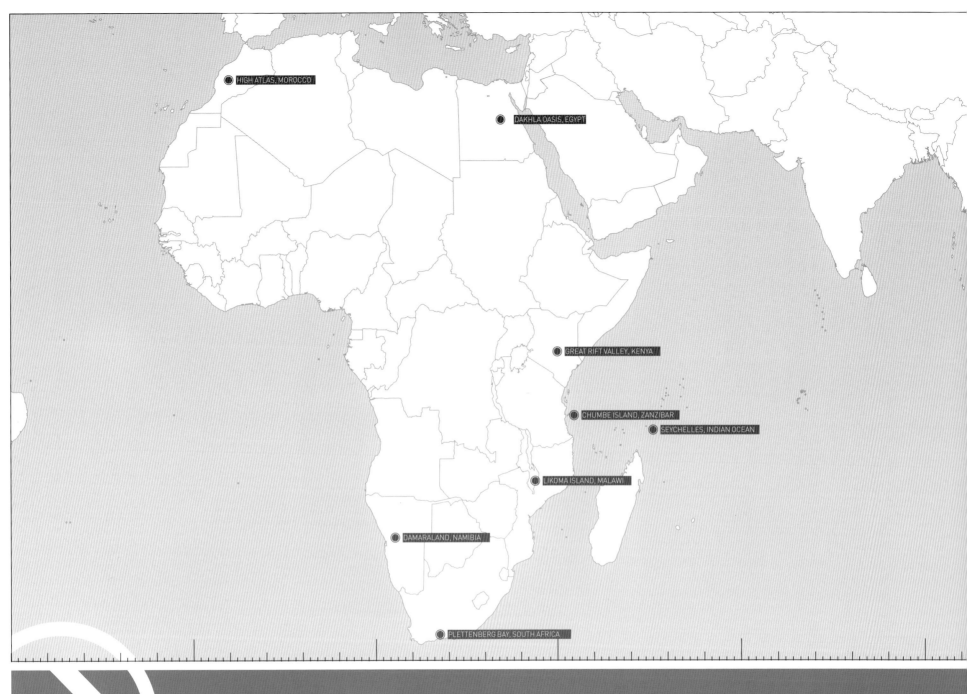

HIGH ATLAS, MOROCCO

DAKHLA OASIS, EGYPT

GREAT RIFT VALLEY, KENYA

CHUMBE ISLAND, ZANZIBAR

SEYCHELLES, INDIAN OCEAN

LIKOMA ISLAND, MALAWI

DAMARALAND, NAMIBIA

PLETTENBERG BAY, SOUTH AFRICA

EGYPT
DAKHLA OASIS

INDIAN OCEAN
SEYCHELLES

KENYA
GREAT RIFT VALLEY

MALAWI
LIKOMA ISLAND

MOROCCO
HIGH ATLAS

NAMIBIA
DAMARALAND

SOUTH AFRICA
PLETTENBERG BAY

ZANZIBAR
CHUMBE ISLAND

AFRICA

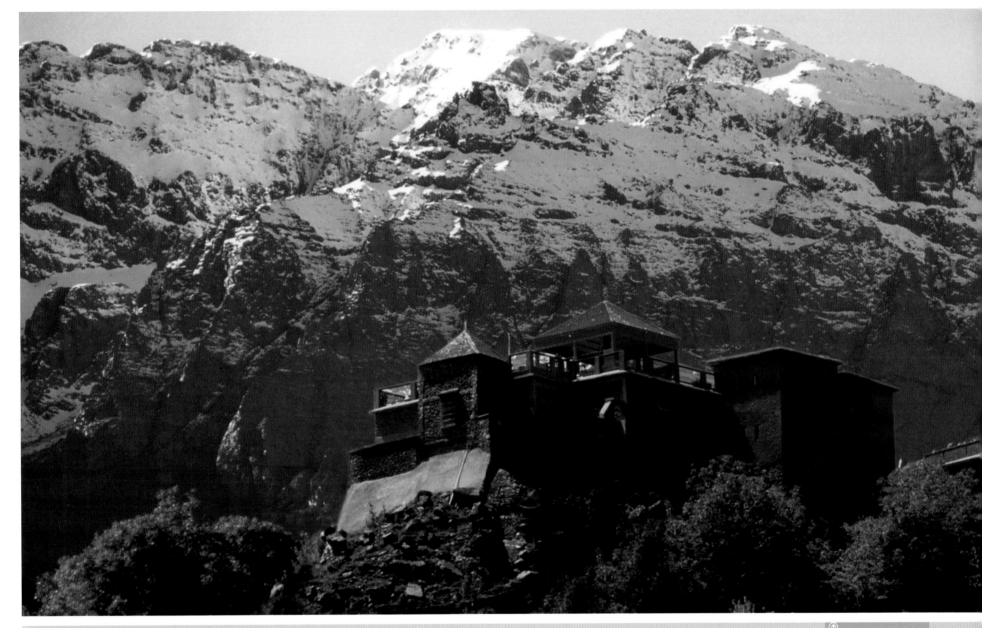

KASBAH DU TOUBKAL
HIGH ATLAS, MOROCCO

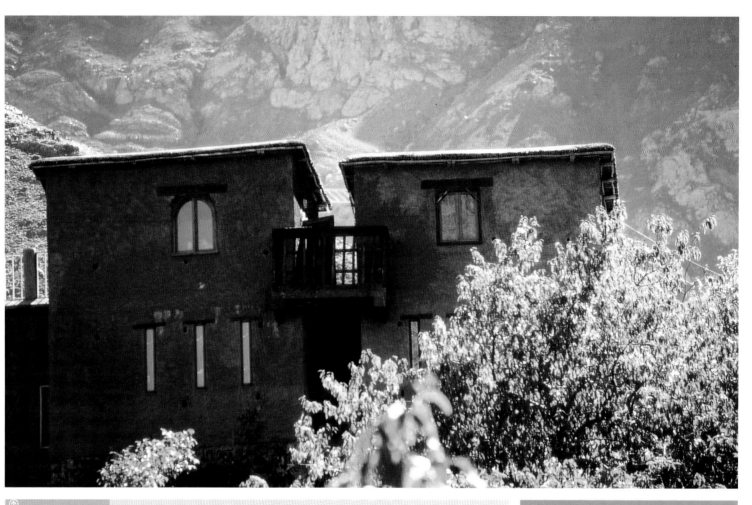

The far end of the Kasbah comprises two sturdy, medieval-looking square towers rendered in mud, following local tradition. These house bathrooms and en-suite rooms.

CONTACT: KASBAH DU TOUBKAL, NEAR IMLIL, HIGH ATLAS, MOROCCO, T: +212 44 48 56 11
KASBAH@DISCOVER.LTD.UK
WWW.KASBAHDUTOUBKAL.COM

Although only 40 miles (c. 64.5km) from Marrakech, the Kasbah du Toubkal mountain retreat could hardly have a more out-there, imposing location. The monumental building on its craggy outpost in the High Atlas region of Morocco has come a long way from its origins as the 1930s palace of a feudal overlord.

Now run as a secluded, luxurious getaway for responsible tourists, it has been converted to offer eight guest bedrooms; a private, three-bedroomed house; and three traditional Berber salons, which provide beds for many people. You can even sleep on the roof, under the stars, if you wish.

In 1995, the task of restoring the vast, ruined palace was given to local villager Omar "Maurice" Ait Bahmed, with professional help from British architect John Bothamley. Bothamley's brief was to respect the local vernacular, forging a style that would allow this massive fortified building to sit comfortably in its dramatic setting, without looking like a pastiche. The construction work-force was sourced from neighboring villages,

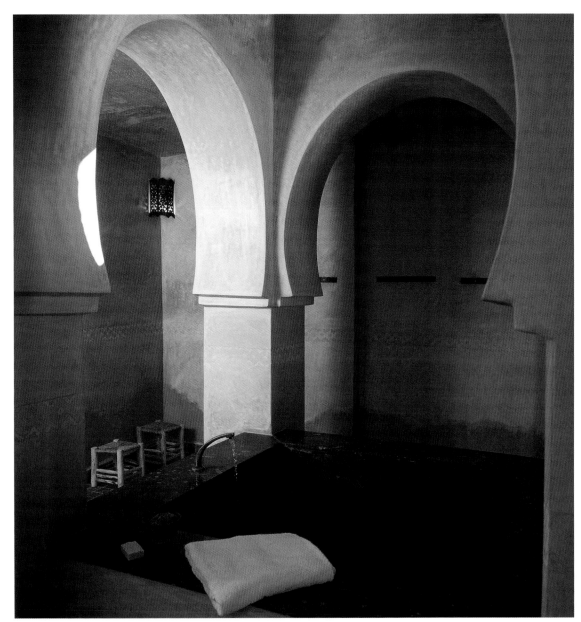

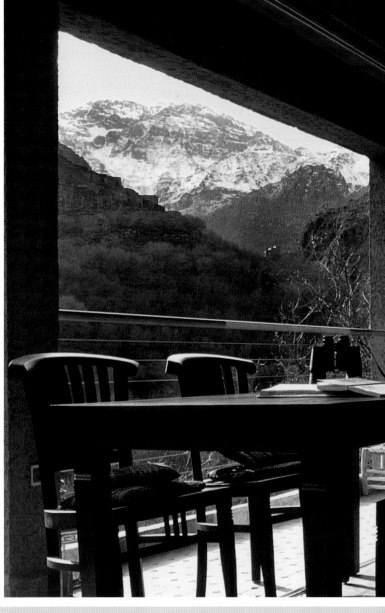

A Berber hammam (steam bath). Because the Kasbah is in an earthquake zone, concrete was used, but rendered with local mud to give it a traditional look.

and the enthusiasm of the builders had a real impact on the project. Bothamley explains, "The exuberance of the local workers was sometimes difficult to control, as they wished to add their own ideas beyond the bounds of the 'local vernacular.' Sometimes they wanted to see extras they might have glimpsed on rare visits to Marrakech. The final style we settled for was a little more imposing than the local houses, with more attention to design details, but the architectural language was all locally inspired."

No power tools were used during the construction—electricity only arrived in 1997. Everything was hauled up the mountain by a team of 30 men and their long-suffering mules. Although Bothamley is proud to acknowledge a leaning toward traditional building methods, he explains that "because the local village of Imlil is in an earthquake zone, concrete construction was adopted, but then rendered in local mud to give a proper traditional look." This building method, which fuses the traditional with the modern, won

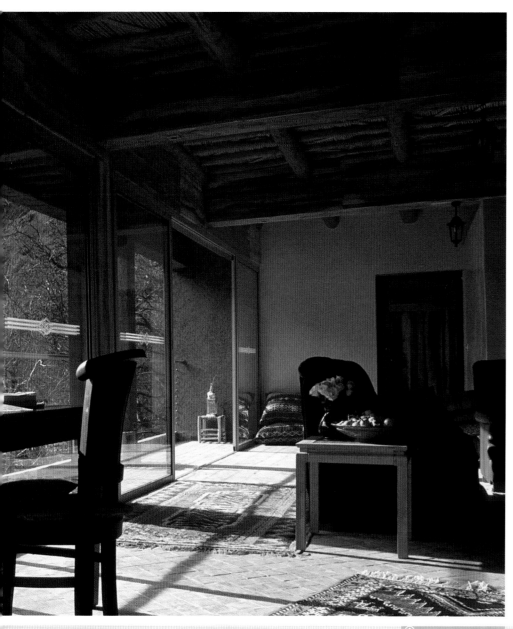

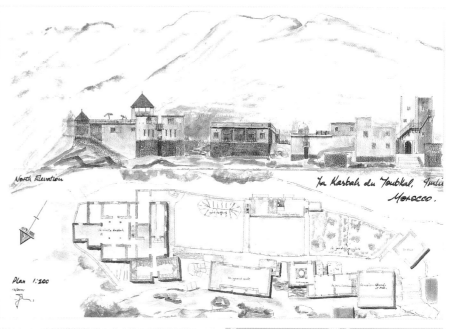

Sketch of the tower at Kasbah du Toubkal. While more imposing than the neighboring village houses, the architecture is locally inspired.

North elevation and plan. The brief was to respect the local vernacular.

the Kasbah a British Airways Tourism for Tomorrow Award. The style of the interior is one of understated luxury; it includes exposed wooden beams, low beds, and rich carpets.

The Kasbah's commitment to the community involves employing all its staff from nearby villages, sourcing as many supplies as possible locally, and drawing water from a local spring, not plastic bottles. The design of this lofty lodge, together with the responsible way it is run, ensures an inspirational, educational experience for visitors.

The floor-to-ceiling glass in the communal lounge affords spectacular views over the surrounding Atlas mountains.

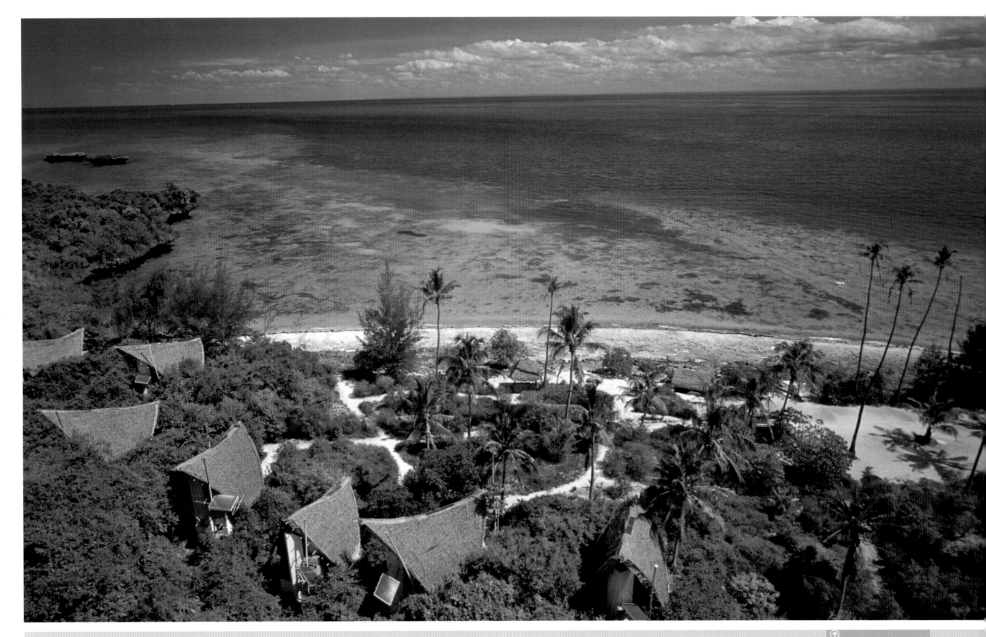

CHUMBE ISLAND CORAL PARK
CHUMBE ISLAND, ZANZIBAR

All seven ecobungalows overlook the Indian Ocean, which is a mere 30-second walk away, and are built to make the most of the cooling sea breeze.
[Photo: Manolo Yllera]

A shaded terrace outside the dining area of the Visitors' Center catches the evening light. The resort generates its own energy and water.
[Photo: Manolo Yllera]

CONTACT: CHUMBE ISLAND CORAL PARK, P.O. BOX 3203, ZANZIBAR, TANZANIA, T: +255 (0)24 223 1040 INFO@CHUMBEISLAND.COM WWW.CHUMBEISLAND.COM

Chumbe Island's fragile, beautiful terrestrial and marine environment is not an obvious place to set up an exclusive holiday retreat. It's not on an electricity grid for one thing, it has no ground water source, and it's teeming with rare and protected species of plant-, bird-, marine-, and wildlife. But the owners' vision of a private nature conservation project could only be funded by proceeds from an ecotourism project.

For the preservation of the island, it is vital that there be close to zero human impact on the various precious ecosystems—a tall order, even by the most rigorous of sustainable tourism standards. To make it happen, a dedicated team of architects was brought in to design the resort. Professor Per Krusche, Georg Fiebig, and Jan Hülsemann from the Technical University in Braunschweig, Germany, not only created the

buildings, they also assisted with the planning, staff training, and on-site building supervision for more than four-and-a-half years.

The resort's seven bungalows are tucked into the forest reserve along the coast and, unusually, have no walls. Living spaces are demarcated by the landscaping of the lush, indigenous trees and bushes around each dwelling. This allows efficient air circulation without the need for earth-costly

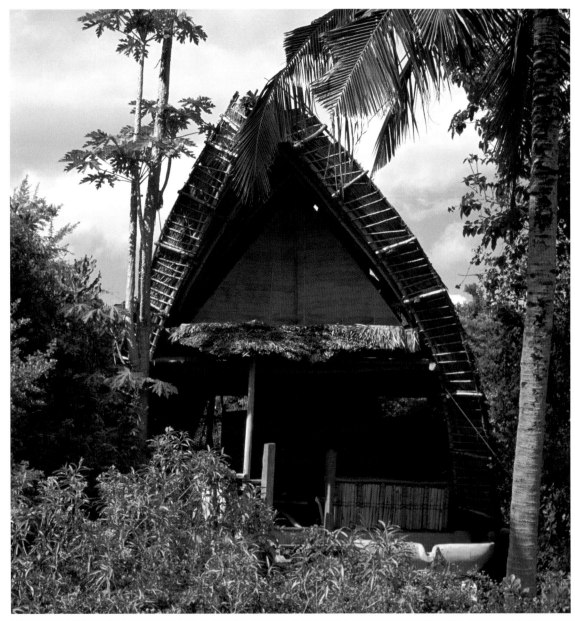

Each bungalow is designed with ventilation control in mind, utilizing passive cooling and open spaces, with wind panels and louvers to control air flow. The bungalows are even positioned to harness the predominant wind direction.
[Photo: Manolo Yllera]

air-conditioning, while intelligently blending the architectural boundaries between indoor and outdoor living.

The structures of the bungalows consist of a light, latticed shell and interlace of mangrove and casuarina poles, with coconut-fiber ropes as joints, and roofs of thatched palm leaf. Each bungalow functions as a self-sufficient entity, generating its own water and energy through the

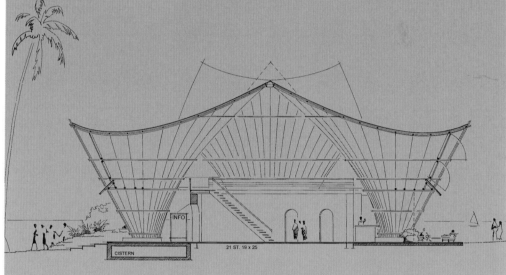

INFO

CISTERN 21 ST. 19 x 25

use of rainwater collection and filtration, with energy garnered from solar water heating and photovoltaic electricity. This individual set-up was more cost-effective than a centralized system, and less disruptive to the island. A centralized system would have involved excavating the rocky, fossil coral ground for expensive cables and pipes. Each bungalow has the capacity to store up to 4,000gal (almost 15,000l) of water in the large cistern underneath the floor, with just over 65gal (250l) of hot water available daily for washing and showers. This is a considerable achievement for an island without its own freshwater supply.

Because of the fragility of the nature reservation, rigorous waste management is crucial. Gray water from showers and the kitchen passes through a filter before entering a sealed plant bed. Species of plant that absorb large amounts of potentially harmful phosphates and nitrates have been chosen for this bed, to ensure that the water is made safe before it enters the ecosystem. Composting toilets recycle human and organic waste—reducing it to one-sixth of its original volume—and produce fertilizer for the gray-water filtration plant beds.

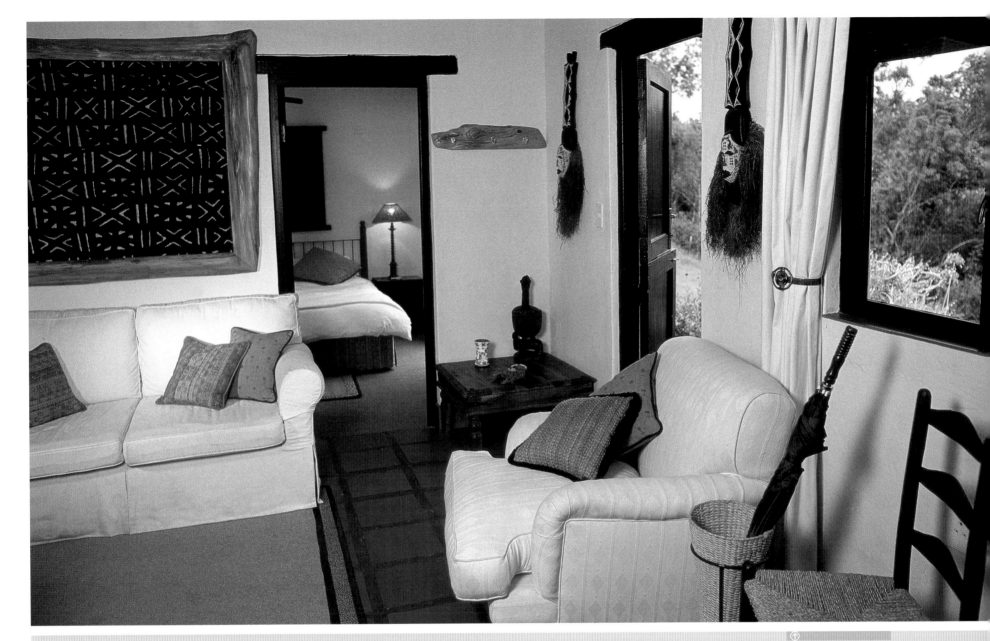

HOG HOLLOW COUNTRY LODGE
PLETTENBERG BAY, SOUTH AFRICA

The African-style rooms are decorated in earthy colors, naturally woven fabrics, and local handcrafted woods. All rooms overlook the indigenous forests and Tsitsikamma Mountains.

CONTACT: HOG HOLLOW COUNTRY LODGE, P.O. BOX 503, PLETTENBERG BAY 6600, SOUTH AFRICA, T: +27 (0) 44 534 8879, INFO@HOG-HOLLOW.COM WWW.HOG-HOLLOW.COM

A short walk from the lodge rewards guests with this view of the sea. [Photo: Mark Andrews at African Rambles (rights owned by Hog Hollow)]

Cape Town resident Andy Fermor moved to the UK in the 1980s to work as an engineer, and there he found the experience and confidence to fulfill a dream. He returned to the Garden Route area of South Africa—where he used to spend his childhood holidays—to build a peaceful lodge that would open up the beauty of this unspoilt area to guests, without damaging the precious landscape that he has always loved.

Hog Hollow Country Lodge, designed and built by Andy on a site 11 miles (18km) east of Plettenberg Bay, aims to provide understated, but luxurious accommodation for people keen to explore the Garden Route who also wish to learn about the surrounding fertile landscape, which teems with wildlife and birdlife.

Starting work on the construction was not easy: the team had to deal with removing vast areas of Australian wattle, a nonindigenous, fast-growing species planted 25 years previously to produce tannin and pulp for the money-making leather industry. The wattle has now been replaced with indigenous species and the habitat of the area is well on the way to returning to its natural state.

The lodge has a main house containing 15 rooms, each with its own private deck overlooking the forest, and an en-suite bathroom. Top of owners Andy and Debbie's list for the lodge was providing careers for local people. The lodge is entirely staffed by locals who were previously unemployed, or whose talents were wasted in poorly paid jobs. "Within our community was a new and vital energy with lots of exceptional talent waiting to be unleashed," they confirm.

DESERT LODGE
DAKHLA OASIS, EGYPT

Local villagers were deliberately involved in the interior decoration of the rooms.

CONTACT: DESERT LODGE, AL QASR VILLAGE, DAKHLA OASIS, EGYPT
T: +20 (0)12 734 59 60, INFO@DESERTLODGE.NET, WWW.DESERTLODGE.NET

Research has shown that Dakhla Oasis has been inhabited since prehistoric times, with Neolithic rock paintings indicating that there was once a lake there, frequented by elephants, buffalo, and ostriches. The lake has long since dried up, but a Swiss-Egyptian ecotourism venture is breathing new life into the area in the shape of Desert Lodge. Founder member Ursina Rüegg describes the lodge as "the result of collective thinking of international tourism experts—people who like outdoor life, nature, and the beauty of the desert."

Situated in Al Qasr, about 23 miles (35km) from the oasis' capital Mut, the lodge borrows its architectural language from local villages, and merges Egyptian heritage with ecofriendly concerns. Architect Khaled Etman was informed by the owners about the importance of building an ecoresort that would have a low impact on the environment once it was up and running. "We understood that materials should be natural and as local as possible. We used limestone blocks for the walls instead of manufactured blocks. Roofs

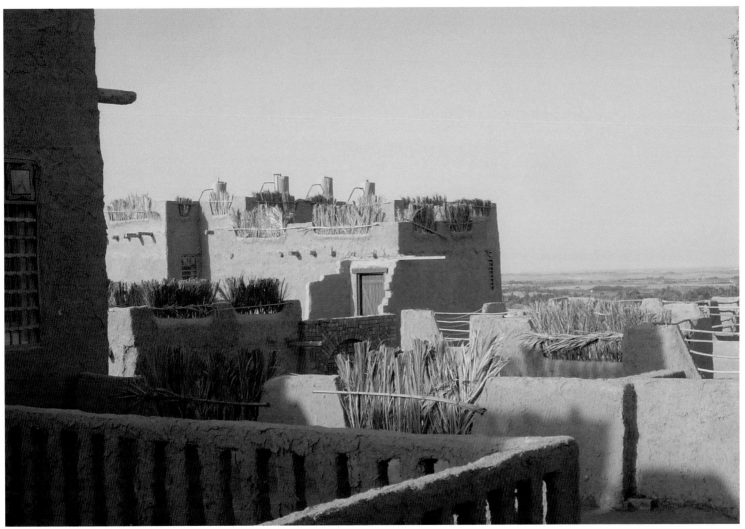

The buildings around the
courtyard display an
architectural language that
is typical of the region.

The crenellated roofline is
covered in mud screed to
achieve a traditional look.

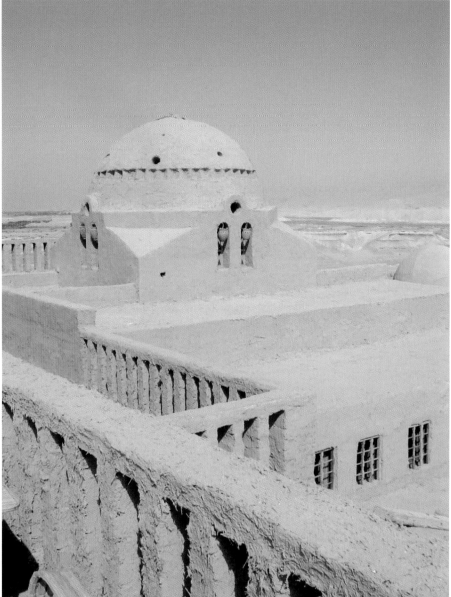

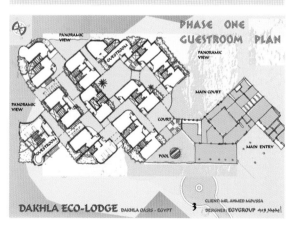

DAKHLA ECO-LODGE DAKHLA OASIS - EGYPT

PHASE ONE
GUESTROOM PLAN

PANORAMIC VIEW

PANORAMIC VIEW

PANORAMIC VIEW

MAIN COURT

COURT

MAIN ENTRY

POOL

CLIENT: MR. AHMED MOUSSA
DESIGNER: EGYGROUP

were constructed from wooden joists and palm reeds covered with mud screed, according to local tradition," says Khaled. The entire construction of the lodge was carried out by neighboring craftsmen, and the owners went to great lengths to involve locals in the interior decoration, even if it wasn't the most straightforward choice. Ursina adds, "One man, for example, was making our mattresses in the middle of the town street because his workshop was too small."

The lodge offers 32 large rooms, all with private bathrooms and telephones, and all decorated in a local style. Despite the understated luxury of the hotel, great care is taken to keep operations environmentally sound. High ceilings and fans remove the need for air conditioning. Waste is kept to a minimum and separated at the hotel, and board members of the lodge are working with the village authorities of Al Qasr to find a way to separate and recycle the villagers' waste.

Khaled Etman's plans for the lodge.

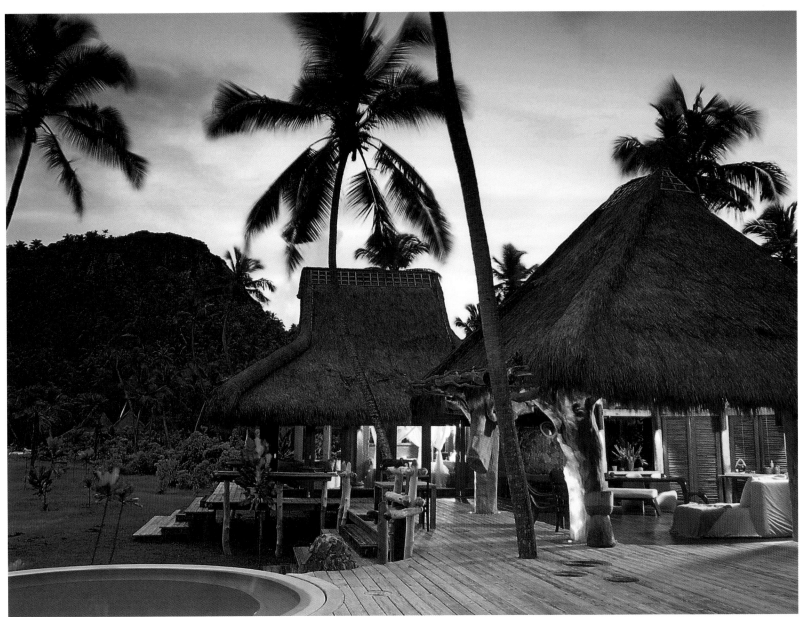
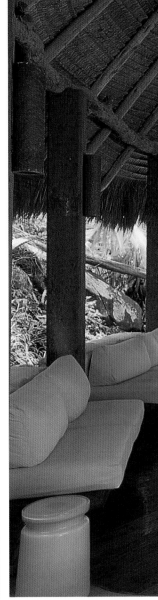

NORTH ISLAND
SEYCHELLES, INDIAN OCEAN

The villas by night, gently lit to avoid disturbing the local wildlife. The structures are set back from the beach so as not to disrupt the nesting turtles.

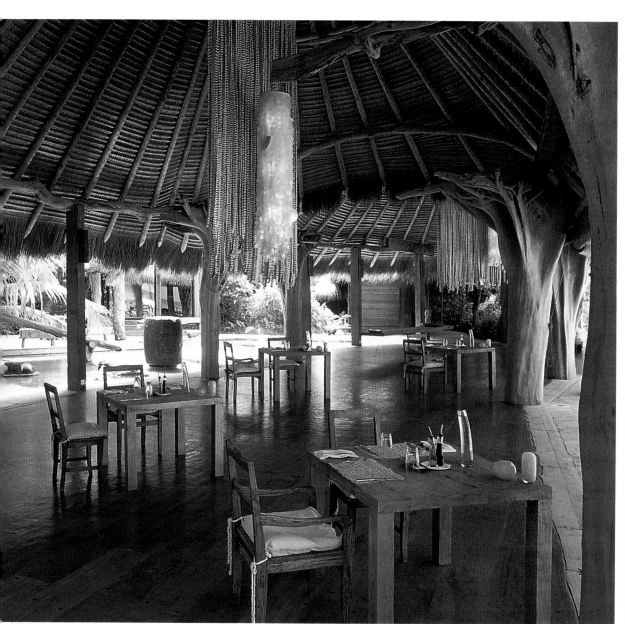

The dining room has an organic, amorphous feel that is enhanced by the use of inverted takamaka trees in place of traditional structural features such as columns. The grandiose light fittings are made from strands of shells and mother-of-pearl.

The plan for Villa 11, one of the largest private villas on North Island.

CONTACT: NORTH ISLAND, P.O. BOX 5219, RIVONIA 2128, SOUTH AFRICA
INFO@NORTH-ISLAND.COM, WWW.NORTH-ISLAND.COM

Although just one of hundreds of islands that make up the Seychelles, North Island is a resort that stands out from its neighbors. Measuring just under 1 mile (c. 1.5km), the private granitic island offers the epitome of barefoot luxury accommodation. It comprises nine spacious villas that sit in the tree line along Anse d'est Beach, and two extra-large villas that are tucked away in the takamaka forest.

Husband-and-wife architectural team Silvio Rech and Lesley Carstens created a unique architectural language for the resort by fusing building with nature. Their hands-on philosophy led them to live on-site, with their two children, throughout the design and construction of the retreat. The "style," if indeed it can be called a style, is a true celebration of nature, drawing on the granitic rocks and indigenous timber for inspiration. Silvio comments, "Here, trees have become columns and rocks are chairs. It's an architectural language that people respond to, as it helps them to relax and feel more in touch with

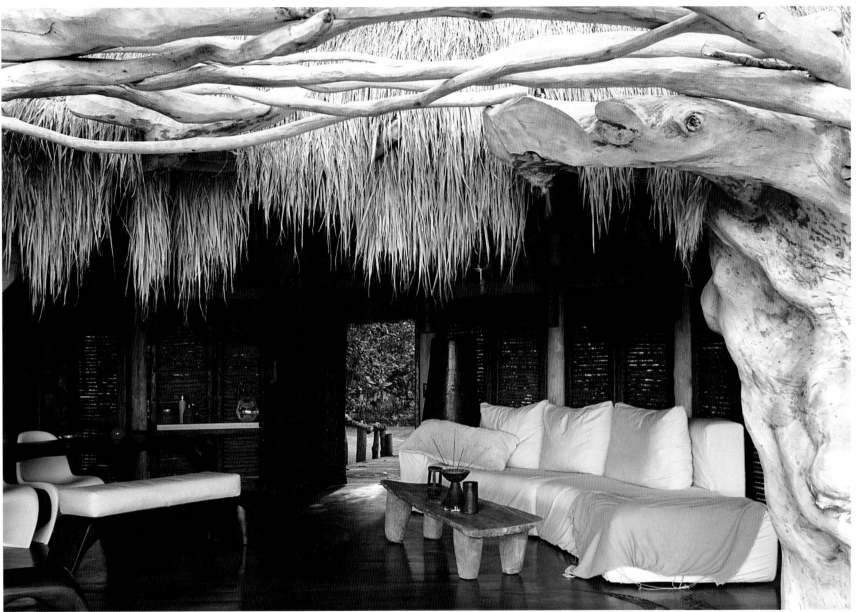

The boundaries between inside and out are blurred in the lounge of this villa, which is framed by an arch of twisted takamaka wood. The interior floor is polished teak, while the exterior decking is sandblasted pine.

the island." For example, the local "upside-down" takamaka tree plays a dominant role in the structure of the villas and public spaces of the resort. Silvio and Lesley salvaged the trees, which had died from vascular wilt disease and were destined to be burnt, and integrated them into their designs. Smaller takamaka branches were used to make handrails, showers, and screens. This is one of the many ways in which the architects encourage guests to interact with

nature; the villas all feature an outdoor shower, for which the water pours through a log rather than from a modern showerhead.

The architectural team's biggest challenge concerned logistics rather than design. Silvio continues, "It was difficult getting staff and raw materials to a pristine island. This involved 150 boatloads of materials arriving at the island from four or five different countries. Craftsmen from Bali, South Africa, and Tanzania were all living

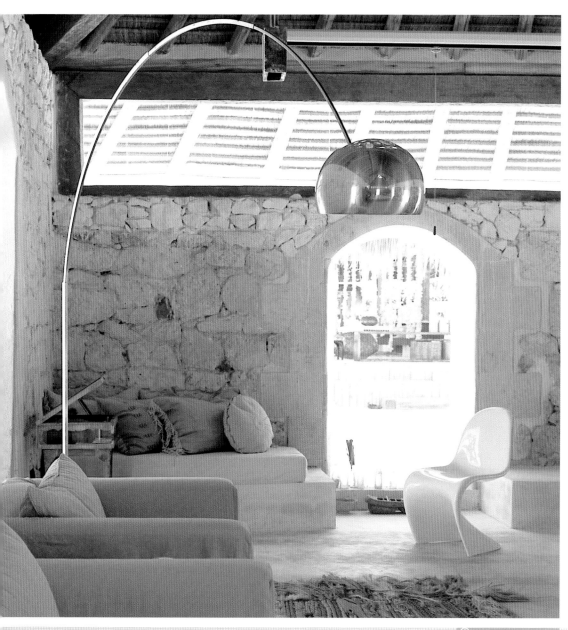

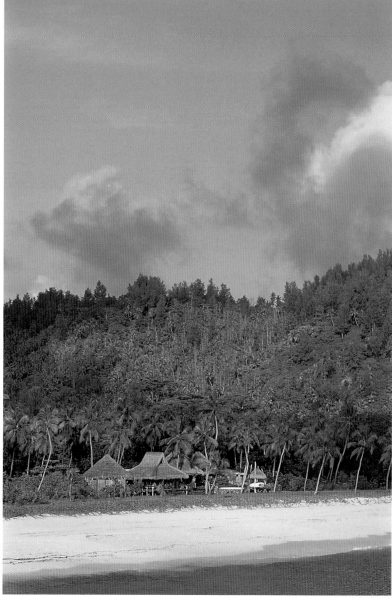

and working side by side, six days a week, with only Sunday off to wash and replenish bodies that were aching from the physical labor."

It is easy to forget that the considerable amount of money it costs to stay in such a luxurious, elegant environment will all contribute to a good cause. The aim of the island's owners is to turn the environmental clock back 200 years, encouraging wild species such as the giant turtle to return and breed.

The library is an imposing space built from white beach rock, with large, glazed, white sandstone archways to let light flood in.

The villas blend in subtly with the surrounding beach and vegetation.

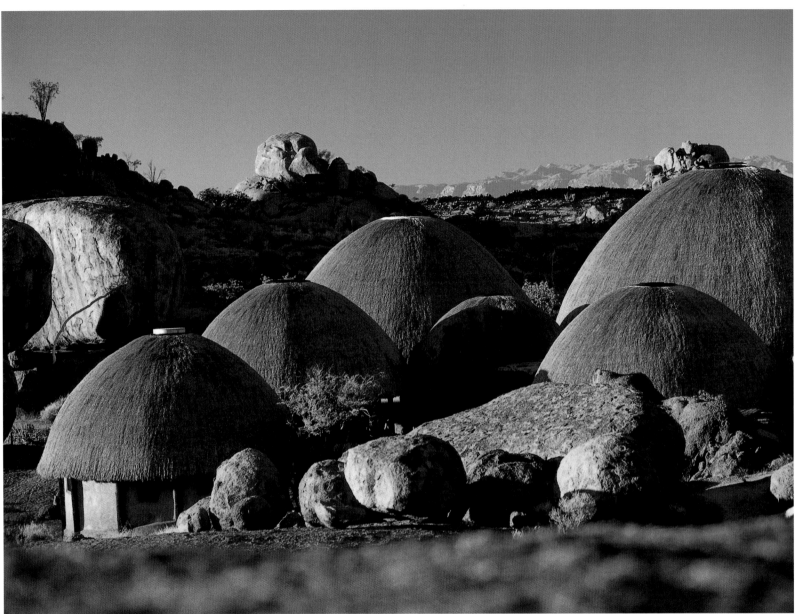

MOWANI MOUNTAIN CAMP
DAMARALAND, NAMIBIA

The seven domed huts that comprise the communal area of Mowani Mountain Camp form a seamless and integral part of this textural, boulder-strewn landscape.

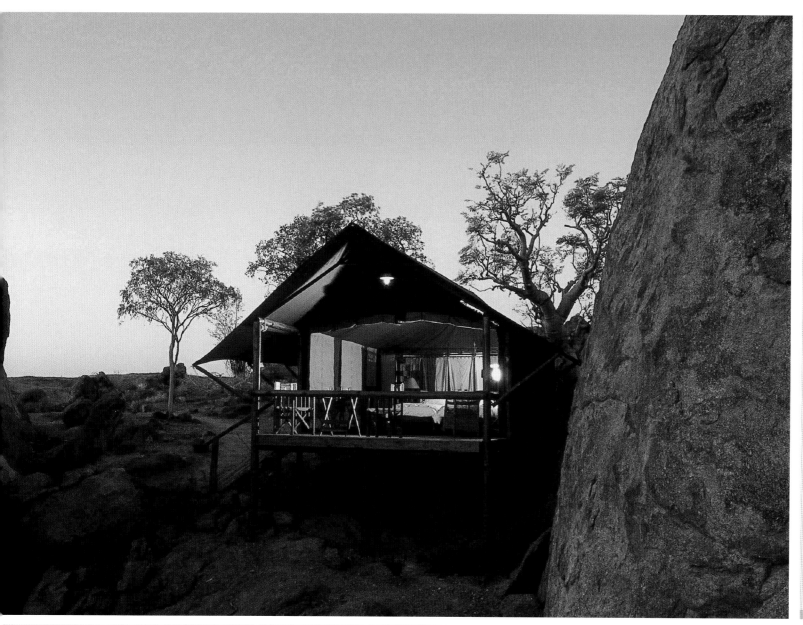

Each tented hut nestles between massive rocks and has a private veranda that offers striking views of the surrounding landscape. The tents rest on stilted supports, which vastly reduces their effect on the local habitat.

André Louw's Mowani Mountain Camp, an astonishingly sculptural poem to the African landscape of Damaraland, represents the culmination of a journey of self-discovery. Disenchanted with his career as a financial advisor, he followed his dream of building ecohotels in his beloved homeland of Namibia.

André's approach to sustainable tourism ventures is a hands-on, family affair. His first creation, overlooking the Auas Mountains, features the decorating skills of his wife

and family. The success of this project led to another, which in turn saw André search out a site for a new type of retreat; one that would, he hoped, resemble a traditional African village.

The site he chose lies in Damaraland, in the Twyfelfontein Conservancy. A place of tranquillity and statuesque beauty, this desert landscape is scattered with monumental boulders. The new camp, Mowani, from the Swahili word M'wane meaning "Place of God," was designed with the help of architect Klaus Brandt. It seems to grow

out of, and blend into this undulating landscape. Klaus confirms, "The design of Mowani set out to develop a vernacular and unobtrusive relationship with the surrounding semidesert environment of Damaraland, and creates the impression of a hidden African village."

The camp's communal area consists of seven huts with thatched dome roofs that echo the curves of the surrounding boulders, and 12 luxury tents that house guests. Staying true to his philosophy of ecotourism, André specified that

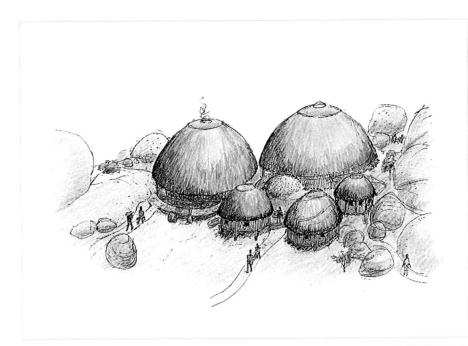

CONTACT: MOWANI MOUNTAIN CAMP, P.O. BOX 40788, WINDHOEK, NAMIBIA, T: +264 (0)61 232 009, MOWANI@VISIONSOFAFRICA.COM.NA WWW.MOWANI.COM

Working sketch of the communal areas, by Klaus Brandt.

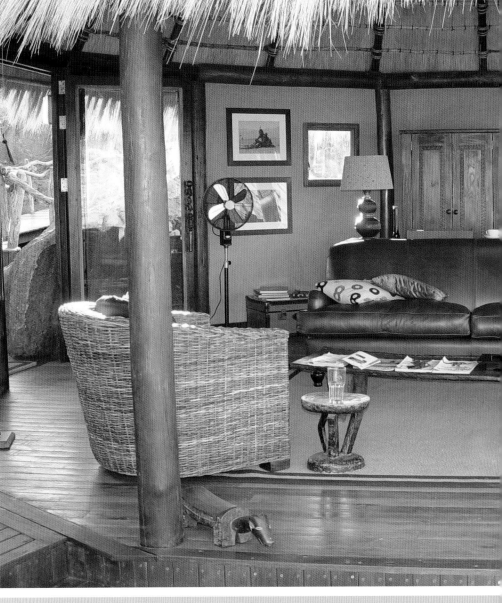

local materials, particularly those "retrieved" from the landscape, should be used where possible. The thatched and tented huts thus use dead tree trunks, stones, and sand from the local area in their construction—gum poles, thatch, saligna timber decks, and cement had to be imported from South Africa. André utilized the skills of local people for building the camp. They employed traditional construction methods—including stick cladding, handfinished plaster, and troweled cement floors—to add to the camp's atmosphere of authentic ethnicity. While much of the design was carried out on the drawing board after careful study of the site, Klaus reveals that "most of the detailing, finishing, and interior decorating was done by André and his construction assistant on-site during the building process, an approach that contributed to the harmony and intimacy between the man-made and Nature that makes Mowani so special."

The doors of this suite feature carved Zimbabwean wooden handles.

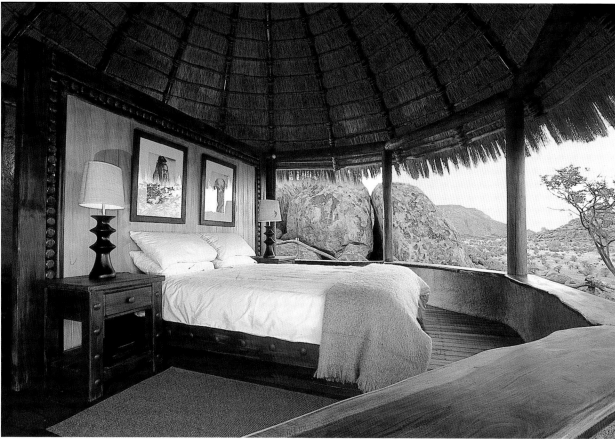

The bedroom in this thatched suite affords open views of the desert. In addition to an en-suite bathroom, it has a bush bath and shower that are open to the elements.

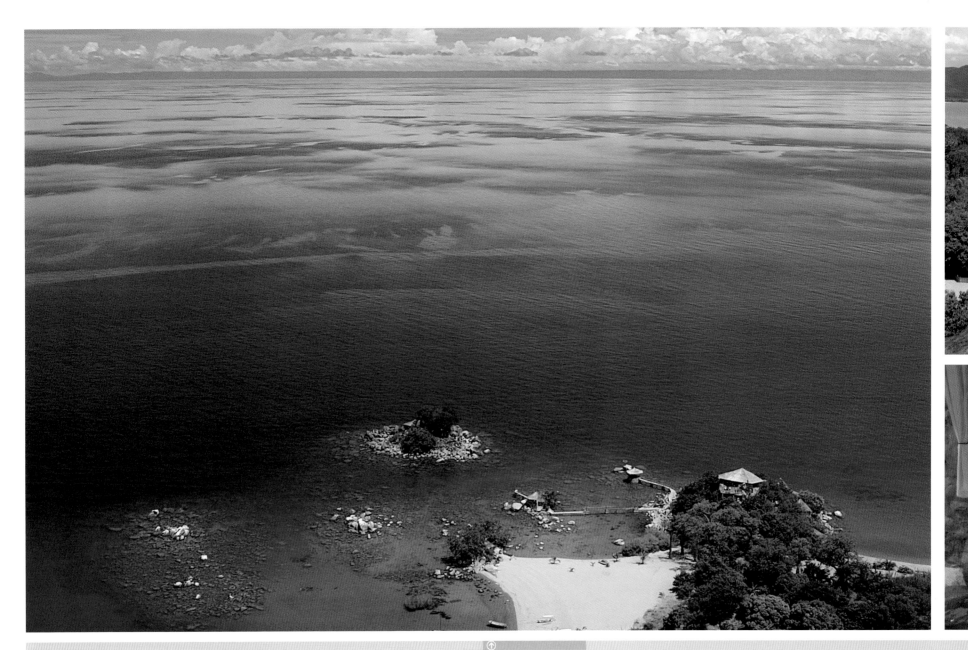

KAYA MAWA
LIKOMA ISLAND, MALAWI

The lodge blends so well into the natural landscape that passersby—on boats only, as the lodge is so remote—catch only glimpses of the buildings.

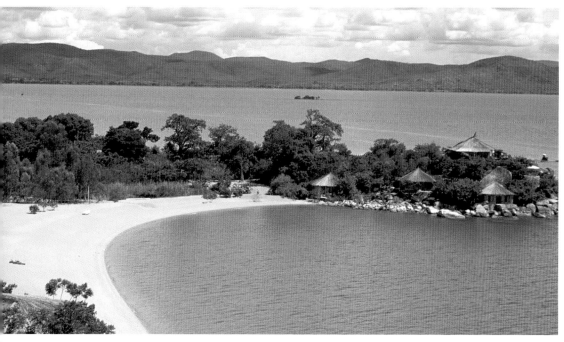

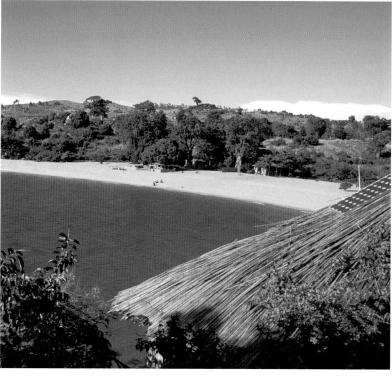

The cottages of Kaya Mawa are set on a crescent-shaped beach. All have panoramic views over the lake, and the mountains of Mozambique 4 miles (c. 6.5km) to the east.

All cottages incorporate solar panels—ranging from 70–120 watts—in their thatched roofs.

Local rock and candle lighting provide a sense of comfort and luxury.

The lush vegetation and quiet bays of Likoma.

English ecomavericks Andrew Came and Will Sutton were the first people to develop land on the remote Likoma Island, in Lake Malawi, for the purposes of tourism. They were invited by the village headman himself to build the island's only hotel. Both Andrew and Will had seen firsthand what tourism had done to similar small-island communities, so from the start they set out to benefit the community in every way they could. "I think the success of the hotel is partly due to the fact that we agreed that if the village would

have the faith to sell their land to us, we would return that trust by making it a community project, in that they would all be involved in the construction and running of the lodge," they say.

The pair designed the lodge without help from architects, taking inspiration from Malawian materials to achieve a look that they describe as "thatch and hardwood meets English country cottage." They designed seven dwellings, all made from local rock, and an additional, secluded cottage for honeymooners. This sits on a tiny

island just off the coast, and a private boat is provided for guests to reach it. The resort has minimal visual impact on its environment, with the cottages tucked discreetly into their surroundings. Andrew adds, "We wanted the cottages to blend in with the natural rock and let nature take center stage, so that in five years' time, people passing the lodge by boat would only catch glimpses of the buildings."

Although advised by the government to bring in labor from outside to assist with the

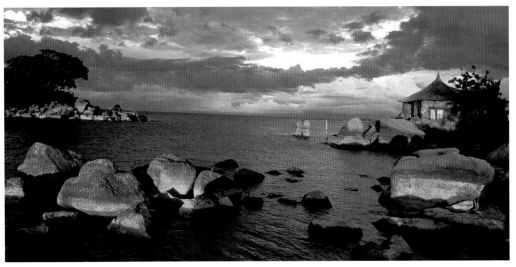

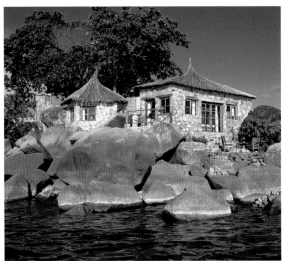

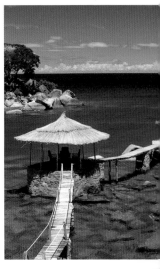

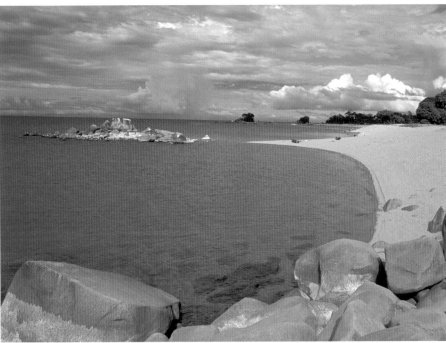

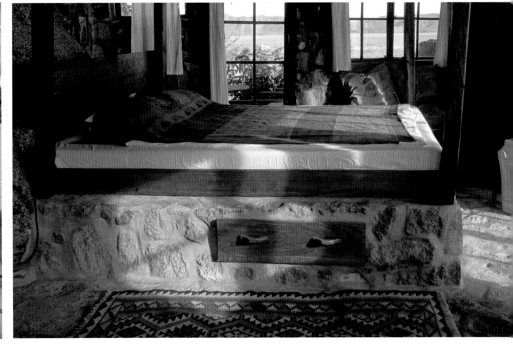

The walls of the honeymoon cottage, glowing in the evening sun, blend with the surrounding boulders. No power tools were used in its construction.

The guests' beach at Kaya Mawa is also used by nearby villagers for washing and fishing.

The honeymoon bed is a 7 x 8ft (2.1 x 2.5m) four-poster made from sustainable mahogany, and enjoys a 200° view of the lake.

The honeymoon cottage blends into the surrounding rocks; the entire back wall of the building is made from one huge slab of granite.

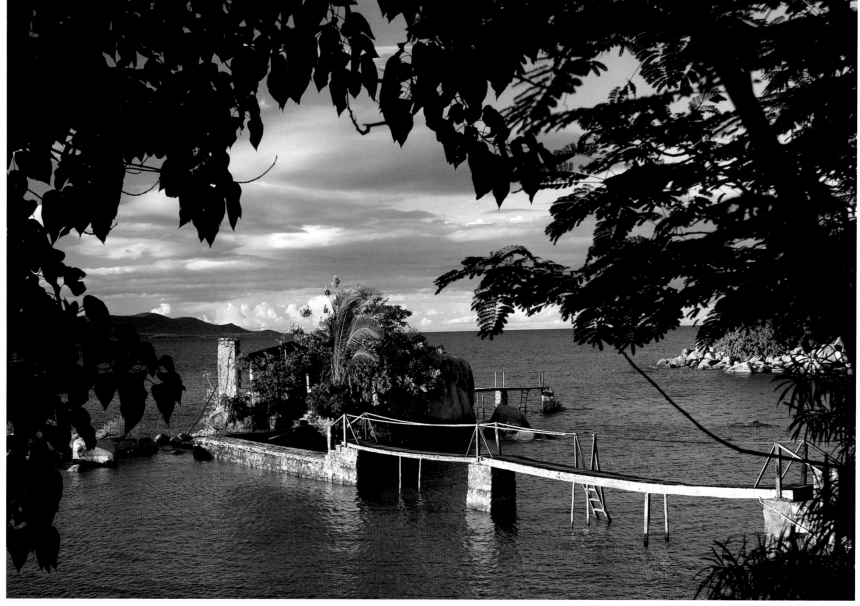

construction, Andrew and Will employed only locals. They built the lodge entirely by hand, without any power tools—without even a cement mixer. It wasn't easy, with a visit to the nearest hardware store requiring a four-day round trip. Most of the timber used for the cottages was cut from sustainable sources in a local forest, and carried back to the site—nearly 4 miles (6.5km) away—on the workers' heads. All the doorframes, windowframes, lintels, and furniture were made on site by village craftsmen, using this timber.

Because the lodge is so remote, it has to be completely self-sufficient. Will and Andrew have made Kaya Mawa the only renewable energy lodge in all of Malawi, with a total of 45 solar panels and three 500-watt windmills to power the resort.

Water is pumped from Lake Malawi by a clever panel-to-pump system, with a control box that alters the voltage according to the sun's strength. Two tanks hold 350 and 706ft^3 (10,000 and 20,000 liters) of water, respectively. An additional tap that runs into the village provides their neighbors with free, clean water.

Raised walkways provide easy access to the various small huts and lodges out in the bays.

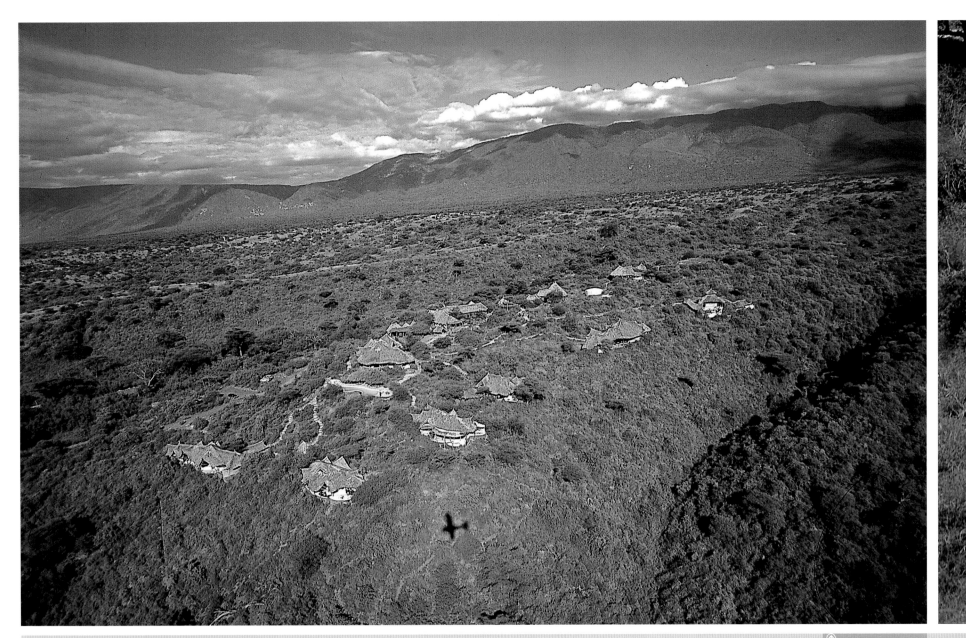

SHOMPOLE
GREAT RIFT VALLEY, KENYA

The Shompole Group Ranch, home to Shompole Lodge, lies at 2,500ft (757m) above sea level. The eight tented dwellings and main lodge blend seamlessly into the landscape.
[Photo: David Coulson]

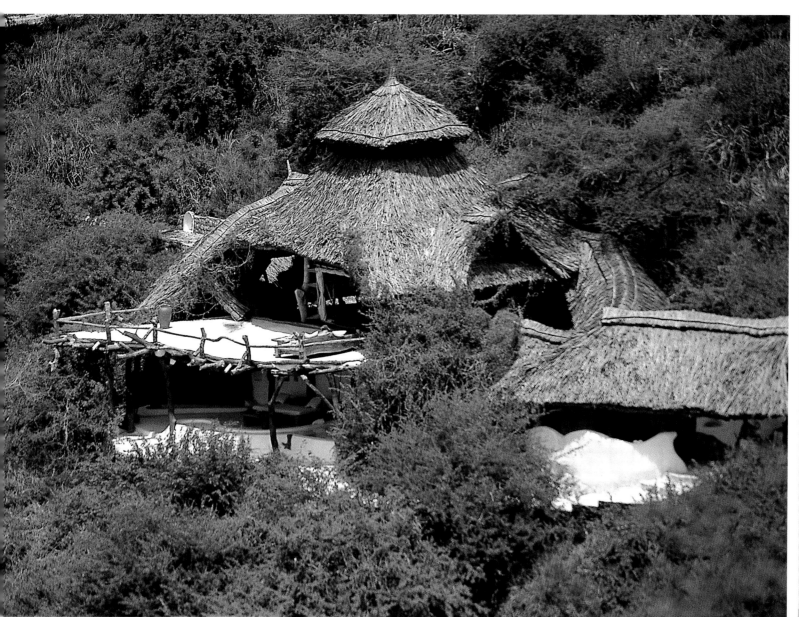

CONTACT: SHOMPOLE,
ART OF VENTURES, P.O. BOX 10665,
NAIROBI 00100, KENYA
T: +254 (020) 600457,
INFO@BUSH-AND-BEYOND.COM
WWW.SHOMPOLE.COM

Each "tented room" is designed to meld with the outside, with the traditional barriers of doors, windows, and walls replaced by a light timber frame open to the elements. The thatch for the molded roofs came from bulrushes gathered from nearby swamps. [Photo: David Coulson]

Shompole, which means "the place of the red ocher," is the name given by the Maasai people to the 5,100ft (1,550m) mountain that dominates the landscape of the Kenyan/Tanzanian border. It also gives its name to an ecologically designed and operated lodge set in this 35,000-acre (14,000-hectare) conservation area. Staggeringly simple in its beauty, the lodge at Shompole in southern Kenya is a glowing example of successful partnership between the followers of sustainable tourism and the indigenous population. The land is owned by 1,404 registered members of the Shompole Group Ranch—mostly traditional herders and pastoralists. The lodge itself is owned jointly by a private safari company, Art of Ventures, and the members of the Maasai community of the Shompole Group Ranch. Art of Ventures manage and market the retreat, while the Maasai are fully involved in all decision-making, and comprise the majority of lodge staff and rangers on-site.

The Maasai were integral to the design and building process; between 100 and 200 members of the Group Ranch were consistently employed at this stage, and paid at US $70 per month, instead of the usual local rate of US $2 per month. The striking design is based on ecofriendly ideologies and inspired entirely by the landscape and its natural materials. Positioned on one side of the Nguruman escarpment to make the most of the amazing

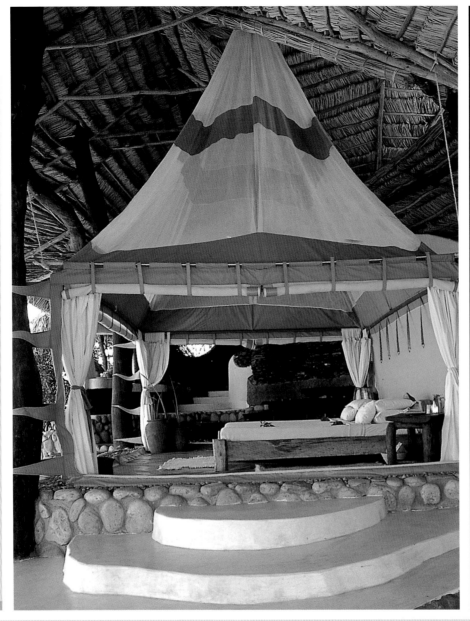

The bedrooms at Shompole are both luxurious and understated; they allow guests to feel close to nature, yet protected by the generous nets which shroud the bed at night. Each room features an en-suite bathroom, a lounge, and a private "cool-pool." [Photo: Simon Cox]

view and the cool breeze, the lodge is constructed from local materials—it uses everything from dead wood to river rock.

The open-plan design of the lodge encourages the blending of man-made construction with the more unpredictable structures of nature, so the traditional "barriers" of walls and windows are mostly shunned in favor of open spaces. The few walls that are present are made from burlap (hessian) and chicken wire, which is then plastered with different cement pigments to achieve a variety of colors. The thatched roofs feature ventilation to increase airflow when the temperature rises.

As well as the construction using ecofriendly materials, the lodge's operations also take into consideration the fragility of the environment and the remoteness of its location. Solar energy provides 80 percent of the electricity, and the Group Ranch is hoping to invest further in renewable energy to bring this figure to 100 percent. Water comes from a natural spring near the lodge, and the drains from the lodge's washing areas have a grease trap that separates the grease from the water to prevent the ground from becoming contaminated when the water is released back into the environment. Conservation is of utmost importance to the lodge and it has acted on this in several ways, including establishing an indigenous tree nursery as a means of providing a sustainable resource for wood fuel and livestock fodder for the Maasai.

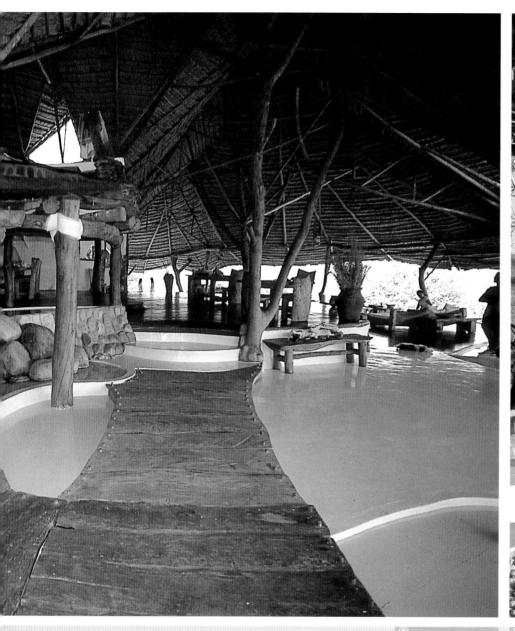

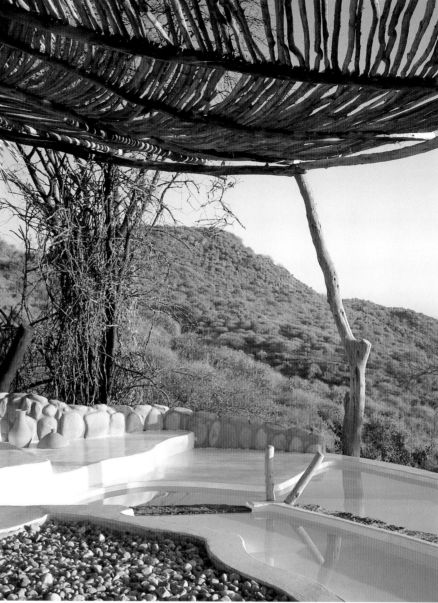

This wide open space in the main lodge reveals the organic nature of the architecture, with an abundance of locally sourced timber and whitewashed walls. The wood framing on the roof came from the cordia bush, which grows abundantly on the ranch. [Photo: David Coulson]

This "cool-pool" is a skillful extension of the flowing, organic style of architecture of the guest tents, and affords magnificent views over the Rift Valley. [Photo: Simon Cox]

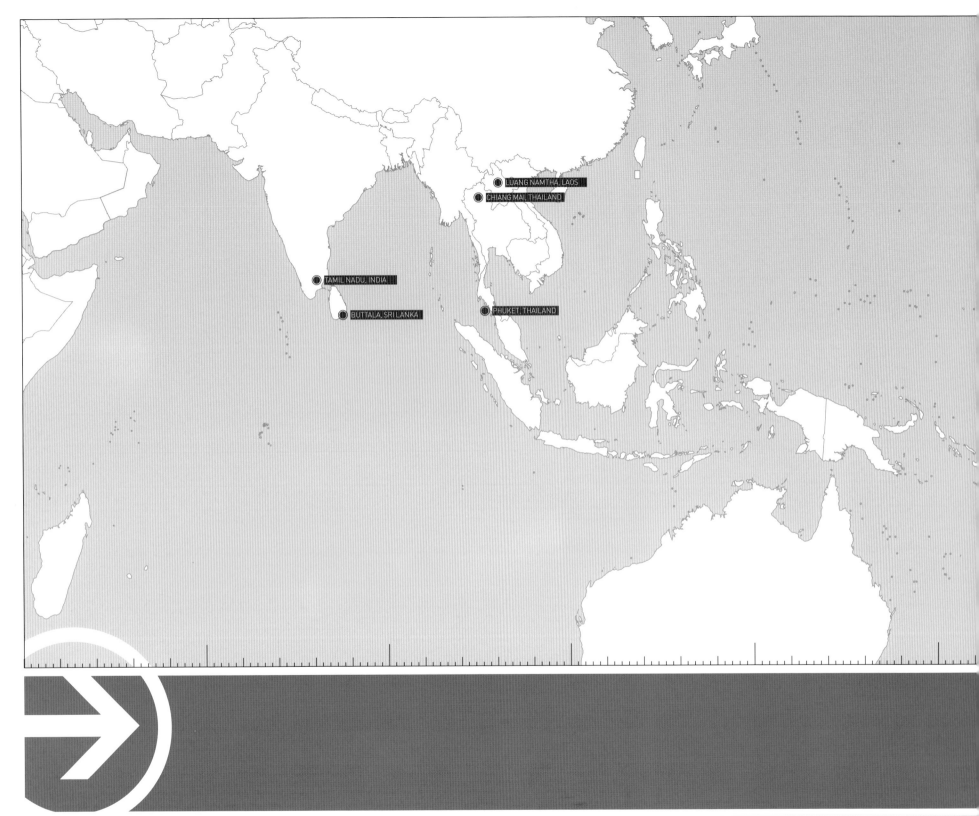

LUANG NAMTHA, LAOS
CHIANG MAI, THAILAND
TAMIL NADU, INDIA
BUTTALA, SRI LANKA
PHUKET, THAILAND

INDIA
TAMIL NADU

LAOS
LUANG NAMTHA

SRI LANKA
BUTTALA

THAILAND
CHIANG MAI
PHUKET

ASIA

Simple shelters, some with roofs of thatched indigenous grass, provide shaded areas from which to observe local wildlife.

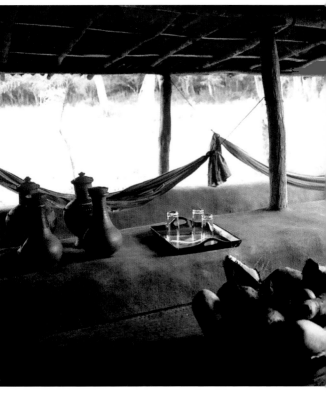

TREE TOPS JUNGLE LODGE
BUTTALA, SRI LANKA

CONTACT: TREE TOPS JUNGLE LODGE, WELIARA ROAD, ILLUKPITIYA, BUTTALA, SRI LANKA, T: +94 (0)777 036554, TREETOPSJUNGLELODGE@HOTMAIL.COM WWW.TREETOPSJUNGLELODGE.COM

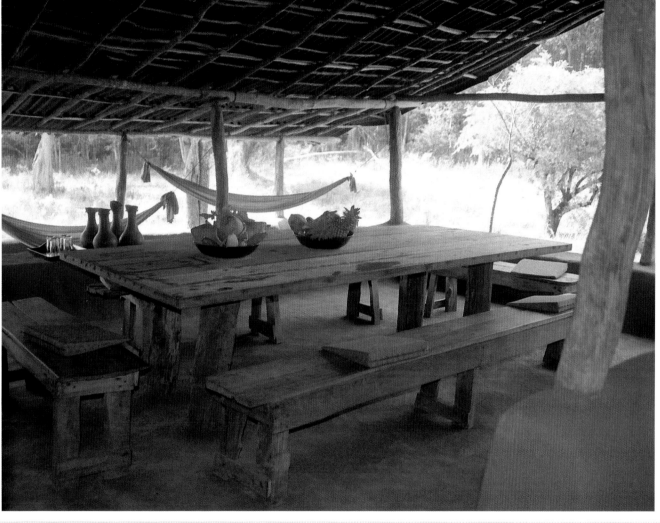

The main lodge house, where guests relax and enjoy meals. With no electricity, cooking is done over a wood fire.

The secret of Tree Tops Jungle Lodge's success is its unpretentious simplicity. With no electricity, baths taken in a local well, and meals cooked over a wood fire, a visit to the lodge is all about getting back to basics and in tune with the environment.

Owner Lars Sorensen built the lodge as a private retreat, only later taking paying guests, when he became attuned to the way of life in this part of southeast Sri Lanka. Situated in the middle of elephant country in the Weliara forest,

between the Yala National Park and the Arahat Kanda mountains, Lars dipped his toe into the waters of sustainable tourism with single-minded determination to fulfil a goal. "Our primary aim was, and still is, to create new jobs as an alternative to hunting and illegal logging, and in this way protect the forest, which is the wild elephants' natural habitat," he confirms. The camp is located beside a main elephant track, and also on paths previously used by hunters and

loggers. Lars continues, "We try to function as an added obstacle to those people who are destroying the environment, while at the same time generating alternative means of income by employing local staff."

The lodge offers basic accommodation—guests have the choice of sleeping in a clay hut on the ground, or in a wooden hut perched in a tree. Lars designed the huts himself. Inspired by the indigenous architecture, and drawing on the

The tree hut stands 26ft (8m) above ground. It is inspired by traditional Sri Lankan "chena" tree huts, from which farmers used to watch their plots safe from wild animals.

The hut is constructed from fallen trees found in the forest. These are plastered with a thick layer of clay dug from the land. Walls and floors are finished with a mix of clay and cow dung which prevents insects from finding a place to live within them.

ancient construction skills of local workers, he rejected the use of concrete, as a practical material that would withstand the power of an angered elephant, and decided to build the huts using traditional clay and wood. To this day, he has never regretted this decision. "The elephants are fully aware of our presence, but because of the natural materials used for building, we appear to be a part of the landscape to them. I'm convinced elephants connect the smell of cement and concrete with humans—and they usually connect humans with trouble." Lars believes that to keep nature in focus, only the most essential comforts are needed. You won't find fluffy white towels or a minibar at the Tree Tops Jungle Lodge, and the experience is all the more rewarding for that. Lars concludes, "For me personally, the conventional tourism-industry ideal of 'luxury,' the more stars the better, is meaningless. In a five-star hotel, you just find all the material things that most people already have at home."

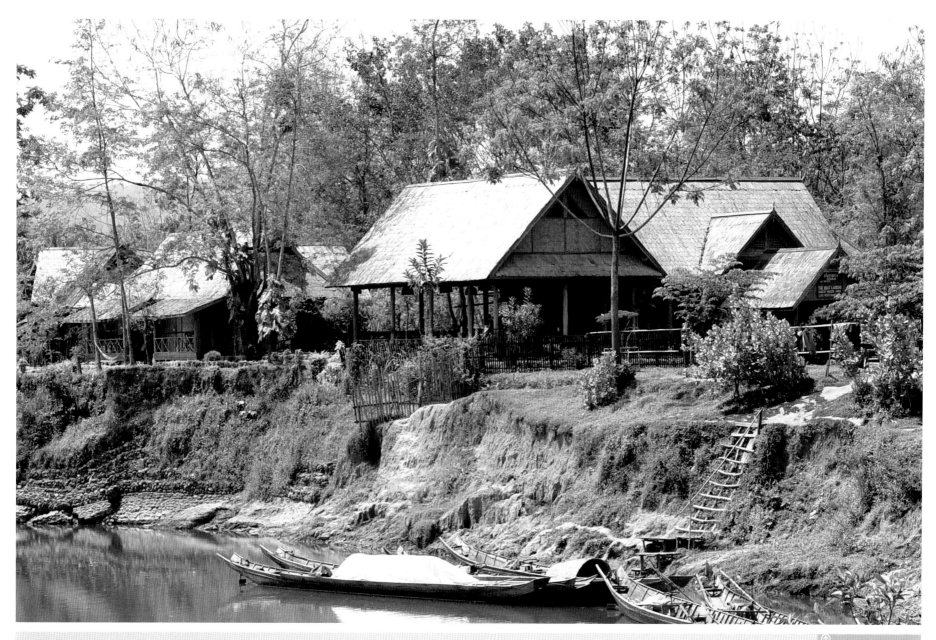

THE BOAT LANDING GUEST HOUSE AND RESTAURANT

LUANG NAMTHA, LAOS

The bungalows are built in the local style, and use the traditional materials, wood and bamboo.
[Photo: William Tuffin]

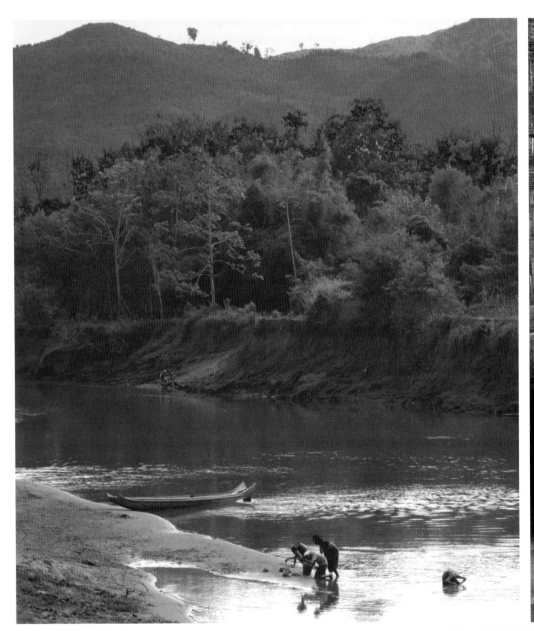

The up-river view from one of the bungalows. [Photo: Peter Whittlesey (rights owned by William Tuffin)]

Up until the mid-1990s, Laos' Luang Namtha province was a no-go area for travelers, cut off from the rest of the world because of political unrest. Among the first batch of western development workers to venture there was American Bill Tuffin, who established a primary health-care project. His experiences made him realize that here was an area unknown to backpackers on the Southeast Asia travel circuit, yet which had so much to offer. It led him to set up

The walls of the double bedrooms are made from woven bamboo following the local tradition.
[Photo: William Tuffin]

Bathrooms have a western design influence, but use local timber and bamboo.
[Photo: William Tuffin]

CONTACT: THE BOAT LANDING GUEST HOUSE AND RESTAURANT, P.O. BOX 28, BAN KONE, LUANG NAMTHA, LAOS, T: +593 (0)856 86 312 398 THEBOATLANDING@YAHOO.COM WWW.THEBOATLANDING.LAOPDR.COM

the area's first ecolodge, without fully realizing at the time that this was what he was creating. "We started out with the idea to build a lodge using local-style architecture and the traditional building materials of wood and bamboo. Many of the 'eco' features were actually very practical measures that we needed to take," Bill says. "For example, the lodge wasn't on the power grid, and depended on a generator. As we grew, it became apparent that we either needed to get a bigger generator or use less power, so we switched to energy-saving lamps, and turned the generator off at 10.30 p.m. Mornings here are often foggy or overcast, and we had trouble drying clothes for our guests, so we built a passive solar room. So you could say that our eco efforts have risen from a practical need, not to jump on an eco bandwagon."

The growth of the lodge has been as steady and organic as the development of ecotourism in the area. The first two rooms and the restaurant opened in 1999, with the final two bungalows finished in November 2003, bringing the accommodation to a total of 10 rooms. The intention was never to attract tourists in their hundreds. Limiting the number of people staying at the lodge leads to a more rewarding experience for tourists, with a less invasive impact on the locals. The bungalows were built using materials gathered by hand from the local forest, and village carpenters made all the furniture.

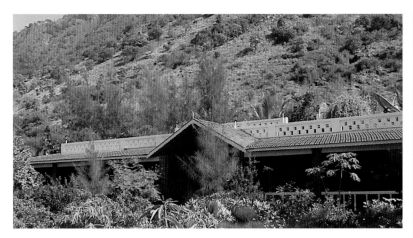

The single-story design of Cardamom House allows it to blend into its lush hillside surroundings.

The view of Cardamom House from the southeast. The lodge uses bricks made in local kilns.

The view from Summit House, a few feet up the hill from the main house, which offers a two-bedroom suite. The area offers fantastic hiking and birdwatching opportunities.

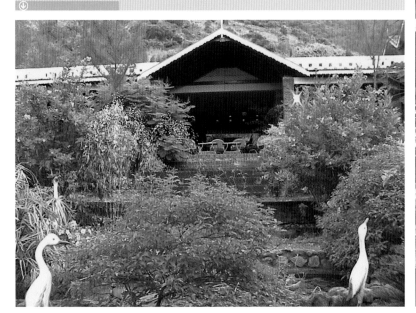

South of the bedrooms, a veranda runs the full length of the building, providing much-needed shade during the day, and moderating the temperature indoors.

CONTACT: CARDAMOM HOUSE, ATHOOR VILLAGE, DINDIGUL DISTRICT 624 701, TAMIL NADU, INDIA, T: +91 (0)451 2556765 CARDAMOMHOUSE@YAHOO.COM WWW.CARDAMOMHOUSE.COM

CARDAMOM HOUSE
TAMIL NADU, INDIA

After spending many holidays in India, Chris Lucas bought land close to the village of Athoor in Tamil Nadu, and set about designing a small complex on a south-facing hill. Without any architectural training, he drew up plans for the dwellings, and had them checked over and amended by an engineer. Planned to house just friends and family, after a couple of years of incredible feedback and encouragement, Chris opened up to paying guests.

Cardamom House is constructed using bricks made in nearby family-run kilns, while the sand used for building was taken from the lake at the bottom of the garden. The bare floors are sprayed with water every day to cool the whole area. Five solar water collectors on the roof provide plentiful hot water. During the rainy season, any surplus water is piped back into a dry bore well to replenish the deep groundwater table.

Chris laughs, "Our ecofriendly credentials were not planned— they simply happened! But it has been so rewarding to realize what nature has to offer, in particular, the sun."

Lisu Lodge comprises four bungalows all built using traditional skills and sustainable, local materials—thatched roofs, wooden frames, and walls of woven bamboo.

The Lisu Lodge patio, where guests can come to relax after a day's exploring. The lodge's structure is adapted from hilltribe design.

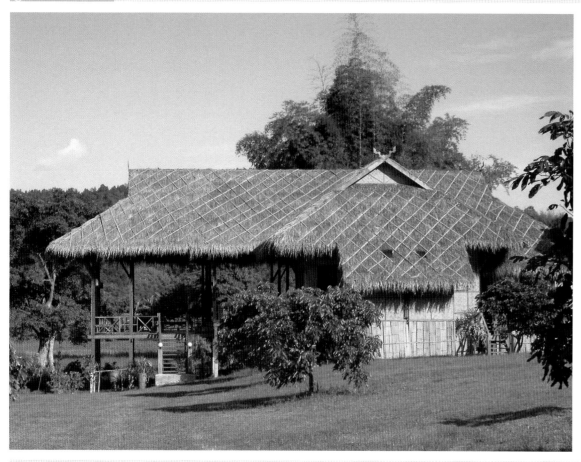

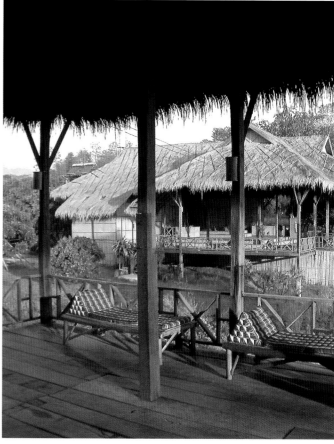

LISU LODGE
CHIANG MAI, THAILAND

Lisu Lodge, a small eco retreat 30 miles (50km) north of Chiang Mai, is the alternative face of tourism in backpacker-stuffed Thailand. It came into being because of one traveler's dissatisfaction with the tourist experience he had there, and his suspicions that profits made from tourists were being pocketed rather than invested in the indigenous host communities.

After his disappointing foray into this beautiful area of northern Thailand John Davies, the lodge's founder, decided to make traveling in the area a more rewarding experience for

The thatched veranda overlooks the mountains and the lamyai (longan) orchard. The construction and maintenance of the lodge helps to preserve ancient customs and skills.

Dinner is served on the veranda, either at Western-style tables with chairs, or at low, Thai-style khan toke tables with traditional Mon Kwan triangular padded cushions.

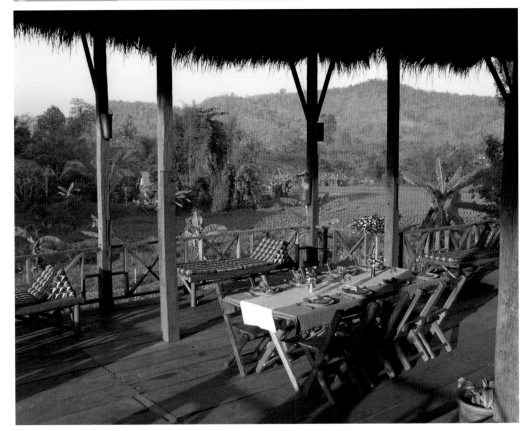

CONTACT: ASIAN OASIS, 15TH FLOOR, REGENT HOUSE, 183 RAJDAMRI ROAD, LUMPINI, BANGKOK 10330, THAILAND, T: +66 (0)2 651 9768, INFO@ASIAN-OASIS.COM, WWW.ASIAN-OASIS.COM

tourists and host communities alike—he started running itineraries to hilltribe villages. He comments, "Realizing that facilities had to be upgraded a little to be tolerable to Western guests, at first I distributed mattresses and other necessities to volunteer families in villages I knew well. This was awkward, since the guests felt like specimens on the wrong side of the zoo bars, so I built a small house in a village specifically for guests." John sought approval from the village's headman for this venture, which then took off with great enthusiasm from both villagers and tourists. The villagers helped to build the lodge and were all paid a generous market price. But John wanted to appeal to an even wider audience. He found a village in which to build a more mainstream lodge that would lay gently on the land and give back to the community more than it took. The lodge's staff is drawn entirely from the local Lisu village, and the lodge itself has boosted the economy of this ethnic minority community. At the same time, in John's opinion, it has increased the Lisu people's self-respect for its cultural history, and helps to promote and preserve ancient customs and skills that might otherwise fade.

John describes the design of the lodge as a very informal affair, commenting, "I remember the company wanting architects' drawings, but since this was simply an enlarged hilltribe house with a few add-on conveniences built largely by the village, there was no need. The aim was simply to give guests the experience of living with an ethnic minority community."

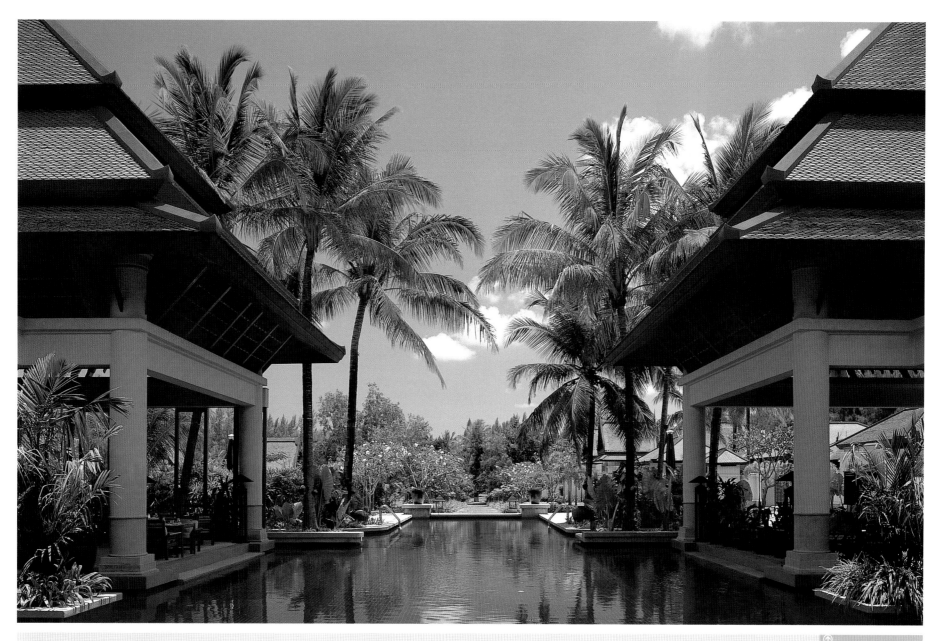

BANYAN TREE PHUKET
PHUKET, THAILAND

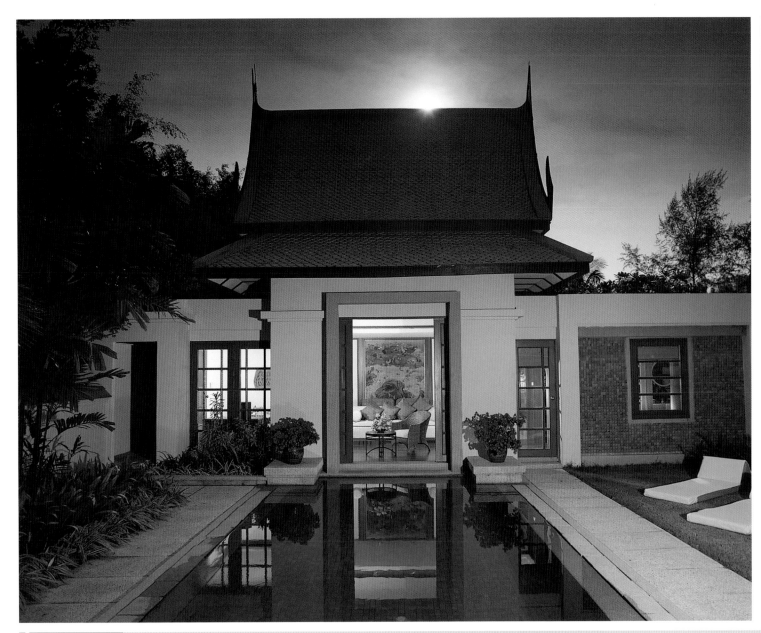

One of Banyan Tree Phuket's pool villas, this lodge, which has Bang Tao Bay as its backdrop, reveals the typically Thai-inspired architecture of the guest accommodation.

Banyan Tree Phuket, located at Bang Tao Bay on the northwestern coast of Phuket Island, was the first project in sustainable tourism from ecohotel company Banyan Tree Holdings. (See also Banyan Tree Bintan, page 148.) When the company was established, there was no other provider of luxury hotel accommodation that respected the environment and embraced local culture. It is dedicated to making business decisions based on the physical and human environment. In the words of the corporate mantra, "Only a healthy environment can sustain a healthy business."

Considering this, the choice of location for Banyan Tree Holdings' flagship resort was unconventional to say the least. The 1,000-acre (400-hectare) site in Laguna, Phuket, had been declared unfit for development by a 1977 United Nations' report. Contaminated with chemicals left over from decades of tin mining, it was deemed far from healthy. In order to create the "healthy environment" needed to give rise to the thriving business of their dreams, the company moved on to the island, bringing with them tons of fertile topsoil to return nutrients to the parched earth.

They converted acid-filled craters into safe, clean pools and stocked them with fish, tiger prawns, and crabs. Native trees, such as casuarinas and Asian palms, were planted in their thousands and now attract migratory birds and Siberian ducks.

For this invigorated environment they designed a development that includes 121 luxuriously appointed villas, all with private gardens and swimming pools or jacuzzis. Judged by normal standards, this could be seen as a large number of buildings for an ecoresort, but Banyan Tree Holdings have won several awards—including

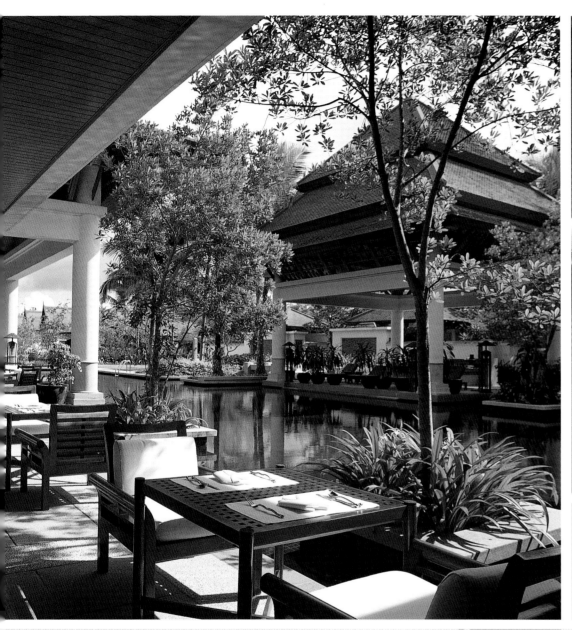

CONTACT: BANYAN TREE PHUKET, 33 MOO 4 SRISOONTHOM ROAD, CHERNGTALAY, AMPHUR TALANG, PHUKET 83110, THAILAND T: +66 (0)76 324 374, PHUKET@BANYANTREE.COM, WWW.BANYANTREE.COM

a Green Planet Award in 2001—for their ecologically sensitive resort, designed to sit in harmony with the landscape. The hotel's luxurious atmosphere is enhanced by the fact that it also boasts one of Asia's largest Oriental garden spas. This focuses on a blend of ancient healing and relaxation techniques combined with European rejuvenation therapies.

Native trees, such as casuarinas and Asian palms, were planted in their thousands and now attract migratory birds and Siberian ducks.

The hotel's luxurious atmosphere is enhanced by its locally inspired interior design.

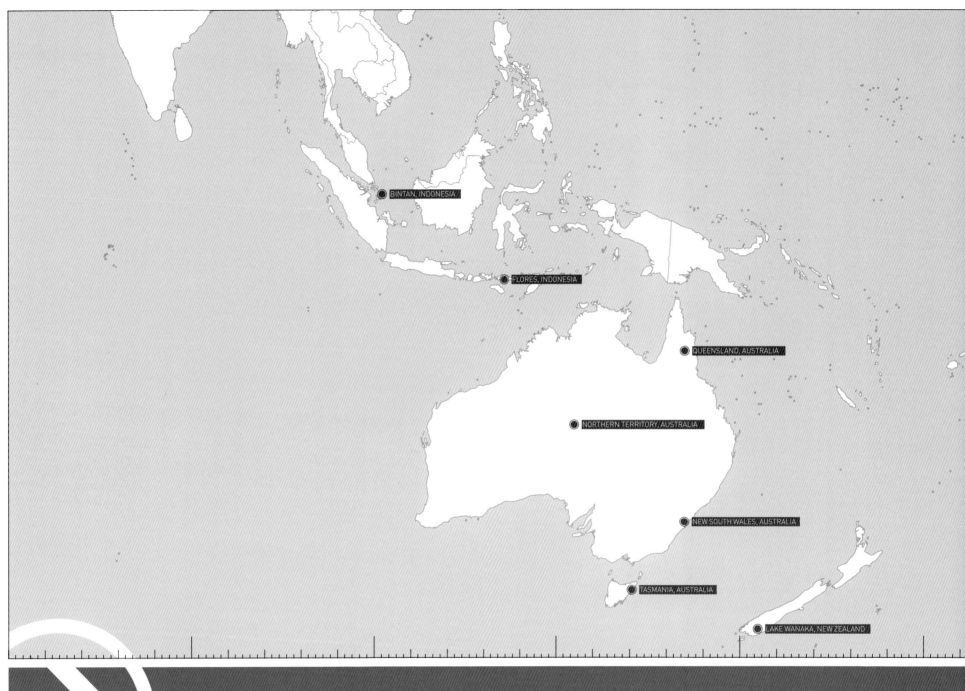

BINTAN, INDONESIA

FLORES, INDONESIA

QUEENSLAND, AUSTRALIA

NORTHERN TERRITORY, AUSTRALIA

NEW SOUTH WALES, AUSTRALIA

TASMANIA, AUSTRALIA

LAKE WANAKA, NEW ZEALAND

AUSTRALIA
NEW SOUTH WALES
NORTHERN TERRITORY
QUEENSLAND
TASMANIA

INDONESIA
BINTAN
FLORES

NEW ZEALAND
LAKE WANAKA

AUSTRALASIA

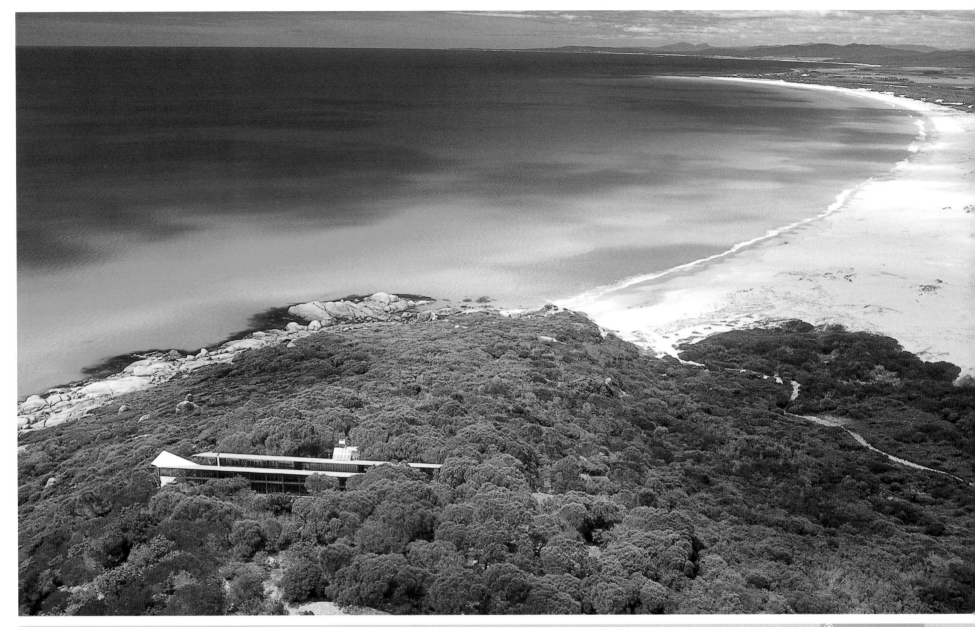

BAY OF FIRES LODGE
TASMANIA, AUSTRALIA

The long, parallel buildings that make up Bay of Fires Lodge sit on a wooded hilltop 130ft (40m) above the Tasman Sea with its rocky coastline and beautiful white beaches. Being remote from normal services, water, power, and waste management are dealt with on-site.

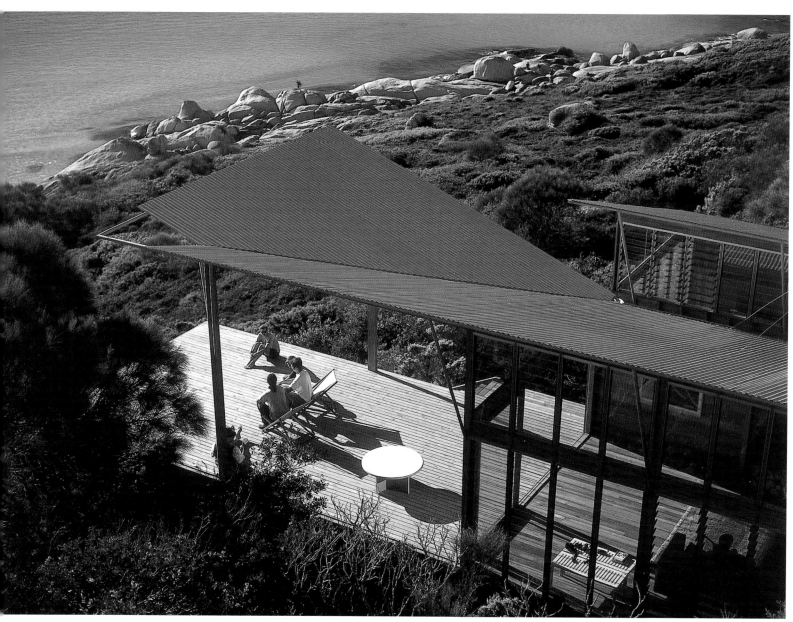

The northern "shed" of Bay of Fires Lodge opens out into a deck with spectacular sea views. On all other sides the building is shielded by casuarina trees and is barely visible.

CONTACT: BAY OF FIRES LODGE, P.O. BOX 1879, LAUNCESTON, TAS 7250, AUSTRALIA, T: +61 (0)3 6391 9339 BOOKINGS@CRADLEHUTS.COM.AU WWW.BAYOFFIRES.COM.AU

The location of Bay of Fires Lodge is of such cultural and ecological importance that it took a year of deliberation, analysis, and on-site inspections before the final site was decided upon. The lodge is set in an area next to the 34,600 acre (14,000 hectare) Mt. William National Park, by the north coast of the island, which is due to be returned to the Aboriginal people in the near future. The man who took up the challenge of slotting a retreat for walkers into this sensitive environment is Ken Latona, an architect and builder who is no stranger to creating buildings that lie gently on the land. Known for his small-scale ecotourism ventures in Tasmania, he has earned respect for the dwellings he has built to comfortably accommodate walkers who brave the island's wilderness areas. Bay of Fires Lodge, known affectionately, and somewhat humbly, as The Sheds, is testament to his pared-down style of architecture. Ken stresses, "A shed has great structural honesty. With no flourishes, no decorative elements, and no unnecessary details,

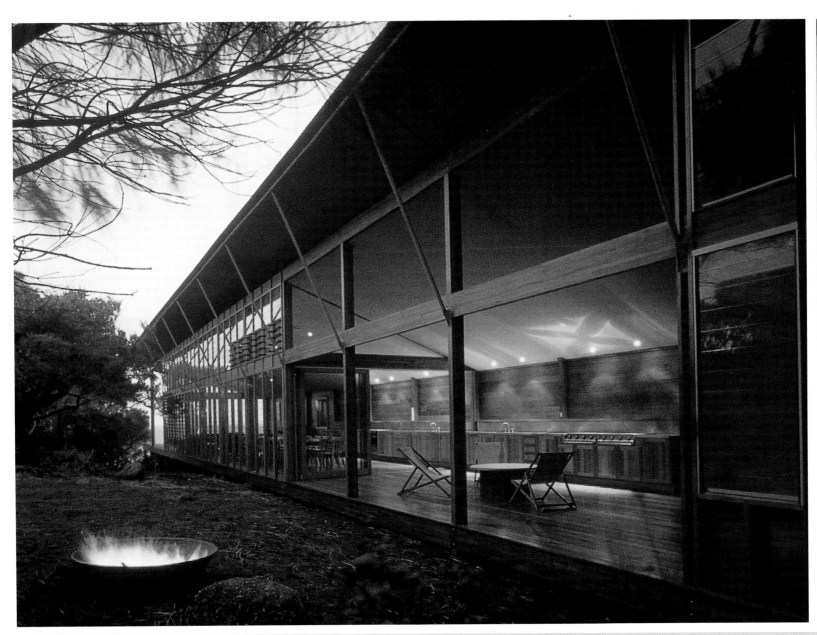

The glass-louvered northern building houses the kitchen and dining areas which, in the middle of the building, open out into a barbecue zone. The lodge is built from sustainable hardwood and plantation pine.

there's nowhere for the designer to hide." Despite such an unpretentious attitude to his work, the wood and glass of the lodge create a bold and challenging building that manages to dissolve into its surroundings and yet, on closer inspection, is hard to ignore. Shielded by native casuarina trees on all sides, except for a window facing the Tasman Sea, it is barely visible from a distance.

Built from sustainable materials—hardwood and plantation pine—the building comprises two parallel timber and glass-louvered "sheds" separated by an open, central walkway. The

southern "shed," which measures 89ft (27m) in length, contains bedrooms, bathrooms, and a louvered communal space, while the northern "shed" contains cooking, dining, and socializing areas, as well as staff bedrooms.

Because the site is remote from normal services, water, power, and waste management have to be dealt with on-site. Rainwater is collected on the roof, and measured amounts are then dispensed to guests for showers and handwashing in order to prevent wastage. Gray water from the kitchen is treated and then reused.

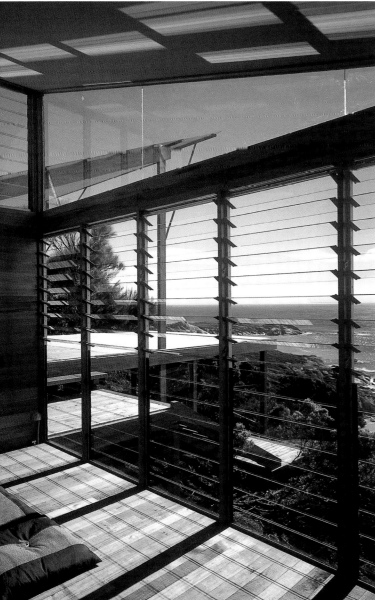

At the eastern end of the southern building lies the library. The louvered glass allows for both natural ventilation and illumination.

The open walkway, which is partially protected by the roof, lies between the north and south pavilions. From this, doors to the guest bedrooms lead off. The interior elevation is local, and sustainable, Tasmanian oak.

The plan for the Bay of Fires lodge buildings incorporates the siting of its solar panel stand. The solar system provides all the energy for the lodge.

An intermediate-sized solar system provides the energy. This was brought to the site by helicopter, as using overland vehicles would have damaged the unspoilt landscape.

Bay of Fires Lodge is low-impact tourism at its most chic. Offering stylish accommodation to a maximum of just 20 people, guests can use this inspirational creation as a pit stop as they walk across the island, exploring the flora, wildlife, and birdlife that proliferate in the national park.

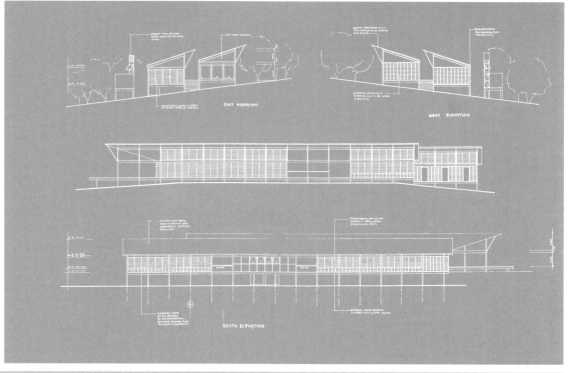

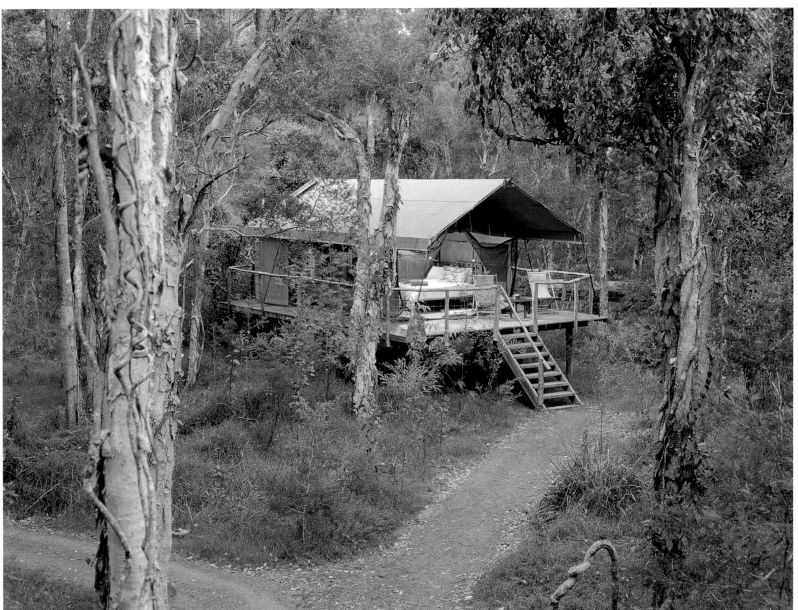

PAPERBARK CAMP
NEW SOUTH WALES, AUSTRALIA

Guest tents sit on a pole-and-platform structure 4ft (1.2m) above the ground, and feature wraparound balconies with private, open-air bathrooms so that visitors can take a shower and look out into the surrounding bush.

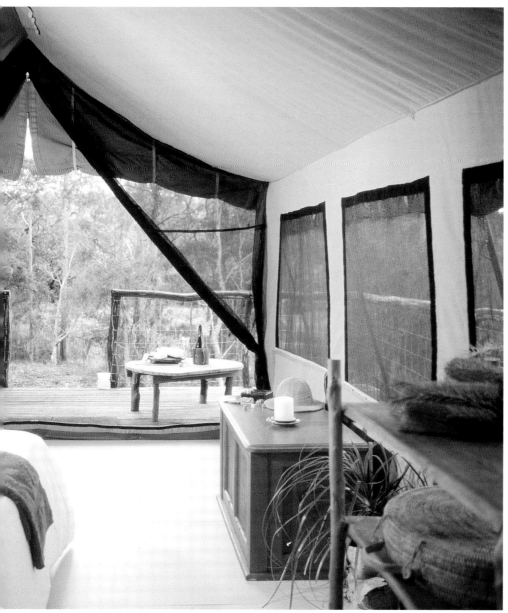

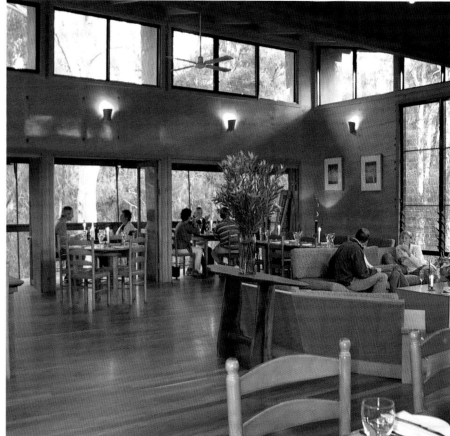

Paperbark Camp, a chic ecoretreat near Jervis Bay, 120 miles (200km) south of Sydney, is no overnight success story. Its owners, Irena and Jeremy Hutchings, spent 10 years formulating the ideas for their creation, finding the site, and turning their lives around in order to make it happen. Inspired by the permanent tented safari camps they visited while on vacation in Africa, the couple saw a niche in the Australian market for a similar model; they sold their family home, left the city, and started a new life in this relatively undeveloped, but spectacular coastal area of New South Wales. There was one site that they knew would be perfect for their vision of a tented camp. This was located on a waterway in a National Marine Park, and from the start they were dedicated to respecting this sensitive habitat.

After discovering from the local Aboriginal community that the site held no ancestral significance for them, they brought Nettleton Tribe Architects on board, and the team came up with an ecofriendly design for the camp.

The resort's 10 luxury safari tents are elevated on wooden platforms and set back from the waterway in order to have the least impact on the wetland habitat. The visual and social focus of the camp is the Gunyah (an Aboriginal word for meeting place or shelter), which is elevated between the treetops. This both protects the floor of the bush below and assists with cooling, which avoids the need for air-conditioning. Despite the Gunyah's size, no large trees were felled to make way for its presence: it was

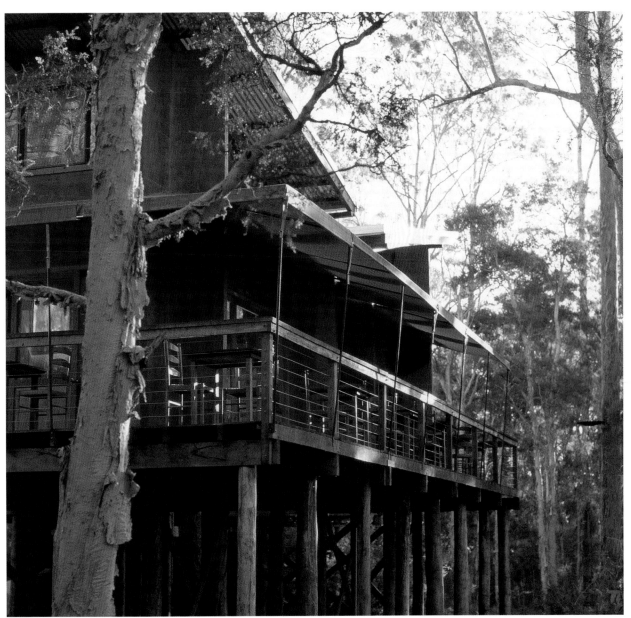

⬅

The camp's central meeting place, the Gunyah, is elevated 16ft (5m) above the ground. Despite its size, no large trees were felled to make way for its presence.

CONTACT: PAPERBARK CAMP, HUSKISSON, JERVIS BAY, NSW 2540, AUSTRALIA, T: +61 (0)2 4441 6066, INFO@PAPERBARKCAMP.COM.AU, WWW.PAPERBARKCAMP.COM.AU

deliberately placed in a natural clearing. The building's floor-to-ceiling glass louvers, together with the clear acrylic panels of the sliding doors along two sides of the main room, provide excellent natural lighting.

Every attempt is made to conserve the earth's natural resources: electricity in the guest tents is powered by solar panels that provide 12V lighting; all storm water is collected, stored, and reused; en-suite bathrooms in guest tents are equipped with water-minimizing shower heads to avoid wastage; and guests are asked to consider their water usage. Due to the delicate nature of the local wetlands, all wastewater is stored on-site before being pumped up to the roadside just under 1 mile (1km) away, from where it is taken away by truck.

Irena and Jeremy's long-term goal is to continue providing stylish, sustainable accommodation in this pristine environment, and for people to enjoy responsible access to the area for many years to come.

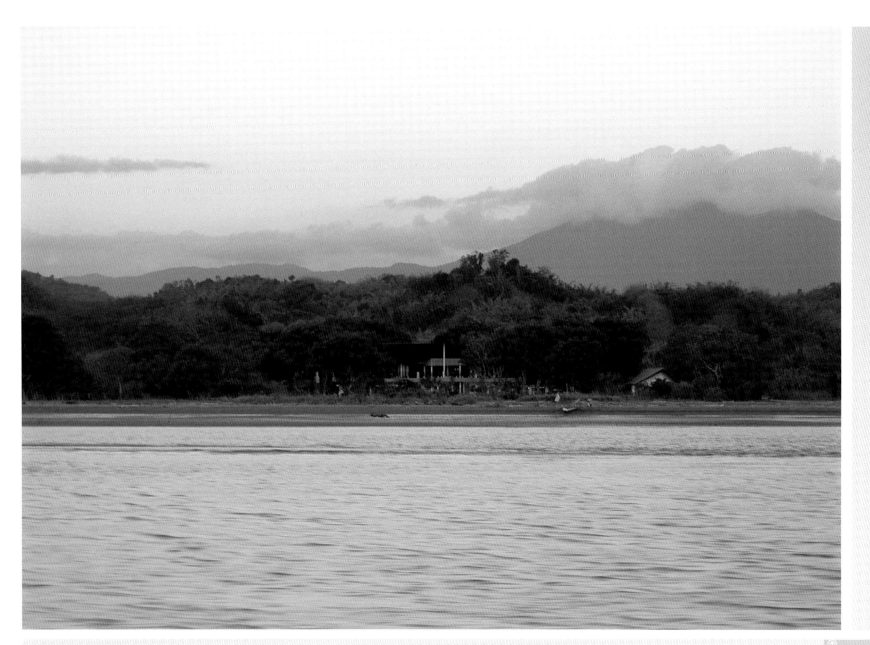

BAJO KOMODO ECO LODGE
FLORES, INDONESIA

Viewed from the sea, the lodge blends in with its surroundings.

Bajo Komodo Lodge is built from local materials; it uses coconut matting for the roof, and locally sourced timber throughout.

Bajo Komodo Lodge offers just six rooms. Meryl designed the lodge to incorporate as much open living space as possible, to cut down on the need for air-conditioning.

Flores, the third island east of Bali in the Indonesian area of Nusa Tenggara, is a peaceful backwater untouched by the political unrest that has dogged much of Indonesia in recent years. Overlooking the Komodo islands, famous for being the only known habitat of the Komodo Dragon, it is the perfect site for an ecolodge. Meryl and Alan Wilson, owners of Bajo Komodo Eco Lodge, saw its potential as a sustainable tourism venture after cutting their teeth as founders of INI RADEF (the Indonesia International Rural and Agriculture Development Foundation). Based at Udayana University in Bali, the founding aim of this private foundation was to use sustainable development to provide jobs for Indonesians. The Wilsons' increasing interest in sustainable tourism resulted in their first venture—an ecolodge in Bali. Alan adds, "We believe that small hotels can play a very large role in protecting the environment as they show that ordinary people can achieve great things."

Using the expertise gained from designing and running a successful, acclaimed ecolodge spurred them on to branch out into this smaller, lesser-known area of Indonesia. For their site on the beach, Meryl designed the lodge to incorporate as much open living space as possible, to cut down on the need for air-conditioning. Following the eco

A reed-bed and water sewerage system ensures that all waste water is returned to the gardens through irrigation.

CONTACT: JI. PANTAI PEDE KM, 3 GORONTALO-LABUAN BAJO FLORES, NUSA TENGGARA, TIMOR, INDONESIA, T: +62 (0)385 41391, LODGE@ECOLODGESINDONESIA.COM, WWW.ECOLODGESINDONESIA.COM

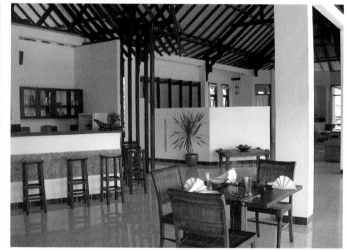

The lodge's restaurant features high ceilings and an open-plan design to maximize ventilation.

principles of their mother lodge in Bali, solar power is used to heat water, a rainwater storage system that holds up to 13,200gal (50,000l) provides all their water needs, and a reed-bed and water sewerage system ensures that all waste water is returned to the gardens through irrigation.

Although they are still honing the eco side of their operations on Flores, the lodge can lay claim to fulfilling several main tenets of ecotourism in that it: depends on the natural environment for business survival; is ecologically sustainable; is proven to contribute to conservation (it protects an area of over 12 acres [5 hectares]); features an environmental training program; and incorporates cultural considerations (it employs 100 percent local staff and adjusts to the main religions of the area, Christianity and Islam).

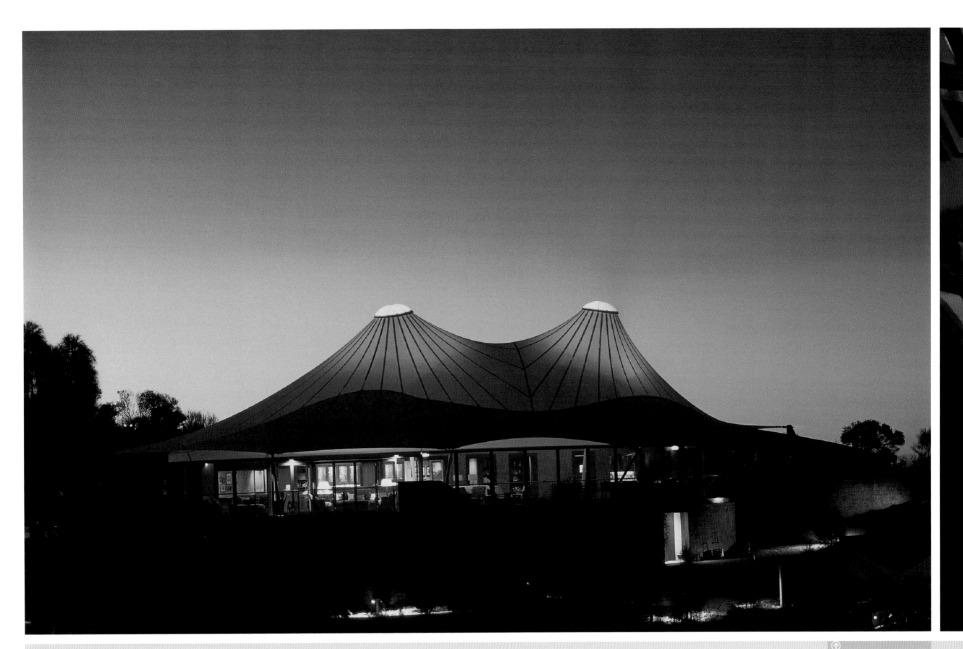

LONGITUDE 131°
NORTHERN TERRITORY, AUSTRALIA

Dune House, the main communal "tent," is built partially into the sand dune to maximize natural insulation and reduce energy needs. The areas of roof not covered by a sail structure contain large solar panels that heat water for the kitchens and swimming pool.

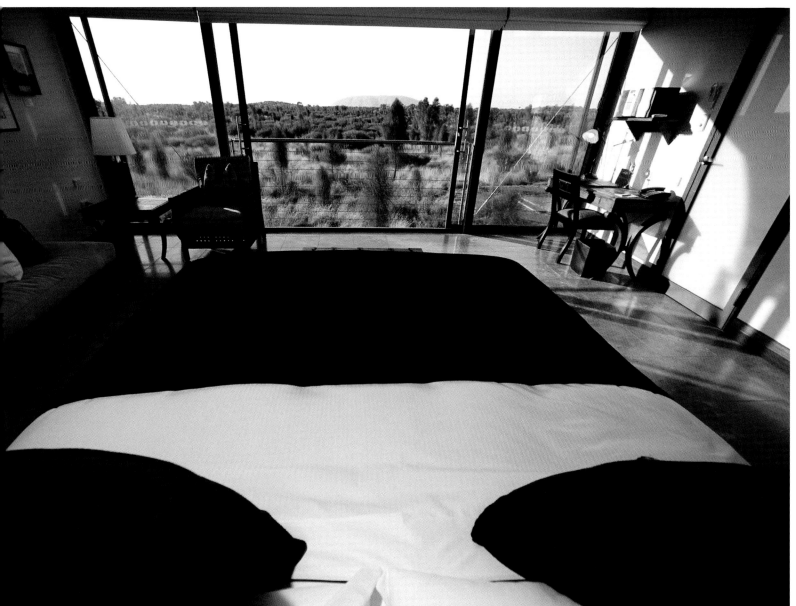

The end wall of each tent faces Uluru, and is fully glazed so that guests can admire an unadulterated view from their beds. The floors are insulated and covered with natural stone, which is cool in summer and warm in winter.

CONTACT: LONGITUDE 131°, VOYAGES, G.P.O. BOX 3589, SYDNEY, NSW 2001, AUSTRALIA, T: +61 (0)2 9339 1030, TRAVEL@VOYAGES.COM.AU WWW.LONGITUDE131.COM.AU

Australia's iconic monolith, Uluru, formerly known as Ayer's Rock, holds an irresistible fascination for visitors from around the globe—around 400,000 tourists visit each year to see the spectacle. The question is, how to provide accommodation nearby that doesn't tread heavily on the country's spiritual heartland? The owners of Longitude 131° have addressed the issue of siting a luxury hotel within sauntering distance of this hallowed rock, in 28,460yd^2 (23,800m^2) of privately owned land surrounded by traditional Aboriginal homelands and the Uluru-Kata Tjuta National Park. The project was agreed only after extensive discussion and consultation with the Central Land Council and the Aboriginal Areas Protection Authority, which confirmed there were no sacred sites in the proposed area.

Named for the number of degrees east of Greenwich, England, through which the prime meridian of 0° longitude runs, the resort lies just over 6miles (10km) from Uluru, and comprises one main "tent," Dune House, and 15 individual

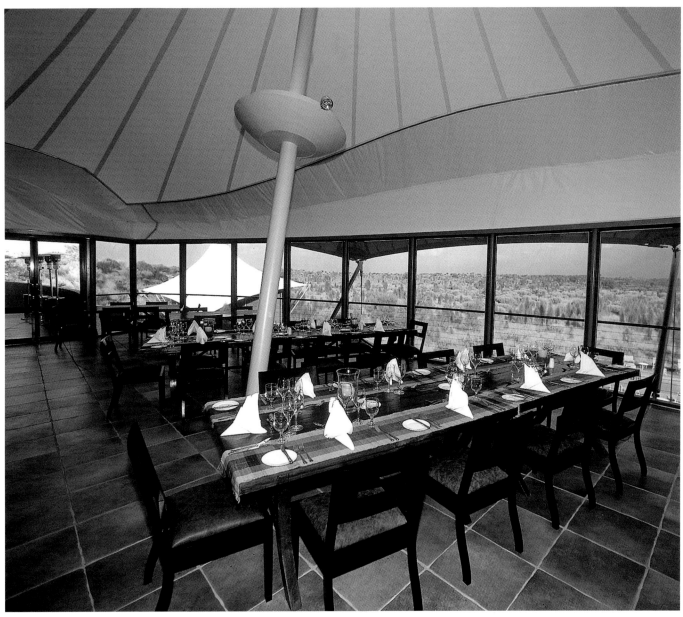

Diners in Dune House enjoy the spectacular panoramic views of the Uluṟu-Kata Tjuṯa National Park. The floor is insulated and covered with natural stone, which is cool in summer and warm in winter.

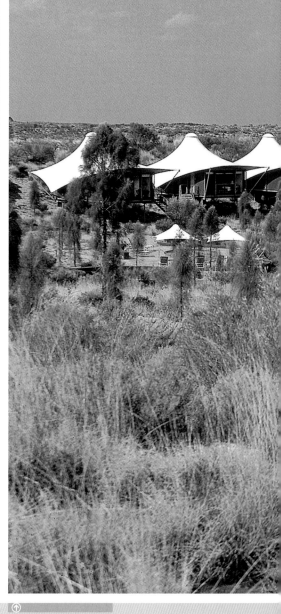

The white polyester roofs seem to grow out of the scrubland in a neatly arranged row. The tents consist of three layers of fabric, which enhances their thermal and acoustic insulation qualities.

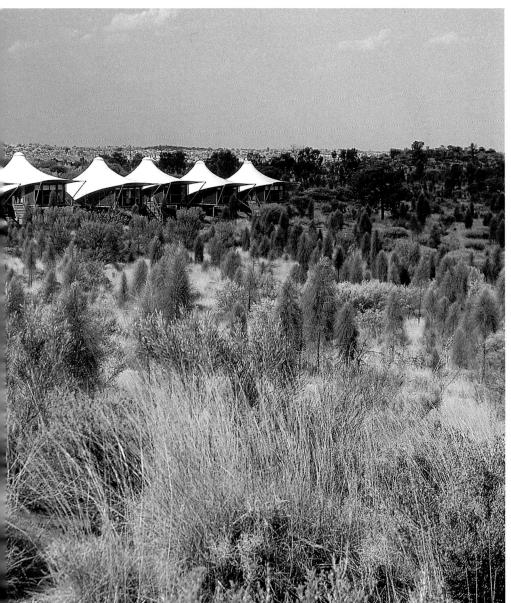

Each "tent" is named and themed after a famous Australian explorer, and the interior decoration has a safari/colonial feel. Wardrobe doors have an ironbark timber frame with mesh insert panels to reflect the food chests used in colonial Australia.

"tents" that provide guest accommodation. After a devastating bushfire in October 2003, the resort has been rebuilt to its original design and is once again open to visitors. To minimize disruption to the local flora and fauna (which have risen phoenix-like since the fire), limited roads and pathways were marked out as the only routes allowed for construction vehicles. When construction was complete, these paths were retained as the only access routes to the resort.

The owners were keen to avoid deliveries from heavy vehicles during construction, so the tents were all prefabricated and assembled, jigsaw-like, on site. Any sand that had to be removed was cleared by hand. The tents themselves appear to float above the sand dune. They consist of three layers of fabric, which enhances their thermal and acoustic insulation qualities, and the floors are insulated and covered with natural stone, which is cool in summer and warm in winter.

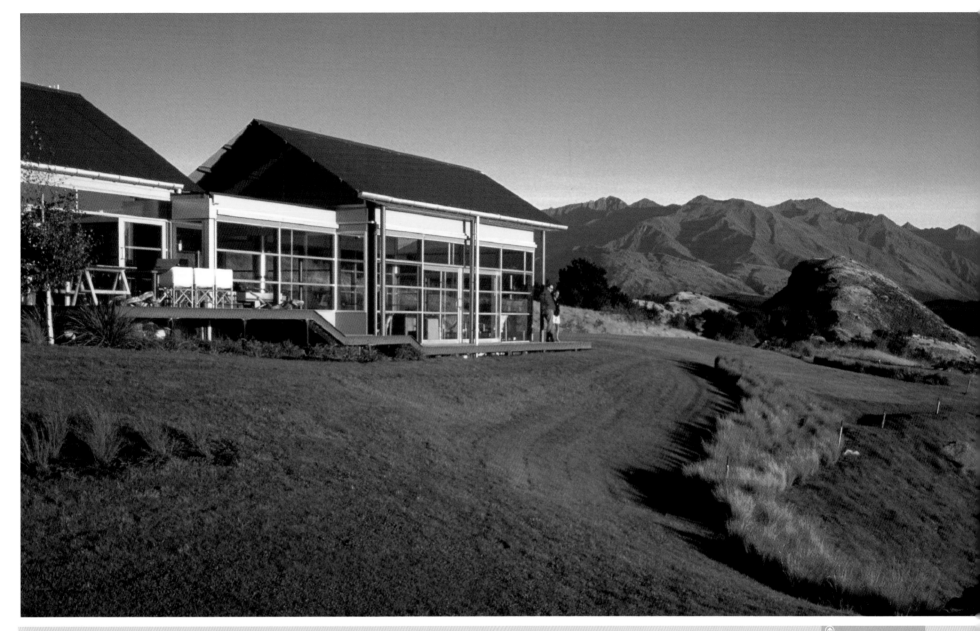

WHARE KEA LODGE
LAKE WANAKA, NEW ZEALAND

Whare Kea Lodge sits on the shores of the glacial Lake Wanaka. The single-story construction means it blends remarkably well into the landscape.

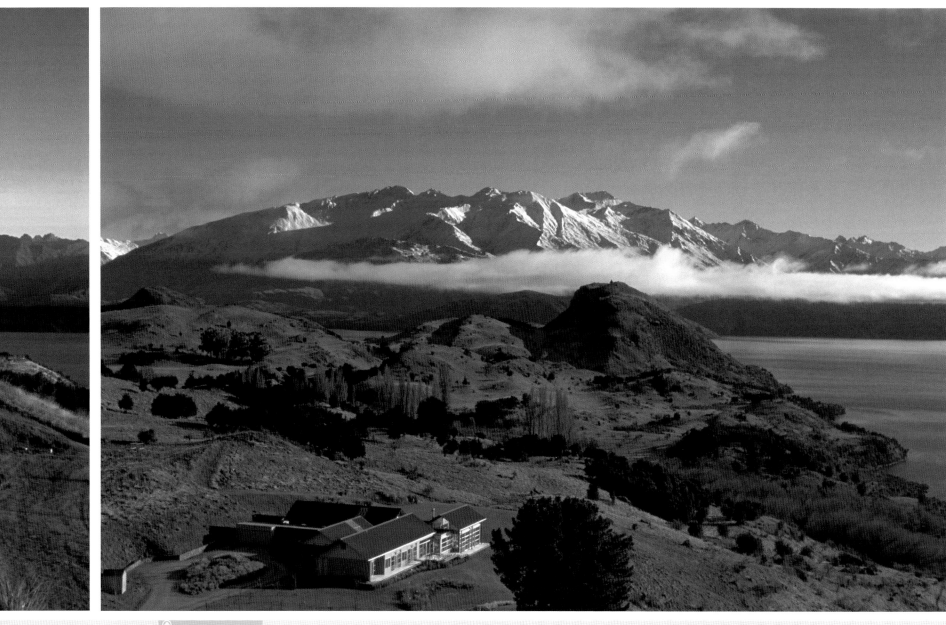

Whare Kea Lodge is dwarfed by its neighbors. Guest accommodation is built on the same level as the exterior timber decking to ensure unobstructed views over the lake.

Whare Kea Lodge, meaning "House of the Kea" (a mountain parrot), is perched on the edge of Lake Wanaka, overlooking the mountains of the Buchanan Range in the Southern Alps, and is nothing short of spectacular. With a view this good, the design of the lodge had a lot to live up to. The owners gave Melbourne architect John Mayne the ambitious task of creating a house that would sit comfortably and unobtrusively in this exposed location, while providing comfortable and intimate accommodation for its guests.

Despite the lodge's isolated position, its single-story construction means it blends remarkably well into the surrounding landscape. Having just a single story was also a deliberately practical design decision: its low-rise form means it is less likely to feel the brunt of the strong winds that blow through the area. The timber-and-steel frame construction is distinctly modern in feel, yet the building's ground plan and gables are inspired by traditional New Zealand farmsteads. In keeping with the design of typical local farms, the lodge

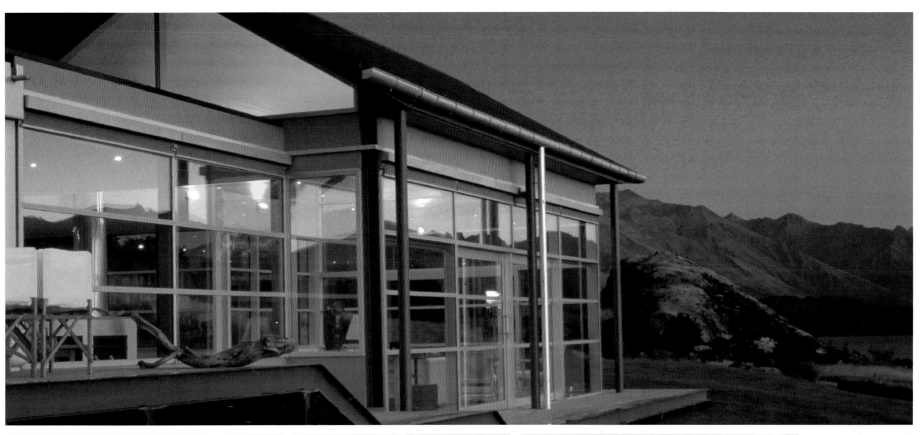

CONTACT: WHARE KEA LODGE, P.O. BOX 115, WANAKA 9192,
NEW ZEALAND, T: +64 3 443 1400, ADMIN@WHAREKEALODGE.COM,
WWW.WHAREKEALODGE.COM

(↑)
The lodge at night,
revealing its contemporary
mix of timber, steel, and
glass. Low-E double-
glazing saves energy by
providing insulation.

(→)
Guests can enjoy a meal
in the central communal
area while taking in the
spectacular views. The
furnishings are all made
from sustainable materials.

sits on a raised timber deck. This gives the house a remarkably weightless feel, almost as if it's hovering by the edge of the lake.

The marriage of traditional and contemporary architecture is nowhere more evident than in the lodge's vast, glazed external elevations. Given the magnificent location, the owners wanted guests to enjoy unimpeded views, but in such an exposed position, this was no mean feat. Low-E double-glazing was used to ensure adequate insulation from the cold winds, and this was supplemented by efficient insulation in the walls, roof, and floors. The initial outlay for this extra insulation was considerable, but it was a long-term investment which saves both precious energy and money.

The lodge-style dwelling consists of two wings and provides accommodation for a maximum of 12 guests in six rooms—three rooms in each wing. The layout of the guest rooms is unified by a centrally positioned, open-plan kitchen and lounge area, which adds to the convivial, informal atmosphere. With such incredible views, it's hard to believe anyone would want to leave, but there are several tempting activities to draw guests out into

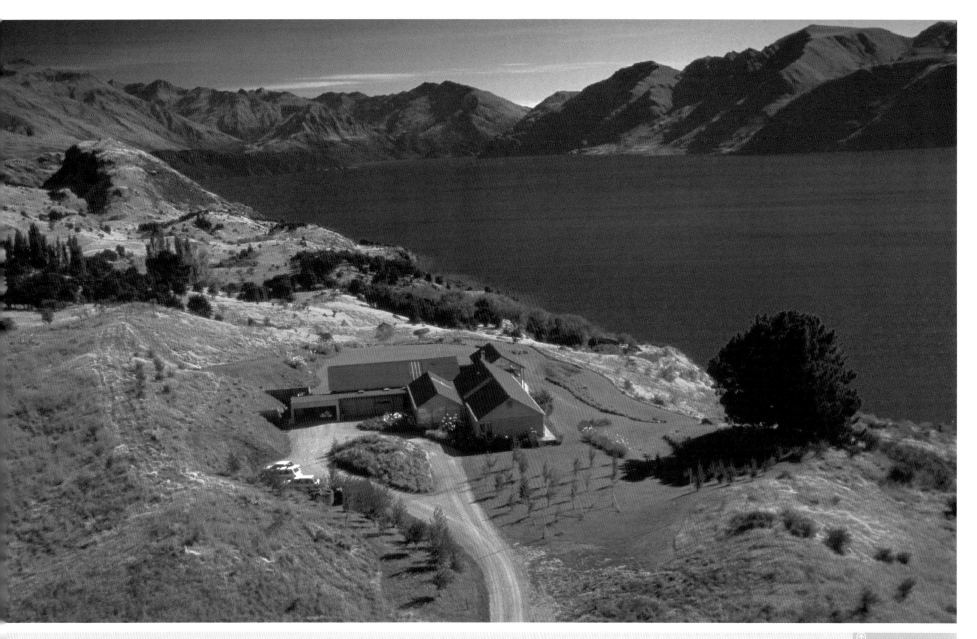

nature; they can go hiking, take a jetboat ride, or experience a river day-trip through Lord of the Rings country. The lodge has recently opened a chalet high up in the Buchanan Range, beside Mount Aspiring National Park, which sits at 5,600ft (1,700m) and is accessible only by helicopter. The chalet shares the same design ethics and levels of comfort as its sister lodge, but here the toilet is located externally for environmental reasons.

The lodge's footprint is extremely small in this barren landscape; the low-level construction helps it to blend unobtrusively into its surroundings.

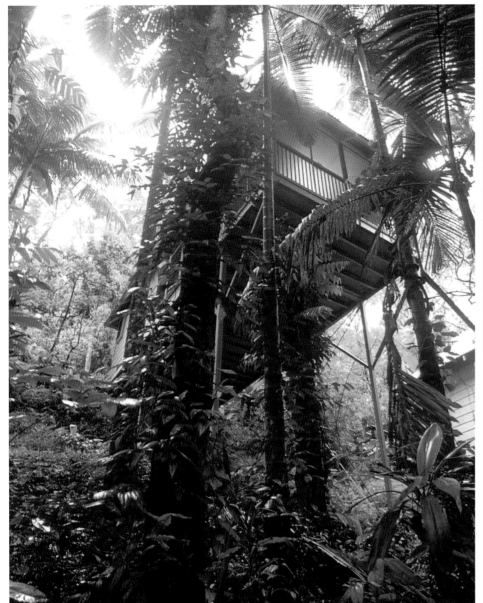

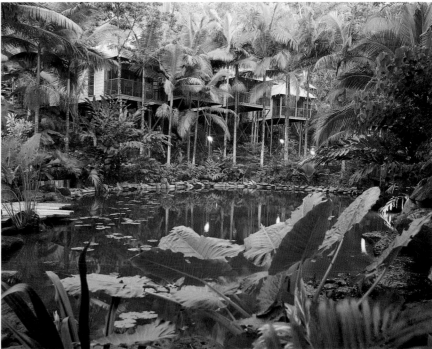

Each villa enjoys majestic views of the rain forest and its diverse habitats.

The villas are perched on steel stilts to prevent damage to the precious rain forest floor. Steel was chosen rather than timber, as timber attracts termites and is less stable.

DAINTREE ECO LODGE & SPA
QUEENSLAND, AUSTRALIA

The resort's restaurant Bilngkumu; this is the word for crocodile in the local Aboriginal dialect.

CONTACT: DAINTREE ECO LODGE & SPA,
20 DAINTREE ROAD, DAINTREE, QLD 4873,
AUSTRALIA , T: +61 (0)7 4098 6100,
INFO@DAINTREE-ECOLODGE.COM.AU
WWW.DAINTREE-ECOLODGE.COM.AU

The resort's undercover swimming pool is solar-heated, so guests can be confident that they aren't wasting the earth's resources when they take a dip.

As the only lodge in the world's oldest living rain forest—40 million years older than the Amazon—the owners of Daintree Eco Lodge & Spa have quite a responsibility to the environment, and to the people who have always inhabited this land. Created and designed by a Swiss-German consortium and now owned and operated by a family business, headed up by Terry and Cathy Maloney, the ecolodge and spa sits in a region of pristine tropical lowland rain forest that has been around for more than 110 million years.

It represents the largest tract of this type of rain forest on the Australian continent and is home to eight different types of natural habitat, including billabong, mangrove, creek, and open grassland.

The lodge consists of 15 villas, all fully flyscreened, luxurious, and designed to have minimal impact on the fragile ecosystem. Villas and amenities are linked by raised boardwalks, beneath which are concealed electrical and plumbing services: siting them here avoids the need to disturb the floor vegetation. Terry and

Cathy are proud of the villa design, stating, "It allows for natural aspects to be capitalized on, for example, the microclimate that is created due to capturing the natural ventilation. At times, the valley is up to 60°F (15°C) cooler than other areas in the region, and that's all down to clever design."

To ensure that the resort's responsibilities are met, the owners set up an Ecotourism Management Unit. This focuses on issues affecting the natural and cultural environment, promoting tourism-based activities and sustainable

tourism practices, and ensuring that Aboriginal culture is preserved rather than compromised by their tourism operations. Terry and Cathy take their responsibility for keeping this area of rain forest pristine very seriously indeed. They add, "Our relationships with nature and the Aboriginal culture have grown since we've been running the lodge, and we've developed strong relationships with the local Ku Ku Yalanji people who traditionally inhabited the area."

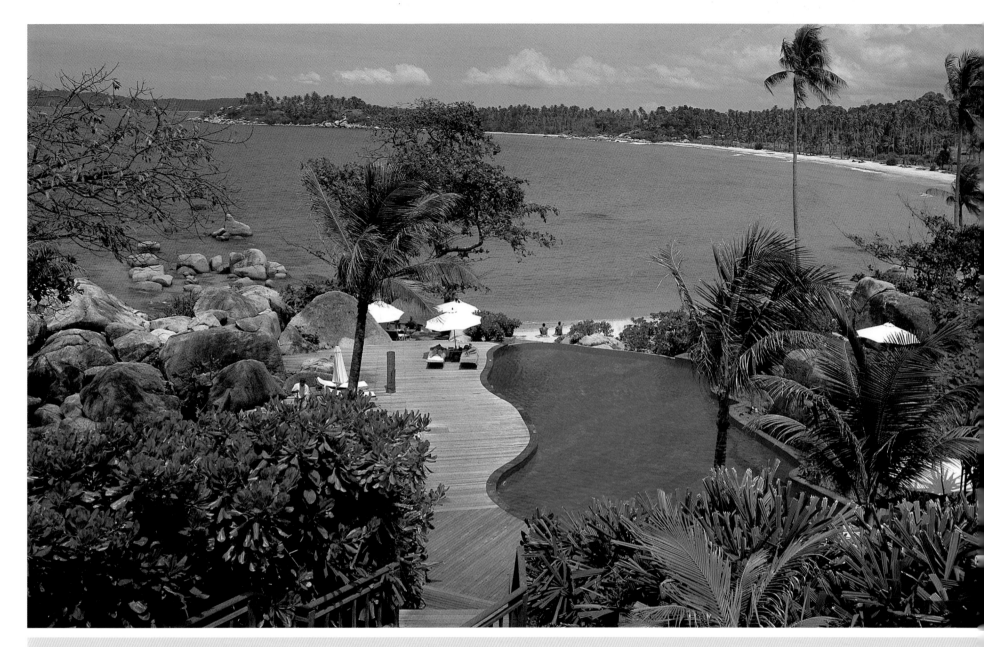

BANYAN TREE BINTAN
BINTAN, INDONESIA

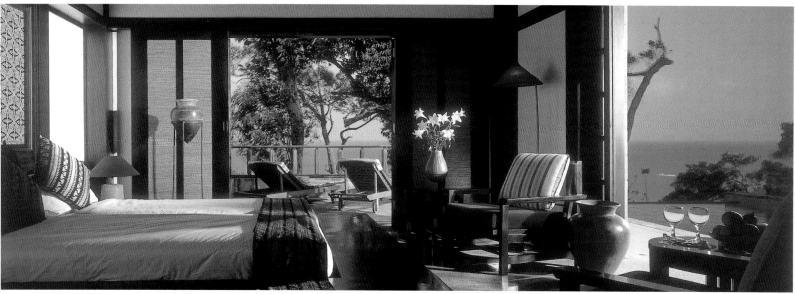

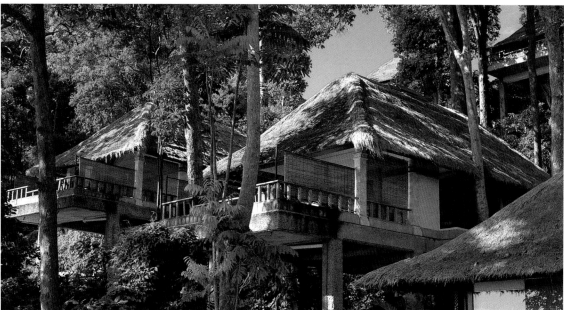

To avoid damaging the ecosystem during construction, the resort's luxury villas were planned around the existing mature trees and perched on stilts. Their design is based on traditional Balinese architecture.

The bedroom of this villa enjoys a shady sundeck with unimpeded views of its own private pool and the bay beyond.

CONTACT: BANYAN TREE BINTAN, SITE A4, LAGOI, TANJONG SAID, BINTAN ISLAND, INDONESIA, T: +62 (0)770 693 100, BINTAN@BANYANTREE.COM, WWW.BANYANTREE.COM

The resort's second pool boasts a sunbathing deck that leads directly down to the private beach of Tanjong Said. To avoid cutting down trees, the attention to site planning and design was meticulous.

Banyan Tree Holdings represents the commercial side of sustainable tourism. A well-known global brand, they have made a success of building ecosensitive resorts in some of the world's most exotic and pristine locations. (See also Banyan Tree Phuket, page 123.) Built on a much bigger scale than the majority of hotels and retreats featured in this book, the company's strict environmental policies ensure that the landscapes and ecosystems around their resorts aren't adversely affected. They also follow many of the most important principles of sustainable tourism, such as protecting the local environment, providing educational programs for guests and locals, and helping to boost local economies rather than take from them.

Banyan Tree Bintan, situated in the northwest of tiny island Bintan, a 45-minute catamaran ride from Singapore, opened in 1995. It was the first resort on the island and is typical of the company's devotion to providing luxurious, private accommodation in an idyllic beachside setting. With 72 villas, it is considerably larger than most eco ventures. Fifty-five villas have a whirlpool tub on a deck facing the South China Sea, while other, more luxurious villas offer private swimming pools or plunge pools. Despite the scale of the development, Banyan

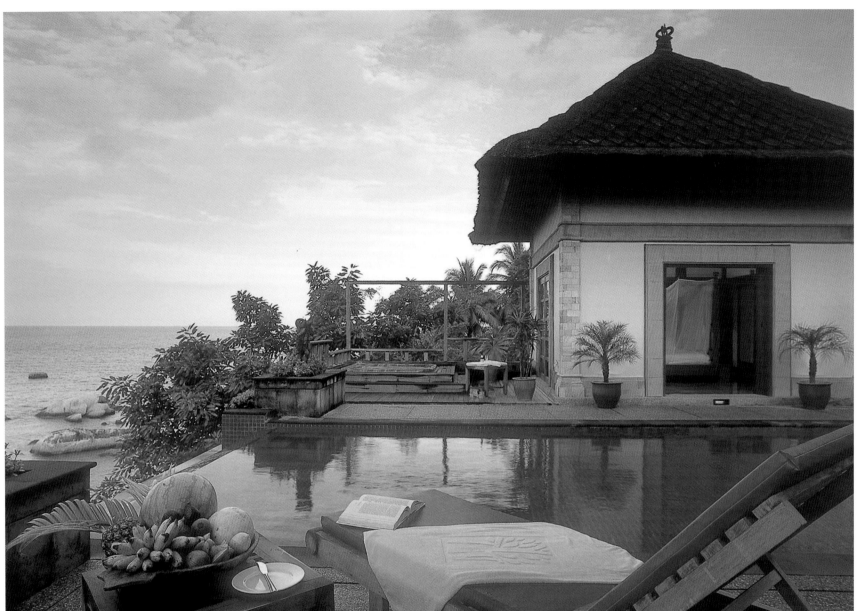

Each villa was designed around the existing natural landscape. Flanked by wooden decks, this elevated pool villa overlooks the South China Sea.

Tree Holdings planned the resort's design around the existing trees—many of which are aged between 50 and 100 years—and the island's rare, indigenous ferns. Each villa was meticulously placed on stilts underneath the jungle canopy so as not to disturb the ground-level or canopy ecosystems. Edwin Yeow, Vice President of Marketing for Banyan Tree Hotels & Resorts confirms, "Difficult site conditions such as steep slopes, huge boulders, and avoidance of cutting

down trees posed a great challenge to us. With these physical constraints, we had to pay more attention to design and site planning for the location of the villas."

As with all remote locations, the problems of getting rid of waste arise—in a pristine island location such as this it was all the more important to ensure that the ocean would not be affected by the waste that a relatively large and well-developed tourism venture generates. A biological wastewater system was thus installed. It uses natural local resources including plants, granite chips, and sand to function as a biological pump, preventing waste from polluting the sea. Banyan Tree's care for its environment extends to its host community through stringent staffing policies. Ninety percent of the staff are local, and the company provides impressive employee development opportunities.

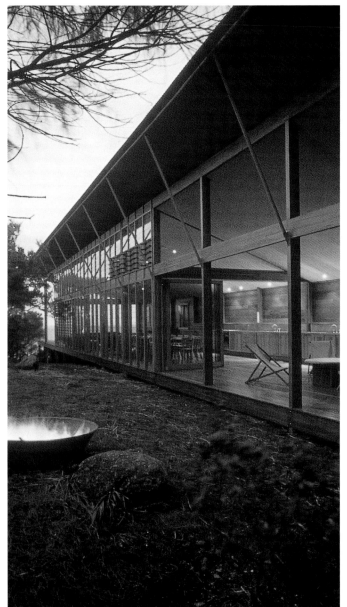
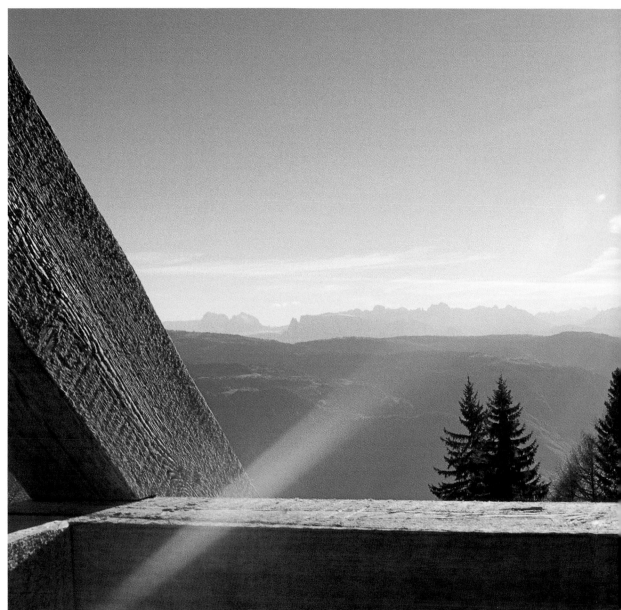

PHOTOGRAPHY CREDITS

BAJO KOMODO ECO LODGE:
BAJO KOMODO ECO LODGE

BANYAN TREE BINTAN:
BANYAN TREE

BANYAN TREE PHUKET:
BANYAN TREE

BAY OF FIRES LODGE:
SIMON KENNY, BAY OF FIRES WALK P/L

THE BLACK SHEEP INN:
BLACK SHEEP INN

THE BOAT LANDING GUEST HOUSE
AND RESTAURANT:
WILLIAM TUFFIN, PETER WHITTLESEY

CANOPY TOWER:
CANOPY TOWER PANAMA

CARDAMOM HOUSE:
DR. CHRIS LUCAS

CHUMBE ISLAND CORAL PARK:
MANOLO YLLERA, GEORGE FIEBIG,
JAN HÜLSEMANN, PER KRUSCHE

CONCORDIA ECO-TENTS:
CONCORDIA ECO-TENTS

DAINTREE ECO LODGE & SPA:
DAINTREE ECO LODGE & SPA

DESERT LODGE:
URSINA RÜEGG, KHALED ETMAN

EL MONTE SAGRADO LIVING RESORT
AND REJUVENATION CENTER:
DHARMA LIVING, EL MONTE SAGRADO

FINCA ROSA BLANCA COUNTRY INN:
FRANK DUFFY

HOG HOLLOW COUNTRY LODGE:
KELVIN SAUNDERS AT STUDIO ATRIUM,
MARK ANDREWS AT AFRICAN RAMBLES

HOTEL ECO PARAISO XIXIM:
HOTEL ECO PARAISO XIXIM

HOTELITO DESCONOCIDO:
HOTELITO DESCONOCIDO

HUZUR VADISI:
HUZUR VADISI

KAPAWI ECOLODGE & RESERVE:
KAPAWI ECOLODGE

KASBAH DU TOUBKAL:
ALAN KEOHANE, JOHN BOTHAMLEY

KAYA MAWA:
CHRISTIAN MOLITOR, DANA ALLEN
AT PHOTOSAFARI

LEVENDI'S ESTATE:
SPERO AND MARILYN RAFTOPULOS

LISU LODGE:
WWW.ASIAN-OASIS.COM

LOCANDA DELLA VALLE NUOVA:
GIULIA SAVINI, AUGUSTO SAVINI

THE LODGE AT BIG FALLS:
ROB HIRONS, MITCHELL-MOODY ASSOCIATES

LONGITUDE 131°:
LONGITUDE 131°

MOWANI MOUNTAIN CAMP:
MOWANI MOUNTAIN CAMP, KLAUS BRANDT
ASSOCIATED ARCHITECTS

NAPO WILDLIFE CENTER:
NAPO WILDLIFE CENTER

NORTH ISLAND:
SILVIO RECH, LESLEY CARSTENS ARCHITECTURE
& INTERIOR ARCHITECTURE

PAKAAS PALAFITAS LODGE:
ANTONIO PINTAR, WALDEMAR JULIO REIS

PAPERBARK CAMP:
PAPERBARK CAMP

PERLEAS MANSION:
ISIDOROS LOIZOS, MARIA XYDA

SENTRY MOUNTAIN LODGE:
ALAN MAUDIE (WWW.ALANMAUDIE.COM)

SHOMPOLE:
DAVID COULSON, SIMON COX

TIAMO RESORTS:
COOKIE KINKEAD

TREE TOPS JUNGLE LODGE:
LARS SORENSON

VERANA:
JAE FEINBERG, VERANA

VIGILIUS MOUNTAIN RESORT:
VIGILIUS MOUNTAIN RESORT

VILLAS ECOTUCAN:
VILLAS ECOTUCAN

WHARE KEA LODGE:
BILL BUCHMAN

BAY OF FIRES LODGE
KEN LATONA
CRADLE HUTS
P.O. BOX 1879
LAUNCESTON
TASMANIA 7250
AUSTRALIA
T: +61 (03) 6331 2006
CRADLE@TASSIE.NET.AU

CHUMBE ISLAND CORAL PARK
GEORG FIEBIG
14 SEABREEZE PARADE
GREEN POINT
NEW SOUTH WALES 2428
AUSTRALIA
T: +61 (02) 6557 5399
G.FIEBIG@GMX.NET

JAN HÜLSEMANN
HERDERSTR.10
28203 BREMEN
GERMANY
T: +49 (0) 421 7901 791
JAN.HUELSEMANN@THAROS-NET.DE

PER KRUSCHE
TU BRAUNSCHWEIG
INSTITUT FÜR ENTWICKLUNGSPLANUNG UND
SIEDLUNGSWESEN
MÜHLENPFORDTSTRAßE 23
38106 BRAUNSCHWEIG
GERMANY
T: +49 (0) 531 391 3546
IES@TU-BRAUNSCHWEIG.DE

DESERT LODGE
KHALED ETMAN
8 EL-OBOUR BUILDINGS
SALAH SALEM ROAD
HELIOPOLIS
CAIRO
EGYPT 11811
T: +20 (2) 402 5209
K.ETMAN@LINK.NET

FINCA ROSA BLANCA COUNTRY INN
FRANCISCO ANTONIO ROJAS CHAVES
P.O. BOX 3037-1000
SAN JOSE
COSTA RICA
T: +506 235 3286
FARO@AMNET.CO.CR

KASBAH DU TOUBKAL
JOHN BOTHAMLEY
56 LESLIE GROVE
CROYDON
CR0 6TG
ENGLAND
T: +44 (0)20 8680 3100
JOHN@JOHNBOTHAMLEY.CO.UK
WWW.JOHNBOTHAMLEY.CO.UK

THE LODGE AT BIG FALLS
ARIEL MITCHELL
MITCHELL-MOODY ASSOCIATES
22 ST THOMAS STREET
BELIZE CITY
BELIZE
T: +501 (0)224 4469
MITMOO@BRL.NET

MOWANI MOUNTAIN CAMP
KLAUS BRANDT ASSOCIATED ARCHITECTS
8 SINCLAIR ROAD
P.O. BOX 22169
WINDHOEK
NAMIBIA
T: +264 (0)61 229 893
KBAA@IWAY.NA

NAPO WILDLIFE CENTER
FAUSTO ACOSTA, JULIO GUAYASAMIN, AND RAMIRO
RANGLES
BARRO VIEJO
7MA TRANSVERSAL N.-157 Y VIA INTERVALLES
TUMBACO, QUITO
P.O. BOX PIC-17-2220160
ECUADOR
T: +593 (0)22374 258
BARROVIEJO@ANDINANET.NET

NORTH ISLAND
SILVIO RECH AND LESLEY CARSTENS
ARCHITECTURE AND INTERIOR ARCHITECTURE
32B PALLINGHURST ROAD
WESTCLIFF
JOHANNESBURG 2193
SOUTH AFRICA
T: +27 (0)11 486 1525
ADVENTARCH@MWEB.CO.ZA

PAKAAS PALAFITAS LODGE
W. JULIO REIS
RUA RIO MAR, 34 CONJUNTO VIEIRA ALVES
N S DAS GRAÇAS
69053120 MANAUS, AMAZONAS
BRAZIL
T: +55 092 6337320
PROART@HORIZON.COM.BR

PAPERBARK CAMP
TREVOR HAMILTON
NETTLETON TRIBE ARCHITECTS
107 ALEXANDER STREET
CROWS NEST
NEW SOUTH WALES 2065
AUSTRALIA
T: +61 (0)2 9431 7474
INFO@NETTLETONTRIBE.COM.AU

PERLEAS MANSION
DEMETRI KAKOUROS
KAKOUROS, XYDA ARCHITECTS
KAMPOS
CHIOS
GREECCE 82100
T: +30 227 103 2098
DEKAMAXY@OTENET.GR

VIGILIUS MOUNTAIN RESORT
MATTEO THUN
STUDIO THUN
VIA APPIANI 9
I-20121 MILAN
ITALY
T: +39 (0) 2 6556911
INFO@MATTEOTHUN.COM
WWW.MATTEOTHUN.COM

ARCHITECTS' DETAILS

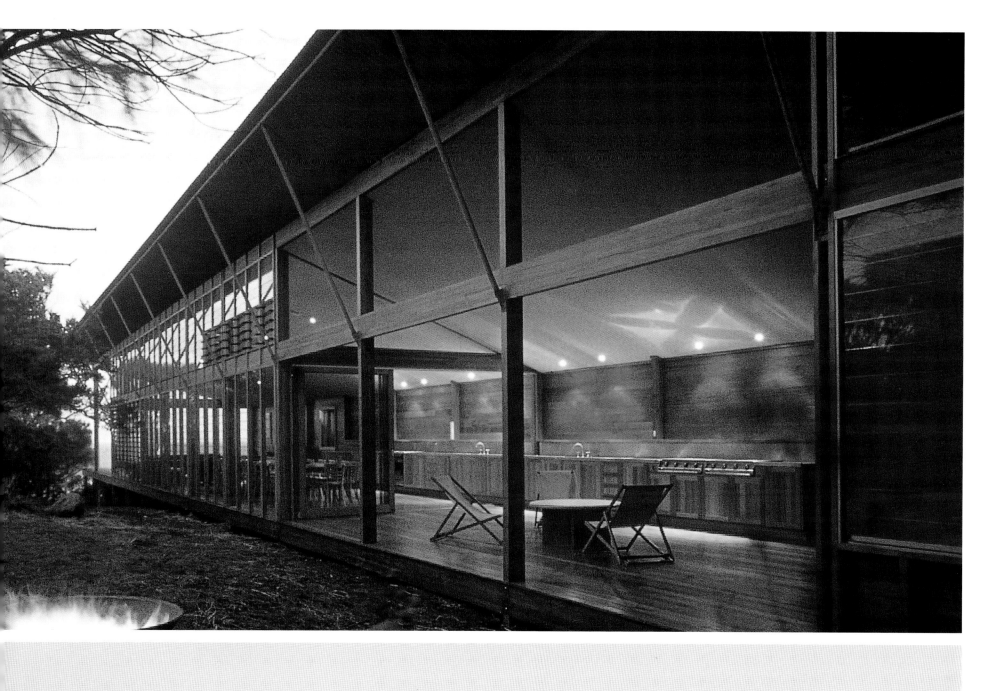

INDEX